GLASS

ART NOUVEAU + ART DECO +
DEPRESSION + MODERN

CANDLEHOLDERS

Paula Pendergrass &
Sherry Riggs

Schiffer Publishing Ltd

4880 Lower Valley Road, Atglen, PA 19310 USA

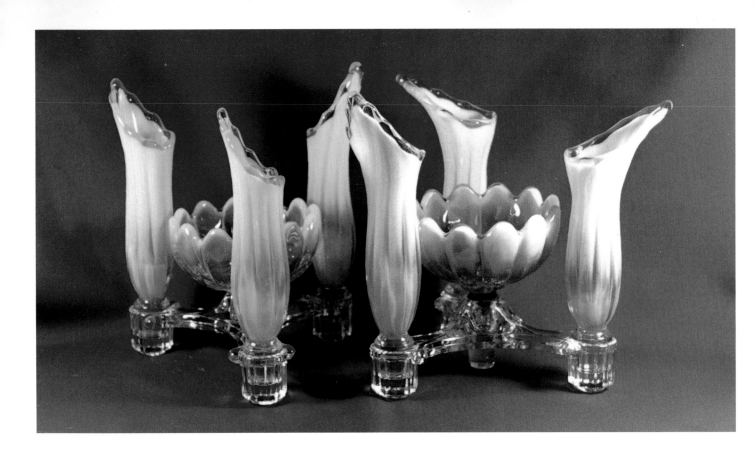

Designed by "Sue"
Type set in Dutch801 SeBd BT/ZapfHumnst BT

ISBN: 0-7643-1210-3
Printed in China
1 2 3 4

Published by Schiffer Publishing Ltd.
4880 Lower Valley Road
Atglen, PA 19310
Phone: (610) 593-1777; Fax: (610) 593-2002
E-mail: Schifferbk@aol.com
Please visit our web site catalog at
www.schifferbooks.com
We are always looking for people to write books on new and related subjects. If you have an idea for a book, please contact us at the above address.

This book may be purchased from the publisher.
Include $3.95 for shipping.
Please try your bookstore first.
You may write for a free catalog.

In Europe, Schiffer books are distributed by:
Bushwood Books
6 Marksbury Ave.
Kew Gardens
Surrey TW9 4JF England
Phone: 44 (0) 20 8392-8585; Fax: 44 (0) 20 8392-9876
E-mail: Bushwd@aol.com
Free postage in the UK. Europe: air mail at cost.

Contents

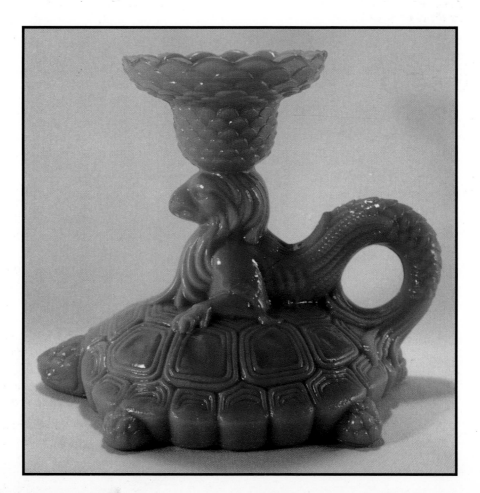

Preface

We wrote our first book to provide a quick reference for commonly found antique and collectible glass candle holders. Guess what? It wasn't enough! We very quickly collected enough material for a second volume, and a third in progress.

This volume concentrates on harder-to-find, and often more expensive, candle holders including special treatments and elegants. While the focus is primarily on U.S. manufacturers, some foreign makers, such as Portieux of France, are also included. Also some of our favorite unknowns are shown in hopes that our readers can help in the identification.

Identification of candle holders in this book is based on publications, catalogs, manufacturer's verification, manufacturers' marks, and affixed labels. **Pricing** is based on publications, mall prices, glass show prices, and advice from expert collectors and dealers. Although our pricing research is comprehensive, it is not fool proof; it cannot account for regional differences, nor predict future trends. Prices are given as a suggested range for mint condition items, with the upper price indicating the most desirable colors and/or treatments.

Candle holders are listed alphabetically by manufacturer or known retailer. For example, a candle holder made by Fenton for L.G. Wright will be listed under L.G. Wright with a note that it was made by Fenton. Foreign candle holders are listed by country with the manufacturer also being identified, if known. The progression in each section is from shorter to taller, and from single, to double, to triple; however, similar candle holders have been grouped by line number or by style in some places.

All measurements in this book are actual measurements of the candle holder shown, not catalog listings. **A word of caution**: candle holders from the same line commonly vary \pm 0.5 inch; so a candle holder described in the literature as being 3", could be as short as 2.5", while another one could be as tall as 3.5". (Here's a **tip** from Sim Lucas: "if you don't have a tape [measure], you can use a dollar bill which is 6" long on the button!")

A **bobeche** is a ring placed or molded around the base of the light; **prisms** are generally attached. For consistency, we have used the term **candelabra** to refer to holders with bobeches and prisms attached. The term **lustre** refers to candle holders with a fixed bobeche; a **nappy** is a candle dish with a handle; an **epergne** is a vase that fits into the light in place of a candle. An **etching** is a roughened surface pattern usually created by sandblasting or the application of acid; a **cutting** is engraved into the glass with a sharp instrument.

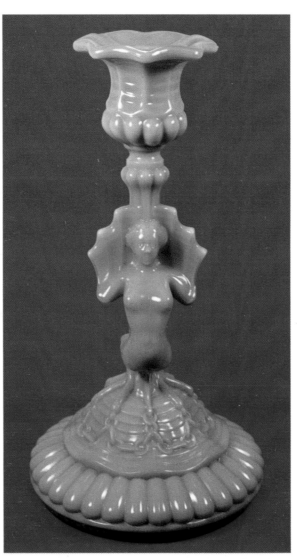

France (Portieux) 9.25" 'Sirene' single light candlestick. Blue milk glass, white milk glass, creamy French opaline: $325-350 each. (Early 1900s). Scarce in any color.

Acknowledgments

Collectors and Consultants

Tom Bloom, C.J. Bodensteiner, Jackie Brown, Al and Lib Davidson, Eddie Dean, Bill and Diane Haight, Sharon Hosack, Hanley and Margaret Jennings, Barbara Kane, Sim and Betty Lucas, Robert Meador, Nancy Rowbottom, Janet and Dale Rutledge, Cheryl Sedlar, Gary and Janice Scheffel, Margaret Speight, Edna Staton, Nona Glass Taylor, Matzi and Jeff Thrasher, Susan Turner, David Vance, Enid and Len Waska, and Jean Westbrook.

Malls

Bloom's Charles Street Antiques, Wellsburg, WV; Han-Mar's Odd Shop, Weslaco, TX; J.T. Texas, Tomball, TX; Sherry Riggs Antiques, Houston, TX; Sisters 2 Too, Alma, AR; Sweet Memories Antique Mall, Russellville, AR; The Antique Company Mall, McKinney, TX; Timely Treasures Antiques, Houston, TX; This and That and Something Else, Russellville, AR; and We Love Antiques, Dover, AR.

Technical Support

Bill Belovicz; Ken Riggs; Victor Vere; Mark and Bridgitt Ussery: Express Foto, Russellville, AR; and Ken Wallis, A.J. Pumphrey, John Roth, and Monica Romero: Eckerd Photo, Houston, TX. A special thanks to Ken Wallis for his continued enthusiasm and support.

Editorial Support

Schiffer Publishing Ltd. and its staff; Peter Schiffer; and our editors, Jennifer Lindbeck and Donna Baker.

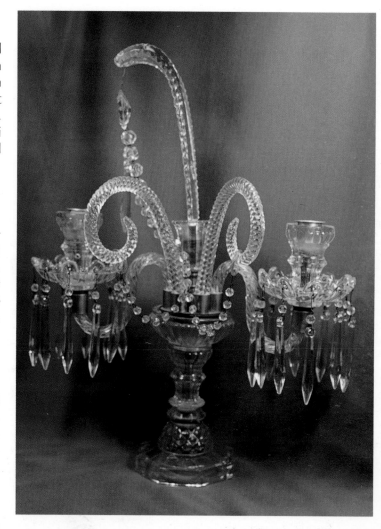

Introduction

Candle holders provoke a rich symbolism in our culture. The single candle in the window, the chamber stick beside the bed, and the lighted elegant centerpiece at a dinner party each symbolize home, comfort, and welcome. Therefore it is no surprise that candle holders continue to capture the eye of a large cross section of our population.

The manufacture and retail of glass candle holders in the U.S. has a rich history. Small and large companies alike have produced literally thousands of glass candle holders that decorate elegant table settings, match glassware lines, and delight the imagination with their whimsical shapes.

Many of the best known 20th century manufacturers, such as Fostoria, Heisey, L.G. Wright, New

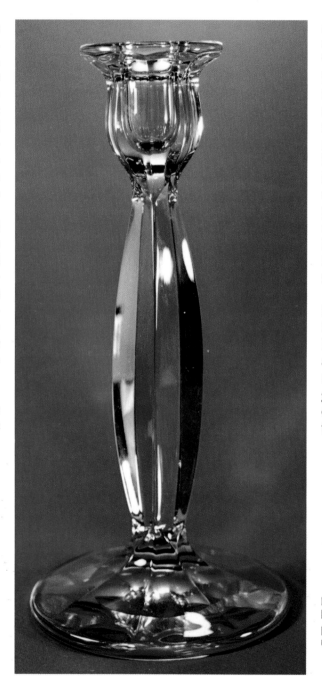

Martinsville, Northwood, Paden City, Dalzell-Viking, and Westmoreland, are gone now, having become victims of the two Fs: fire and finances. Despite the loss, their artistry continues to be collected and admired as the value of their work increases with time. Nevertheless, beautiful glassware and candle holders are still being produced in the U.S. by large manufacturers including, Fenton, Hocking, Indiana, and L.E. Smith, as well as by many small specialty firms.

In this book we provide a blend of old and new: continuing our survey of the major older lines with harder-to-find pieces, and adding representatives from newer, smaller companies. Together the array of candle holders displayed reflects the state of the art in the 20th century.

Heisey 9.75" #29 'Sandford' single light candlestick. Crystal: $140-150 pair. Some marked. (1912-1929). Also made in 7" and 11". Hard to find.

Candleholders
and Their Values

Austria

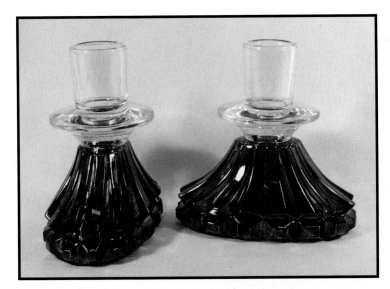

Austria 4.5" x 4.375" single light candle holder. Blue glass with fired on iridescence, cranberry glass with fired on iridescence: $115-125 pair. **Note**: these have been modified from perfume bottles.

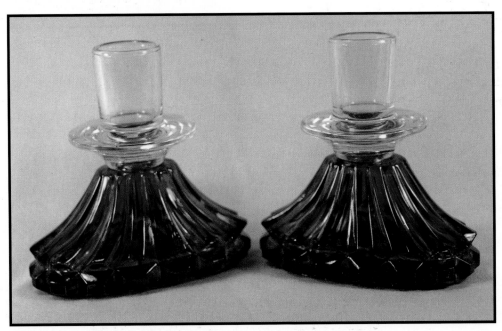

Austria 4.5" x 4.375" single light candle holder. Cranberry glass with fired on iridescence: $115-125 pair.

Beaumont Company

Morgantown, West Virginia, early 1900s to 1962. Tableware, boudoir items, and lighting.

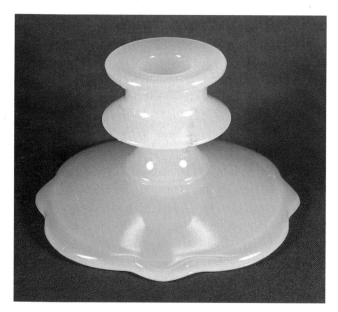

Beaumont 2.625" single light candle holder. Fer-lux (opaque white with semi-transparent look): $20-25 each without decoration; $30-35 each with decoration. Part of #115 console set. (c. 1920s).

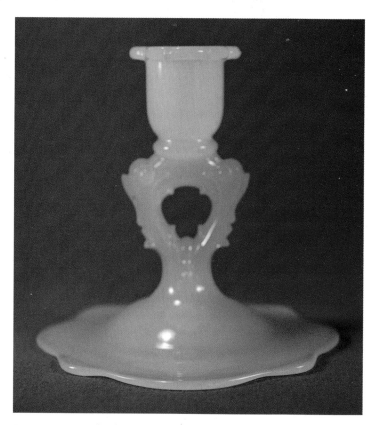

Beaumont 4.75" keyhole style single light candle holder. Fer-lux (opaque white with semi-transparent look): $35-40 each without decoration; $40-50 each with decoration (decorations vary greatly).

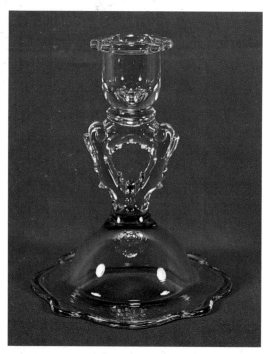

Beaumont 5.375" keyhole style single light candle holder. Crystal: $30-35 each; fer-lux: $35-40 each; ruby: $55-60 each. (c. 1920s-1930s).

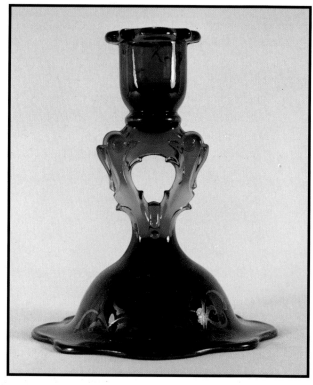

Beaumont 5.5" keyhole style single light candle holder. Ruby or cobalt with sterling deposit: $75-80 each. (c. 1930s).

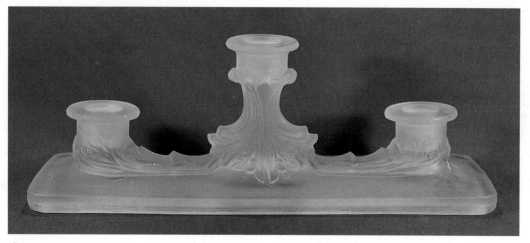

Beaumont 3.625" x 11.125" x 3.75" triple light candle holder. Crystal satin: $100-110 each. (c. 1920s).

Brooke Glass

Wellsburg, West Virginia, 1983 to present. Operated as **Crescent Glass** 1908 to 1983. Hand painted lamps and novelty glass.

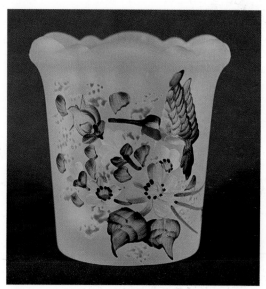

Brooke 2.75" single light votive. Frosted crystal with hand decoration: $7-9 each. Signed.

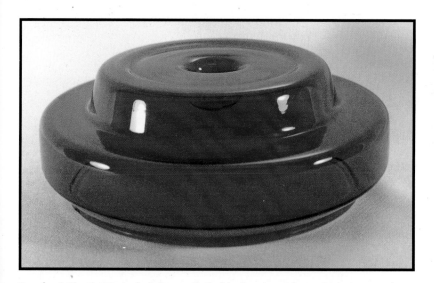

Brooke 2.5" x 6.25" single light candle holder/hurricane base. Red: $6-8 each.

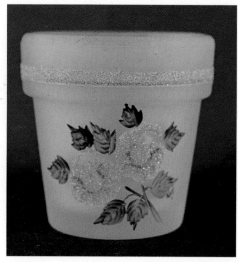

Brooke 2.625" single light votive. Frosted crystal with hand decoration: $7-9 each. Signed.

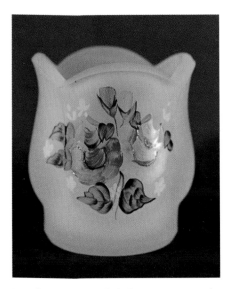

Brooke 2.625" single light votive. Frosted crystal with hand decoration: $7-9 each. Signed.

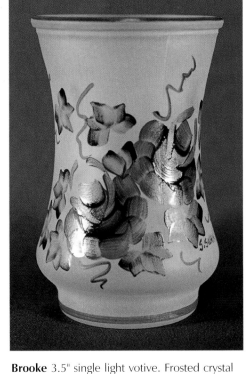

Brooke 3.5" single light votive. Frosted crystal with hand decoration: $5-7 each. Signed.

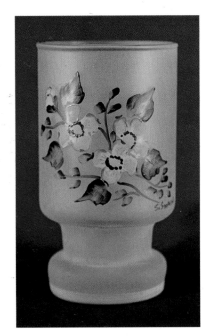

Brooke 4" single light votive. Frosted crystal with hand decoration: $7-9 each. Signed.

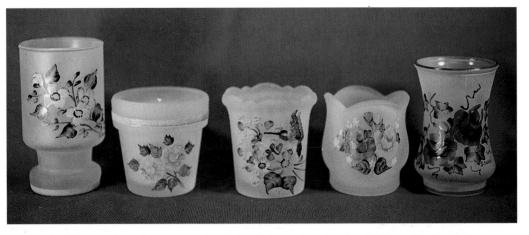

Brooke single light votives. Frosted crystal with hand decoration: $5-9 each. Signed. (c. 1990s).

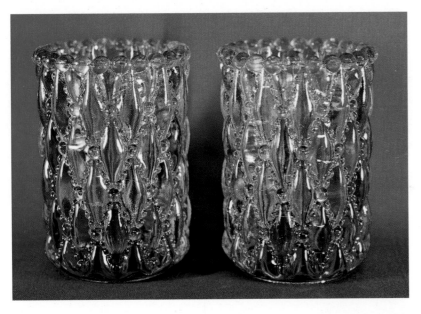

Brooke 3.5" x 2.375" single light quilted bead votive. Pink, jade: $6-8 each; crystal: $4-6 each. (c. 1990s).

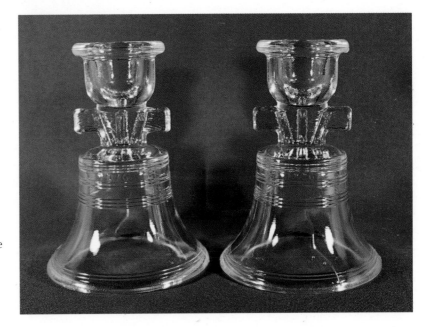

Crescent/Brooke 4.375" liberty bell single light candle holder. Crystal: $15-20 pair.

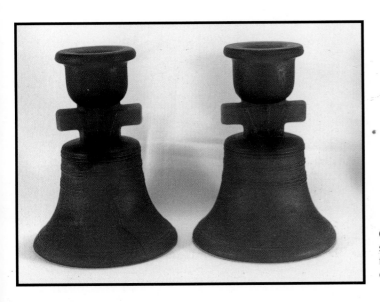

Crescent/Brooke 4.375" liberty bell single light candle holders. Red frosted: $25-30 pair; dark amber, crystal: $15-20 pair.

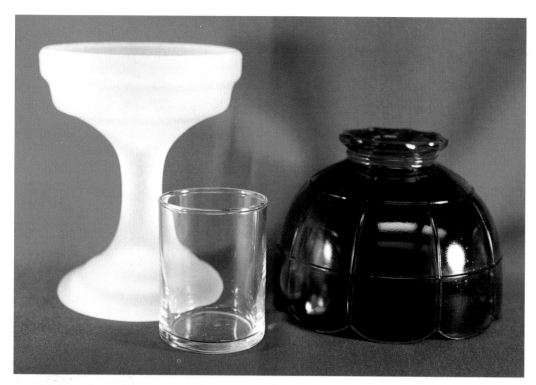

Brooke 7.5" single light three-piece candle lamp. Red shade with frosted base and clear votive: $25-30 each.

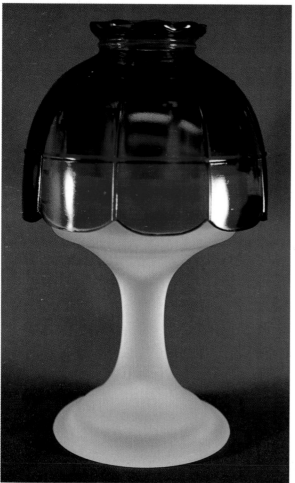

Assembled.

Cambridge Glass Company

Cambridge, Ohio, 1902 to 1958. Tableware, dinnerware and occasional pieces of all kinds. The molds were sold to **Imperial Glass Corporation** in 1960.

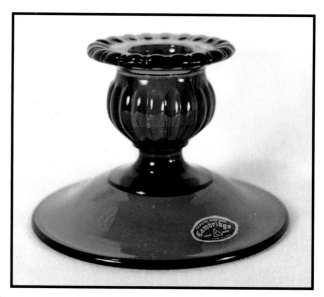

Cambridge 2.625" #3500/108 single light candle holder. Emerald green, Mandarin gold, amethyst: $30-35 each; royal blue, amber, dianthus pink, crystal: $20-25 each.

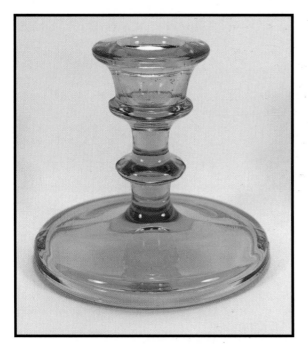

Cambridge 3.5" #687 single light candle holder. Pink, light emerald: $30-35 each; amber: $20-25 each.

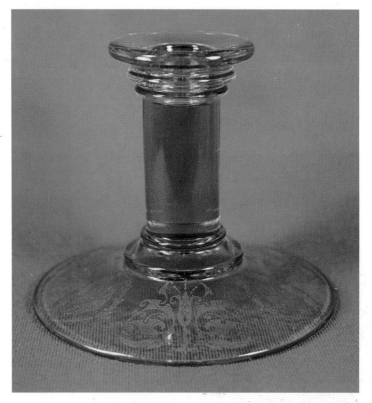

Cambridge 4.125" single light candle holder (line number unknown). Pink with #732 'Majestic' etching: $30-35 each.

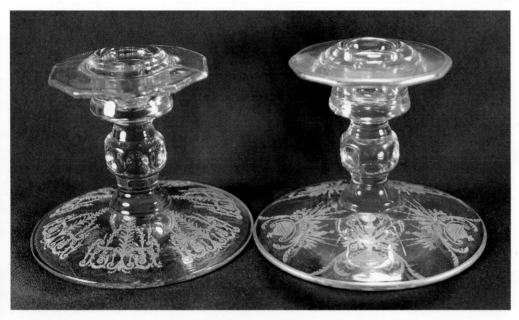

Cambridge 3.875" #627 single light candle holders. Peach blo with 'Cleo' etching, green with #739 etching and gold decoration, gold 'krystal': $40-45 each; yellow, amber, or crystal with etching: $30-35 each; light blue with etching: $50-55 each.

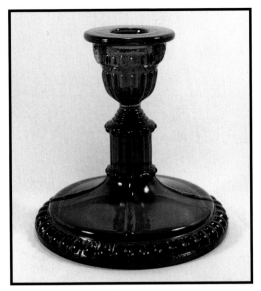

Cambridge 4.5" #3500/74 'Gadroon Ram's Head' single light candle holder. Emerald, amber, peach blo, amethyst, carmen, dianthus pink, forest green, crown tuscan, Mandarin gold, moonlight blue, royal blue, ebony milk glass: $95-100 each; crystal with etching: $75-80 each. (c. 1930s). (Also shown in 1940 catalog as being used for various etchings such as 'Elaine' and 'Rosepoint.').

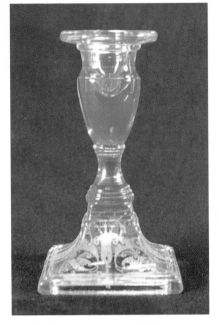

Cambridge 5" #624 single light candlestick. Green with #732 'Majestic' etching, pastels with etching: $35-40 each; pastels without etching: $30-35 each; crystal without etching: $25-30 each; crystal with etching: $30-35 each. (Early 1930s).

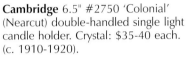

Cambridge 6.5" #2750 'Colonial' (Nearcut) double-handled single light candle holder. Crystal: $35-40 each. (c. 1910-1920).

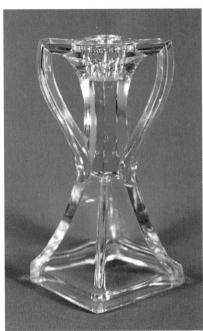

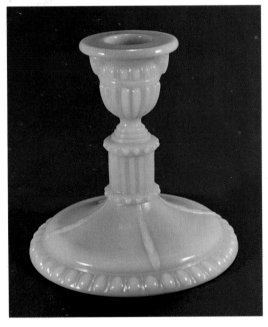

Cambridge 4.5" #3500/74 single light candle holder. Crown tuscan: $95-100 each. (c. 1930s).

Cambridge 6.375" #1402/80 'Tally-Ho' single light candlestick. Ruby red with silver deposit: $65-70 each; carmen: $50-55 each; crystal: $25-30 each. (1930-1934).

14

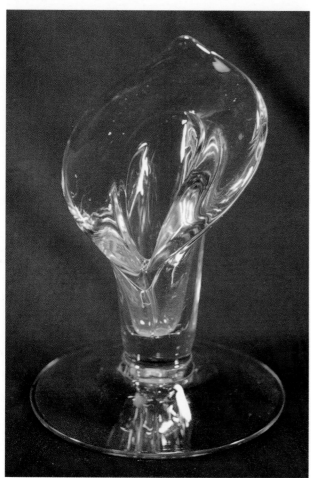

Cambridge 6.5" 'Pristine' #499 'Calla Lily' single light candle stick. Amber: $30-35 each; black, emerald: $60-65 each; crystal: $30-35 each; forest green, light emerald, heatherbloom (light orchid), moonlight (light blue): $70-75 each. (c. 1949-1953). (Can also be found with rock crystal cutting.)

Cambridge 6.875" #2780 'Inverted Strawberry' single light candle holder. Crystal with marigold iridescence (called carnival): light iridescence: $165-190 each; heavy iridescence: $275-300 each. (Early 1900s).

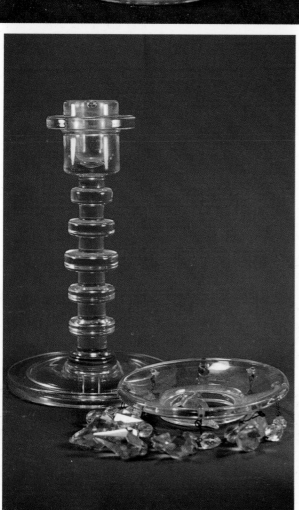

Cambridge 7.5" #507 'Pristine' single light candle holder with locking eight-prism bobeche and lip. Crystal: $70-75 each.

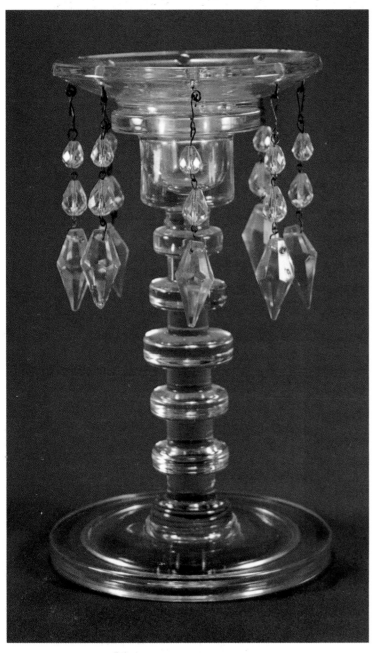

Cambridge 7.5" #507 'Pristine' single light candle holder with eight-prism bobeche. Crystal: $70-75 each.

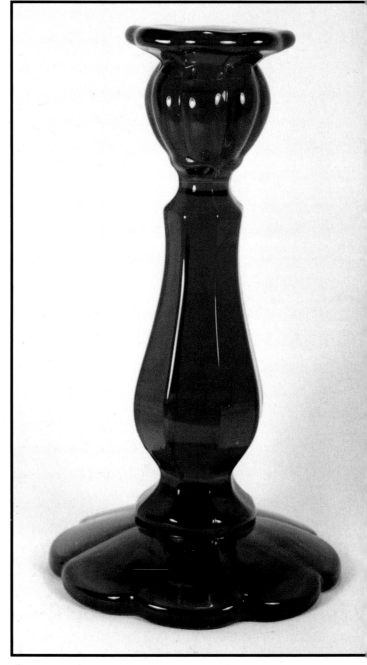

Cambridge 8" #653 single light candlestick. Cobalt, forest green: $70-75 each; crystal: $40-45 each. Used in 'Cambridge Arms' as a base for hurricane lights and candelabra.

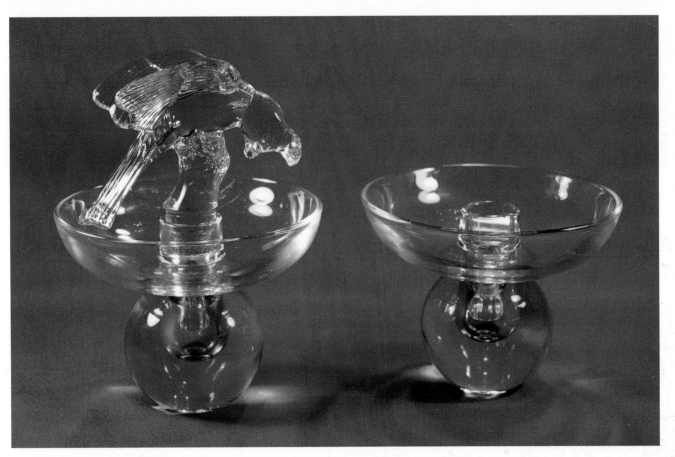

Cambridge 7" three-piece #510 ball, #1538 candle bowl and #1636 eagle peg. Crystal: $185-205. Individual parts: ball: $20-25 each; bowl: $20-25 each; eagle peg: $145-165 each.

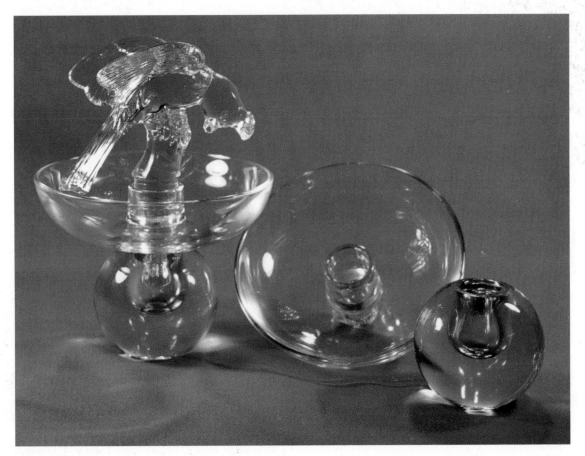

Alternative view.

Cambridge 8" #1595 single light pillar. Ritz blue, mulberry, light emerald: $50-55 each; crystal, amber: $40-45 each.

Cambridge 8" #70 'Nearcut' single light candlestick. Azurite (opaque blue) with gold decoration: $50-55 each; primrose, ebony, crystal (usually with cuttings or etchings): $40-45 each. (c. 1920s-1930s).

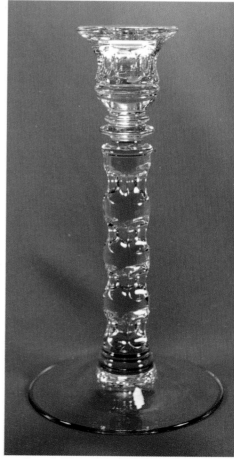

Cambridge 9" #5000/70 'Heirloom' single light candle holder. Crystal: $55-60 each.

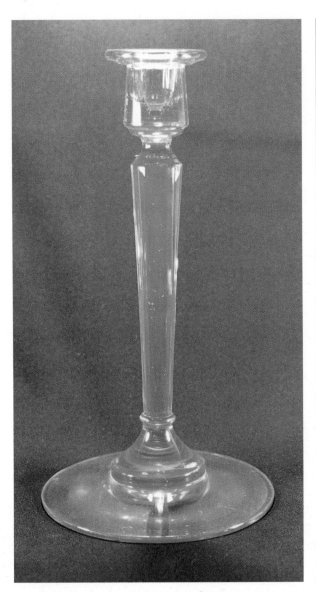

Cambridge 9.375" #636 single light candlestick. Light emerald, pastels: $55-60 each; crystal: $35-40 each. Also found as a 10.5" #1272 lustre. (1930s).

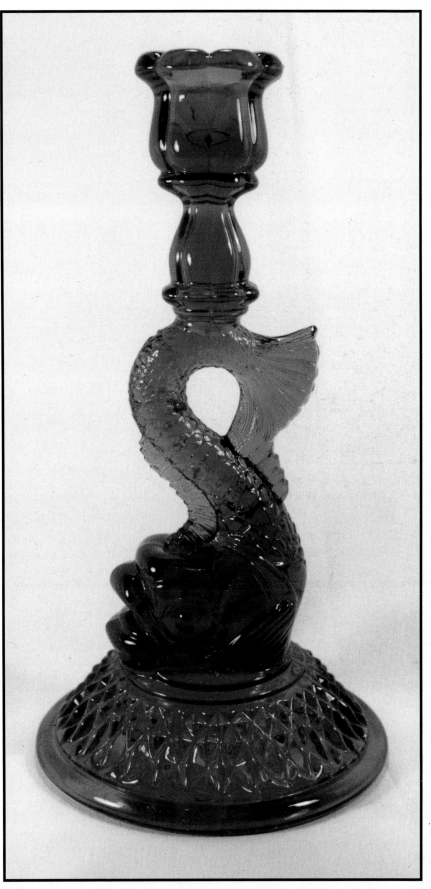

Cambridge 9.5" #109 'Dolphin' single light candle holder. Amber: $95-100 each; light emerald, forest green: $140-150 each; emerald green: $170-185 each; Mandarin gold: $160-175 each; ivory: $225-250 each; cobalt blue 2: $250-275 each; rubina (rare): $475-500.

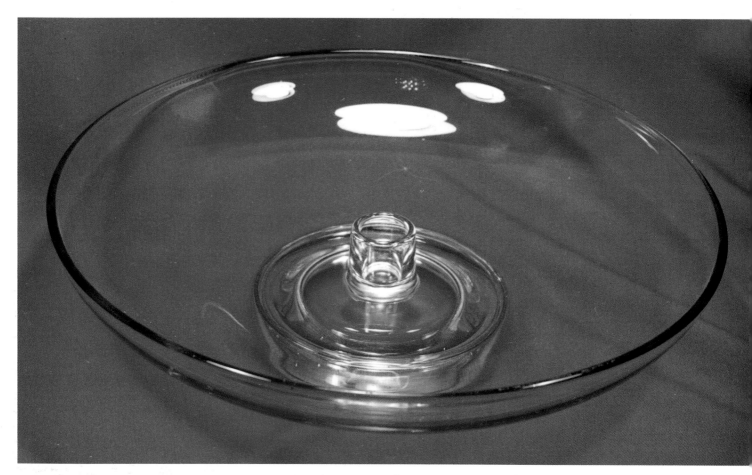

Cambridge 13" #437 single light candle epergne bowl. Crystal: $35-40 each.

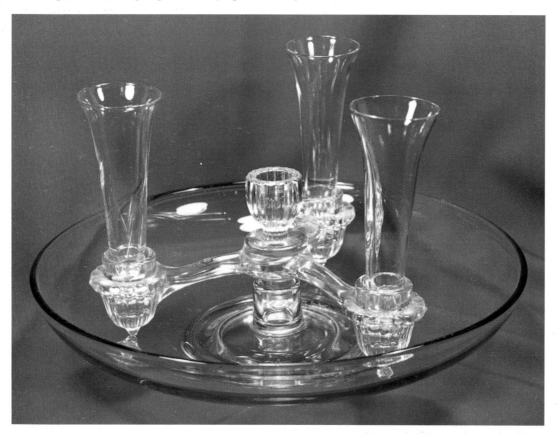

Cambridge candle epergne flower center. Crystal with #1563 arm, #437 candle bowl, and #1634 peg vases. Crystal: $125-135.

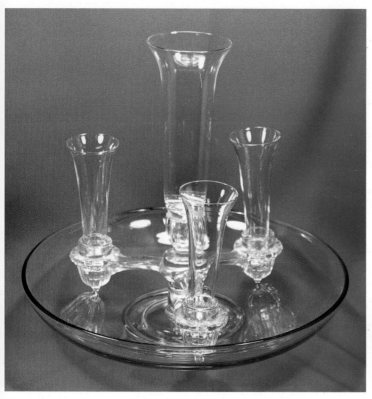

Cambridge table center using a four light #1563 arm, #437 two-piece flower center, and #1633 bud vases. Crystal: $150-165 each.

Cambridge 5.5" x 7.875" #647 double light keyhole candle holder with decagon base. 'Springtime' frosted colors: jade, mystic-willow blue, rose du berry-peach blo, cinnamon-amber: $100-125 each; 'krystal': $85-95 each. (c. 1920s).

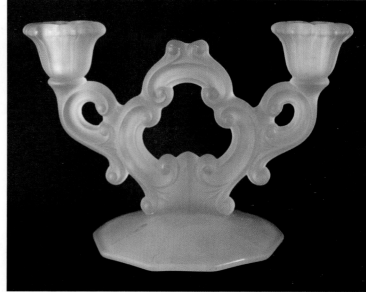

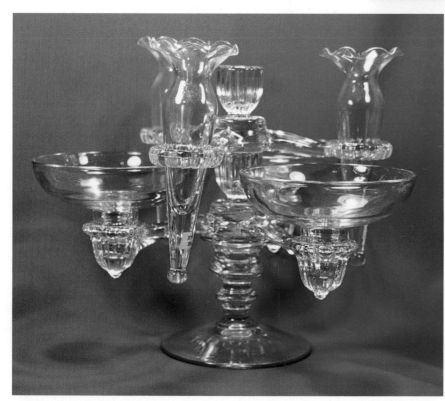

Cambridge 9.625" #628 candle base for 'Cambridge Arms.' Crystal with #1563 four-candle arm, #1562 three-vase arm, #1536 peg nappies, and #2355 7" vases: $210-230 each.

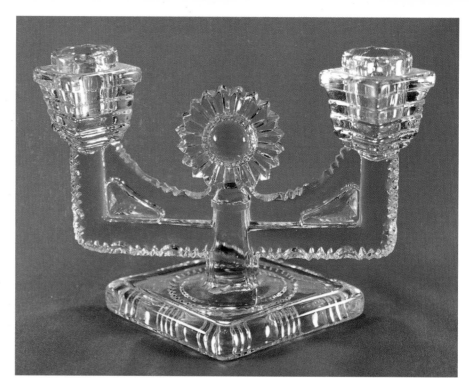

Cambridge 5.875" #501 'Virginia' double light candelabra. Crystal: $65-70 each. (Shown in 1940 catalog).

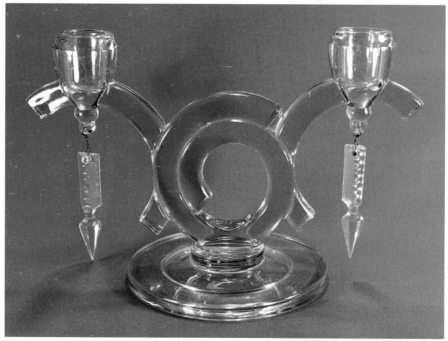

Cambridge 6.125" #1616 or 'Pristine' #502 (listed in catalogs with both numbers) double light candle holder. Crystal (shown in 1940 catalog) with two #4 spearhead prisms: $50-55 each; crown tuscan: $95-110 each. (1936-1954).

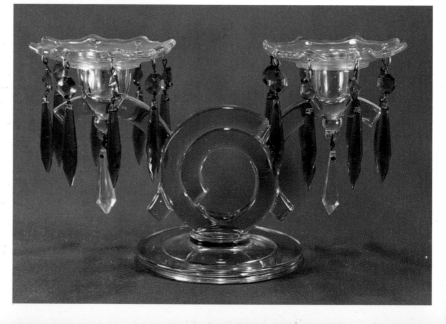

Cambridge 13" x 14.5" #521 double light candelabrum. Crystal with #19 bobeches, 16 blue prisms, and 2 #4 prisms: $145-155 each.

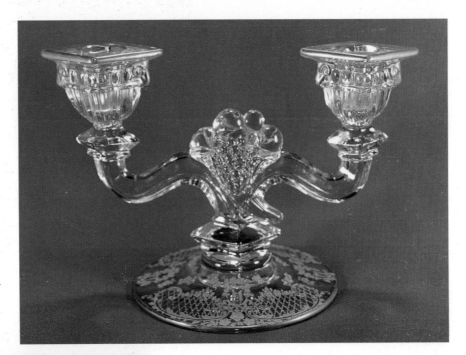

Cambridge 5.75" #657 double light candle holder. Crystal with gold: $75-80 each. In 1940 catalog.

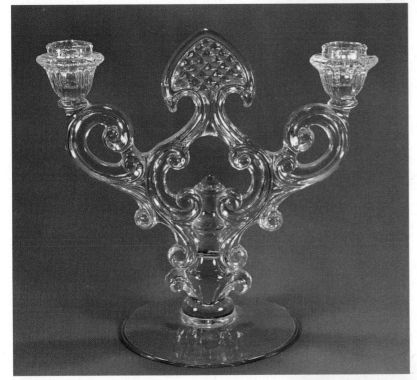

Cambridge 10.125" variation of 'Mt. Vernon' #38 and #1441 keyhole double light candle holder with locking bobeche rims. Crystal: $95-115 each.

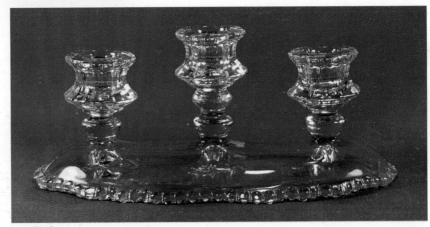

Cambridge 4" x 9.5" #74 line #3500 'Gadroon' triple light candle holder with beaded pattern on base. Crystal: $50-55 each; carmen, royal blue: $100-110 each.

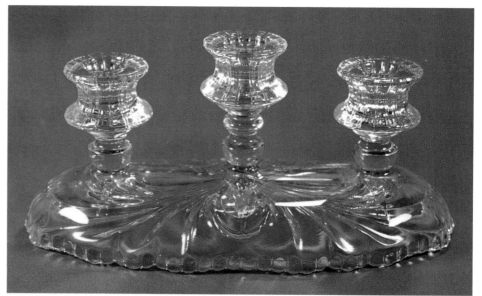

Cambridge 4.375" x 9.625" #74 triple light candle holder with 'Caprice' pattern on base. Crystal: $50-55 each; crystal/alpine: $60-65 each; moonlight: $150-165 each; moonlight/alpine: $175-185 each. (1936-1945).

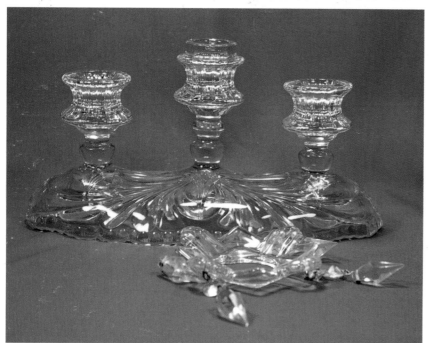

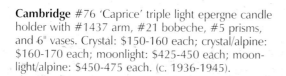

Cambridge #76 'Caprice' triple light epergne candle holder with #21 bobeche and #5 prisms. Crystal: $75-80 each; crystal/alpine: $85-90 each; moonlight: $175-185 each; moonlight/ alpine: $190-200 each. (c. 1936-1945).

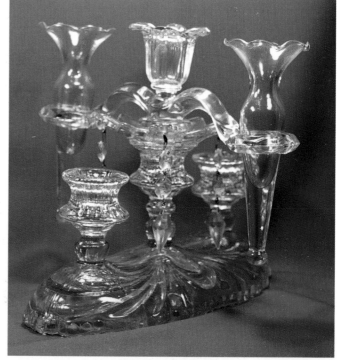

Cambridge #76 'Caprice' triple light epergne candle holder with #1437 arm, #21 bobeche, #5 prisms, and 6" vases. Crystal: $150-160 each; crystal/alpine: $160-170 each; moonlight: $425-450 each; moon- light/alpine: $450-475 each. (c. 1936-1945).

24

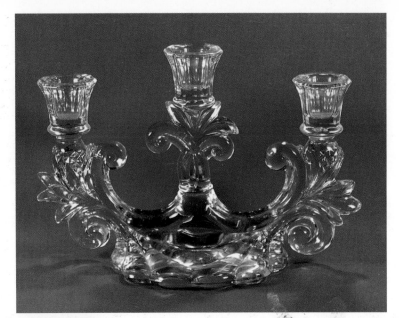

Cambridge 7.125" x 10.75" #1457 triple light candle holder. Crystal only: $70-75 each. (Late 1930s-1957).

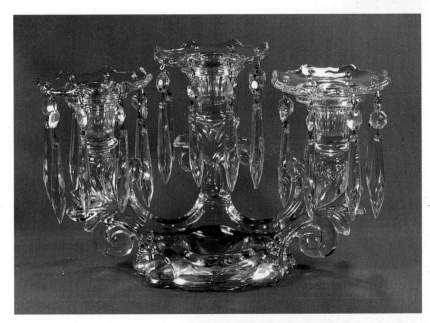

Cambridge 8" x 13" #1458 'Caprice' three light candelabrum with three light #1457 base, 3 #19 bobeches, and 24 #1 prisms. Crystal only: $145-155 each.

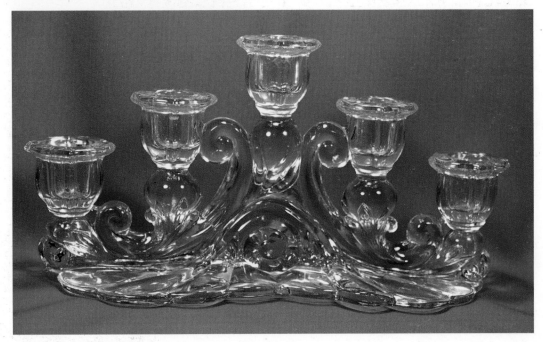

Cambridge 6" x 11.25" #1577 five light candelabra. Crystal only: $145-155 each. (1940-1945).

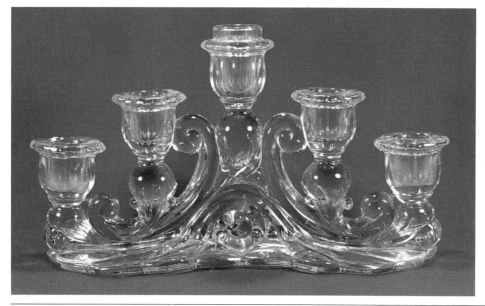

Cambridge 6.25" #1577 five light candelabra with center bobeche rim. Crystal: $145-155 each.

Castle Imports

Hawley, Pennsylvania, mid-1970s to present. Wholesale reproductions.

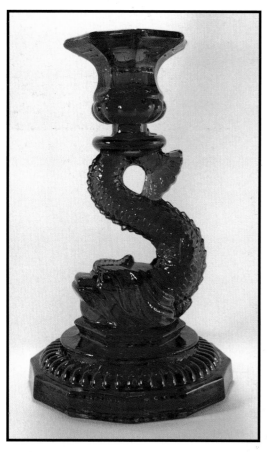

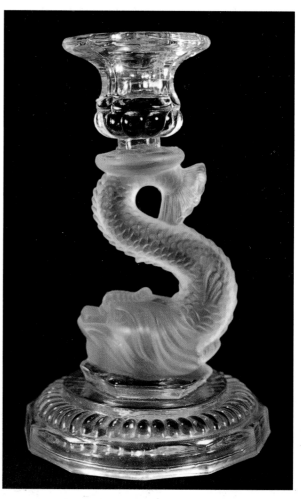

Castle Imports 7.625" single light dolphin candlestick. Cobalt: $40-45 pair; crystal with satin treatment: $30-35 pair.

Castle Imports 7.625" single light dolphin candlestick. Crystal with satin treatment: $30-35 pair.

Central Glass Works

Wheeling, West Virginia. **Central Glass Company**, 1860s to 1896; **Central Glass Works**, 1896 to 1939. Tableware, bar goods, and stemware.

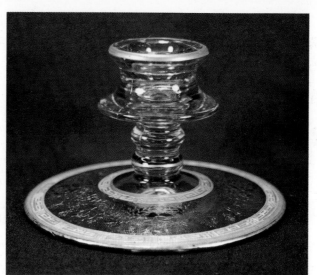

Central 2.75" #2000 single light candle holder. Pink with pressed design on base and heavy gold edges: $30-35 each. (Three part mold).

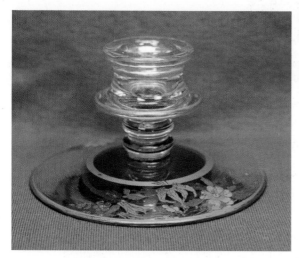

Central 2.875" #2000 single light candle holder. Crystal with hand decoration: $25-30 each.

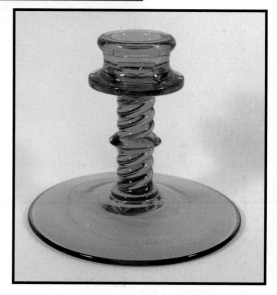

Central 3.75" 'Old Central Spiral' single light candlestick. Amber, pink, green, crystal: $25-30 each. Also comes in 8". (c. 1925).

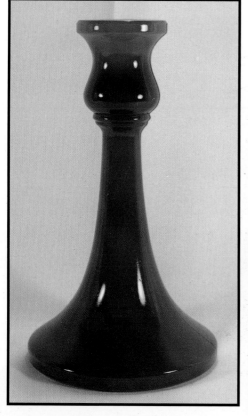

Central 7" single light trumpet style candle holder. Jade green, canary, blue, amethyst, black, amber, and satin glass: $30-35 each. (c. 1920s-1930s). (Two-part mold).

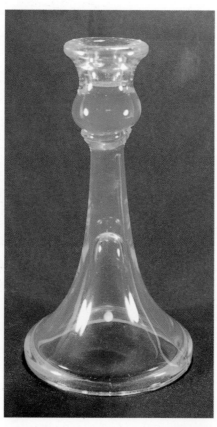

Central 7" single light candlestick. Vaseline: $40-45 each.

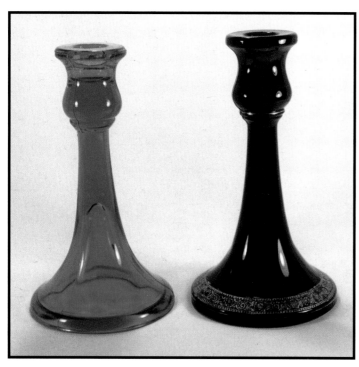

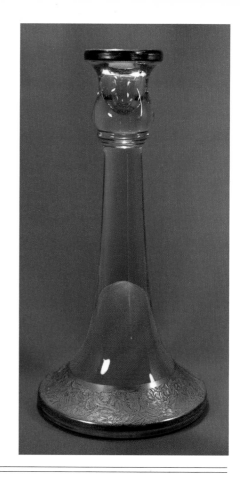

Right:
Central 9.25" single light candlestick. Crystal with Chinese red and gold, crystal with cobalt and gold: $40-45 each.

Central 6.75" single light candlesticks. Blue, black amethyst with gold deposit: $30-35 each.

China

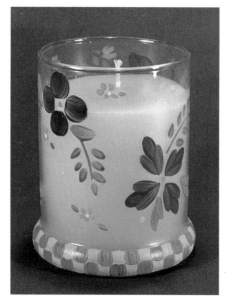

China 4" single light votive. Clear with hand decorated floral pattern with candle: $8-12 each.

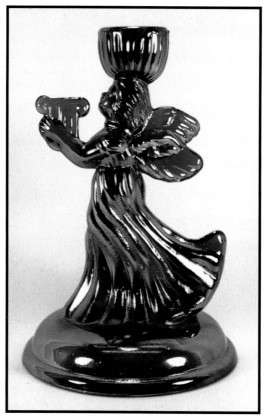

China 7.5" single light angel candle holder. Red iridized glass: $35-40 pair; ruby, cobalt, dark green: $30-35 pair. Paper label. From **Castle Imports**.

Clarke "Pyramid" and "Fairy" Light Company

London, England, 1840s to 1910. Other companies, such as **Webb**, made complete fairy light assemblies using **Clarke** patents for each of the separate pieces, while **Clarke** manufactured candles. Candles and candle lamps.

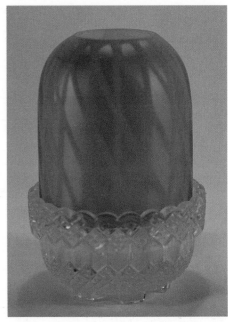

Clarke 4" single light fairy lamp. Blue diamond quilted mother-of-pearl with clear lamp base: $375-425 each.

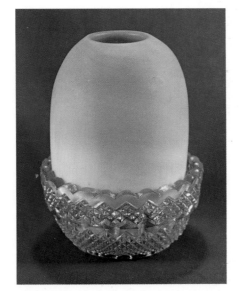

Clarke single light fairy lamp. Acid Burmese with crystal lamp base: $225-250 each.

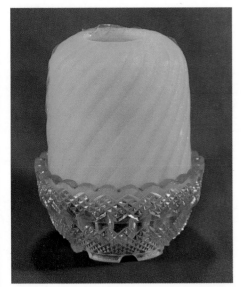

Clarke 3.625" single light fairy lamp. Yellow satin embossed swirl dome with clear lamp base: $175-200 each.

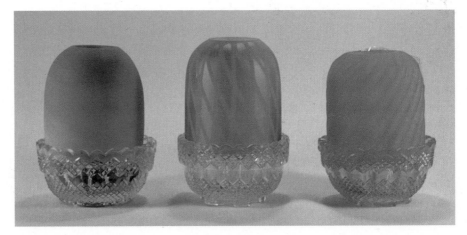

Clarke single light fairy lamps. Acid Burmese: $225-250 each; blue diamond quilted: $375-425 each; yellow satin: $175-200 each.

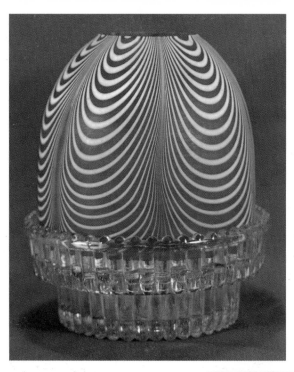

Clarke 4.5" single light fairy lamp. Dome: 3" x 3.25". Base: 1.625" x 3.875". Red and white nailsea swirled dome and crystal base: $375-425 each. Base is marked.

Clarke 4.5" single light fairy lamp. Dome: 3" x 3.25". Base: 1.625" x 3.875". Red and white nailsea swirled dome and crystal base: $375-425 each. Base is marked.

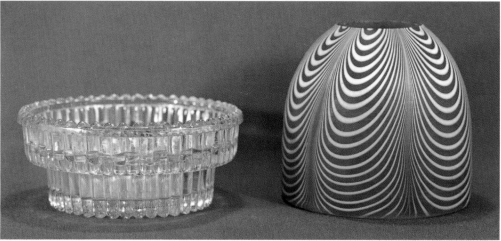

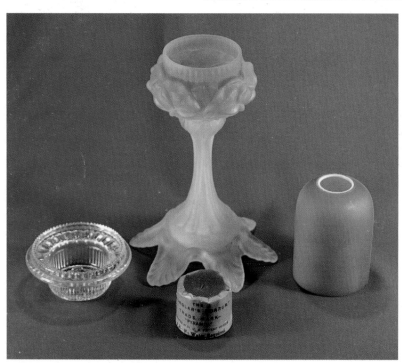

Clarke 10.5" art glass three-piece single light fairy lamp. Satin embossed dome sits in crystal lamp cup with a **Clarke** candle. The cup sits in a petal-patterned standard with tooled and applied leaf feet. Dark pink satin: $875-950 each.

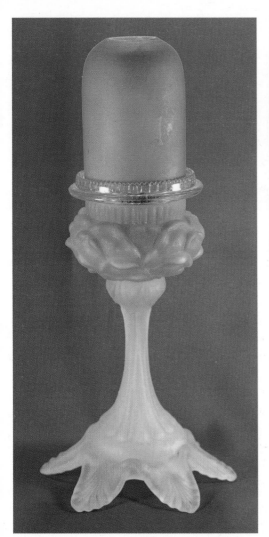

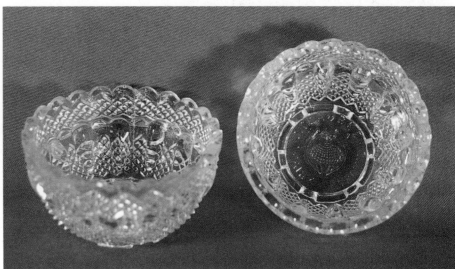

Clarke 1.5" x 2.375" 'Fairy Pyramid' base. Crystal: $25-30 each.

Clarke three-piece pyramid lamp. Dark pink satin: $875-950 each.

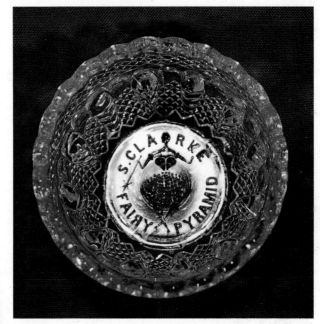

Clarke 1.5" x 2.375" 'Fairy Pyramid' base showing the **Clarke** fairy. Crystal: $25-30 each.

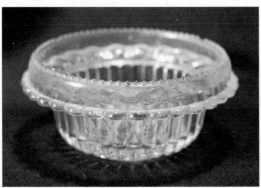

Clarke 1.75" x 4" fairy lamp base. Crystal: $25-30 each.

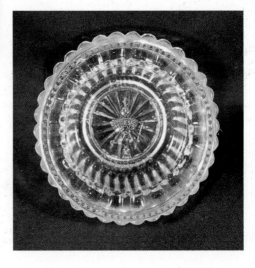

Clarke 1.75" x 4" fairy lamp base with fairy imprint. Crystal: $25-30 each.

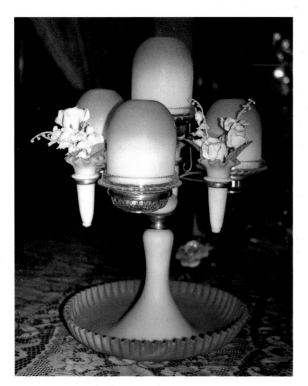

Clarke 16" x 11" fairy light assembly with four **Webb** fairy lamps and three vases on a **Webb** skirted base. Acid Burmese: $4500-5000.

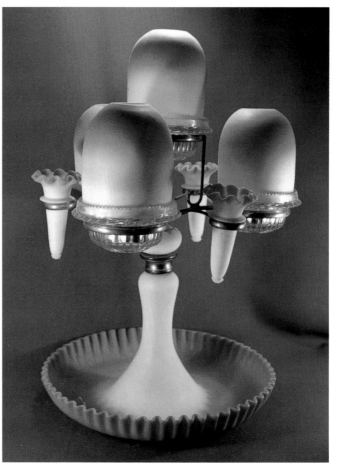

Clarke 16" x 11" fairy light assembly with four **Webb** fairy lamps and three vases on a **Webb** skirted base. Acid Burmese: $4500-5000.

Consolidated Lamp & Glass Company

Beaver Falls, Pennsylvania, 1894 to 1933; 1936 to 1967 at Coraopolis, Pennsylvania. Illuminating wares, tableware, and occasional pieces.

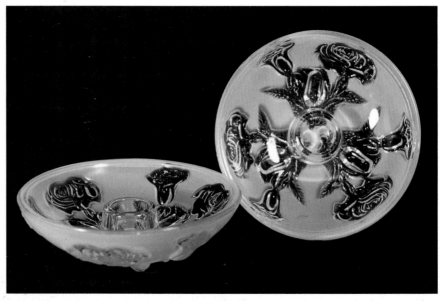

Consolidated 1.5" x 5" single light candle dishes. Soft green, honey, amethyst, blue, frosted crystal with clear flowers: $60-65 pair.

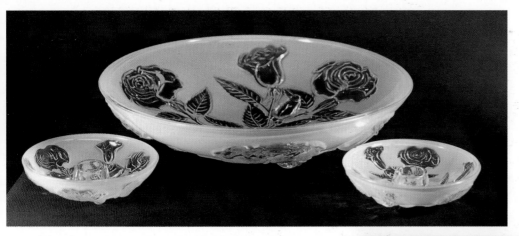

Consolidated console set with 1.5" x 5" single light candle dishes and 13" bowl. Soft green, honey, amethyst, blue, frosted crystal with clear flowers: $120-130.

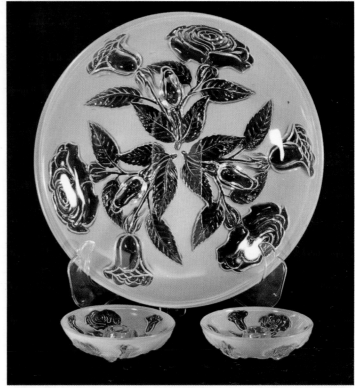

Alternate view.

Co-Operative Flint Glass Company

Beaver Falls, Pennsylvania. **Co-Operative Flint Glass Company, Ltd.,** 1878 to 1889; **Co- Operative Flint Glass Company** 1889 to 1937. Luncheon sets, giftware, and novelty items.

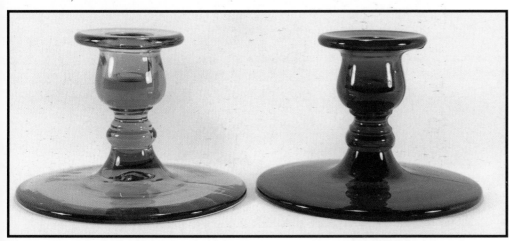

Cooperative Flint 3.125" single light candle holder. Red, green: $25-30 pair.

33

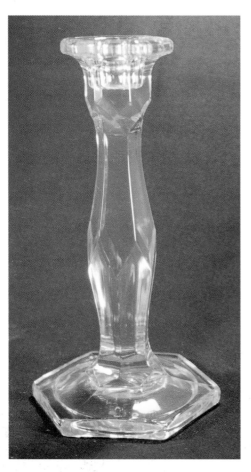

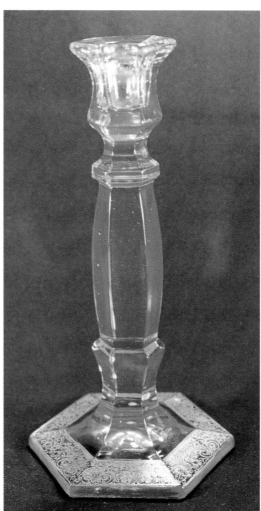

Far left:
Cooperative Flint 8.25" single light candlestick. Vaseline: $35-40 each; black milk glass: $25-30 each; cobalt blue: $30-35 each. (1920s).

Left:
Cooperative Flint 9" single light candlestick. Vaseline with heavy gold deposit: $65-70 each. (1920s).

Czechoslovakia

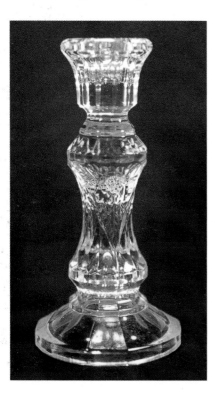

Czech Republic 4.5" single light candlestick. Crystal: $6-8 each. (1990s).

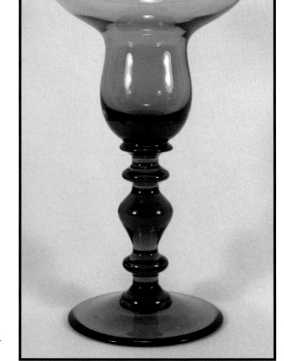

Czech Republic 5.5" single light candle holder. Green: $20-25 each. Has 'Bohemian Glass' paper label.

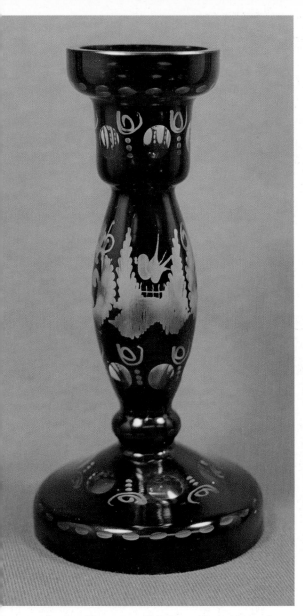

Czechoslovakia 6.5" single light candle holder with bird motif. Ruby case glass with crystal cut to clear: $135-150 each. (1930s).

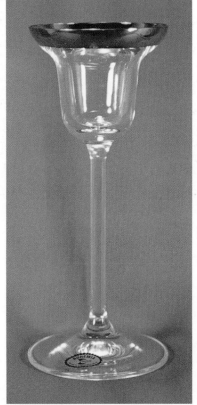

Czech Republic 6.75" single light candle holder. Bohemian crystal with gold decoration: $8-12 each. Paper label.

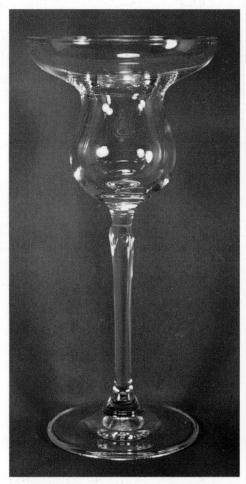

Czech Republic 7.375" single light candle holder. Crystal: $6-8 each.

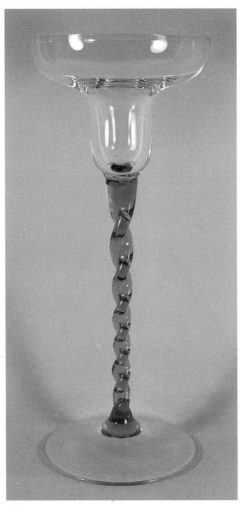

Czechoslovakia 8" single light candle holder. Crystal with sapphire twist stem: $60-65 pair.

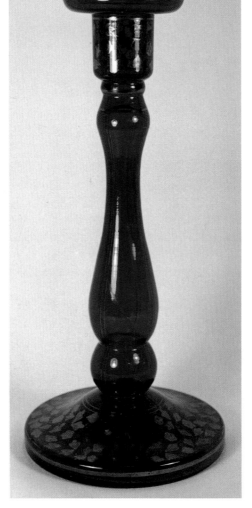

Czechoslovakia 8.25" single light candle vase. Cobalt with silver deposit on light and base: $115-125 each. Marked on bottom.

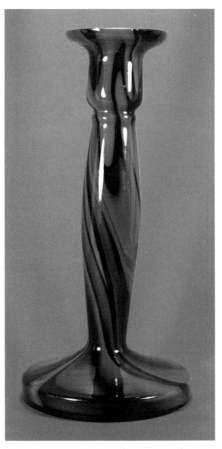

Czechoslovakia 8.375" single light candle vase. Red with black marble: $115-125 each. (1930s). Signed.

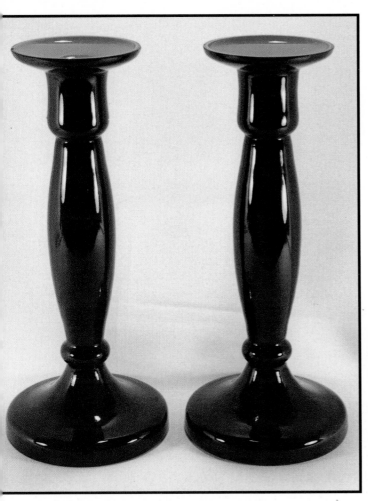

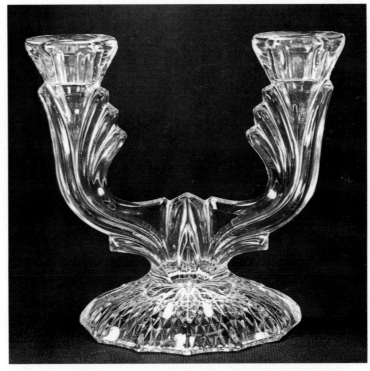

Czechoslovakia 6.5" double light candle holder. Lead crystal: $16-18 each. (1990s).

Czechoslovakia 8.625" single light candle vases. Black and orange case glass: $115-125 each. Signed. (c. 1930s).

Diamond Glass-ware Company

Indiana, Pennsylvania, 1916 to 1931. Tableware and occasional pieces.

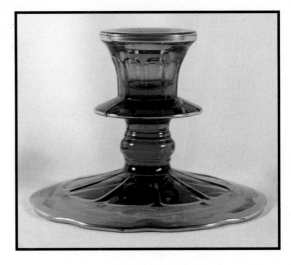

Diamond 3" 'Victory' low single light candle holder. Dark amber with heavy gold edges: $35-40 pair. (Three part mold). (1920s).

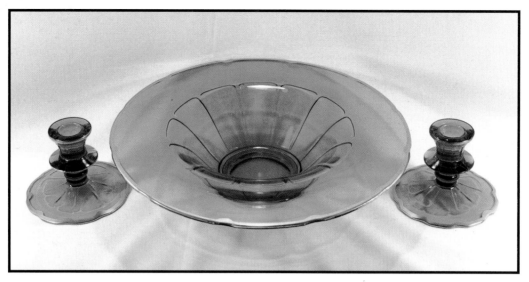

Diamond 'Victory' console set with 3" single light candle holders and 12.25" bowl. Dark amber with heavy gold edges: $75-80. (Three part mold). (1920s).

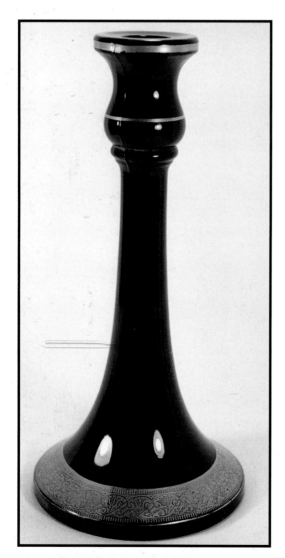

Diamond 9" single light trumpet candlestick. Black with gold: $80-85 pair. (1920s).

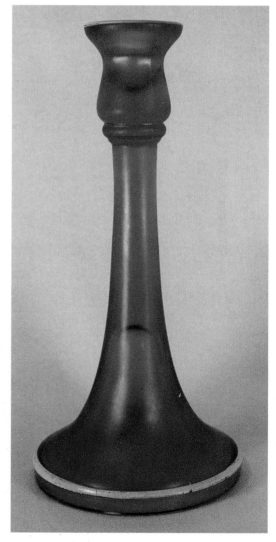

Diamond 9" single light candlestick. Iridescent blue with white trim: $80-85 pair.

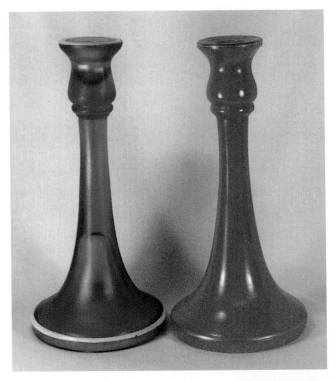

Diamond 9" single light candlesticks. Iridescent blue with white trim, fired on orange: $80-85 pair.

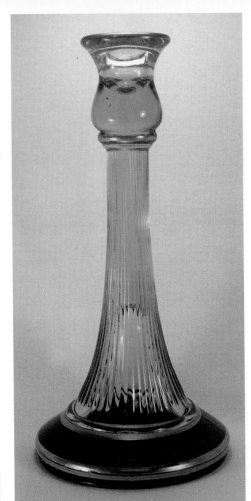

Right:
Diamond 9" #900 single light candlestick. Green with black and gold trim: $80-85 pair. (1920s).

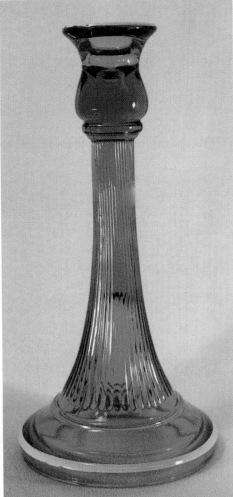

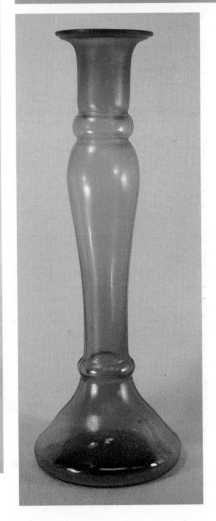

Right:
Diamond 9" #900 single light candlestick. Amber with white trim, green, pink, blue: $80-85 pair. (1920s).

Far right:
Diamond 10" single light candle vase. Iridescent blue: $80-85 pair. (1920s).

Dithridge & Company

New Brighton, Pennsylvania, 1860s to 1901. Formerly **Fort Pitt Glass Works**. Crystal and milk glass tableware and novelties; also opalescent and decorated colored glass.

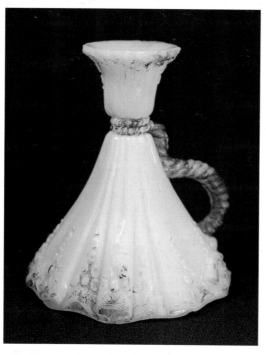

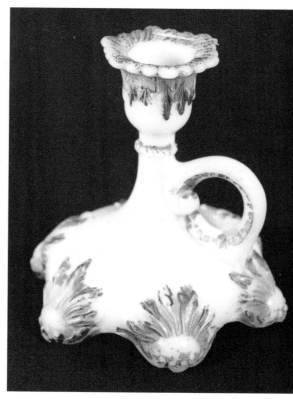

Dithridge 4.75" rope handled candle holder. White milk glass with fired on purple and gold: $35-40 each. (1890s-1910).

Dithridge 4.25" 'Ray End' handled candlestick. Milk glass with blue and gold: $25-30 each. (1890s-1910).

Dunbar

Right:
Dunbar three-piece table center with 2.75" single light candle holders and 12" rolled edge bowl. Crystal with cutting and cutaways on bowl rim and candle base: $75-80. (1920s).

Bottom right:
Dunbar close up of three-piece table center.

Below:
Dunbar 3" #854 single light candle holder. Cobalt: $30-35 pair; amber, crystal: $20-25 pair; pink, green: $25-30 pair. (1920s).

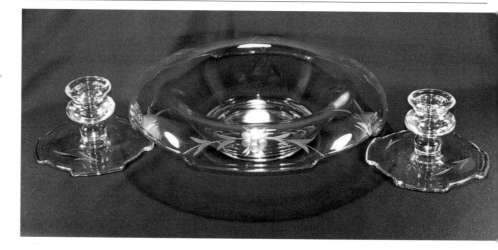

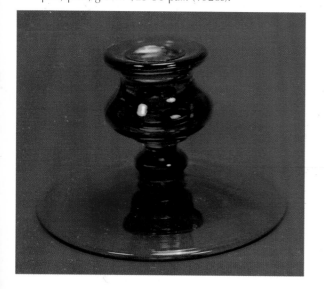

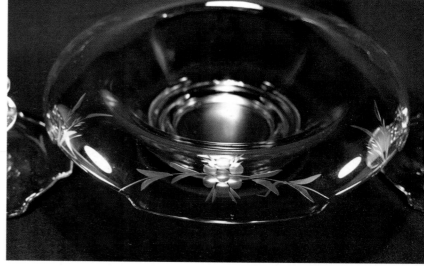

Duncan & Miller Glass Company

Washington, Pennsylvania, 1893 to 1955. Sold to **United States Glass Company** in 1955. The molds were transferred to Tiffin, Ohio. Dinnerware, tableware, and giftwares.

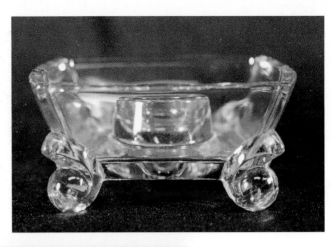

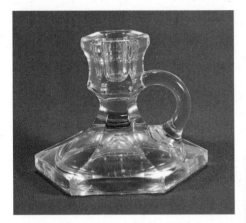

Duncan-Miller 1.5" x 3.5" 'Patio' single light footed candle holder. Yellow: $20-25 each.

Duncan-Miller 2.125" single light toy chamber stick. Crystal: $35-40 each.

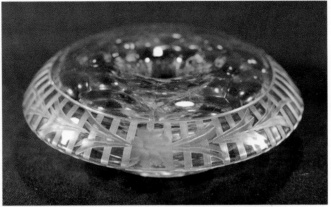

Duncan-Miller 1.875" 'Georgian' single light mushroom candle holder. Amber with cutting: $25-30 each.

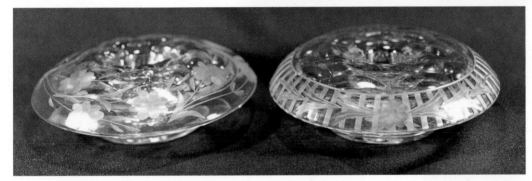

Duncan-Miller 1.625" 'Georgian' single light mushroom candle holders. Pink or green with cutting: $30-35 each; amber with cutting: $25-30 each.

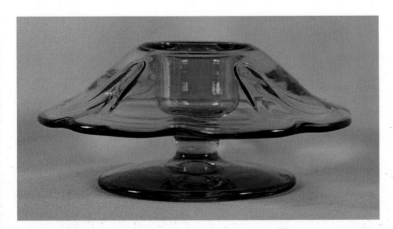

Duncan-Miller 2" 'Puritan' mushroom single light candle holder. Green, pink: $55-60 pair; crystal, amber: $35-40 pair; crystal with amber stain: $115-125 pair. (1925).

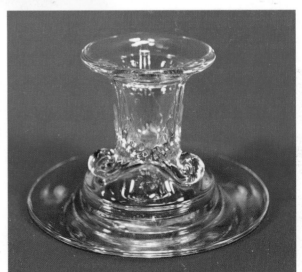

Duncan-Miller 2.75" 'Triple-Scroll' single light candle holder. Pink: $65-70 pair.

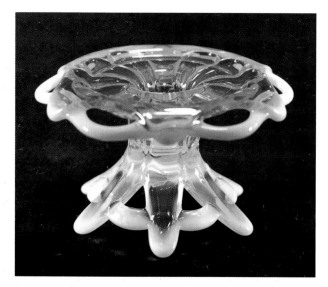

Duncan-Miller 2.75" #125 'Murano' single light candlestick. Pink opalescent, blue opalescent, yellow opalescent: $70-75 each; crystal: $20-25 each.

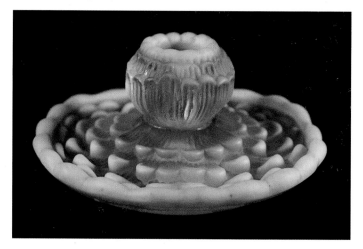

Duncan-Miller 2.25" x 5" line #128 'Sculptured Glass': 'Chrysanthemum' single light candle holder. Frosted blue opalescent: $200-225 pair; crystal satin: $140-150 pair.

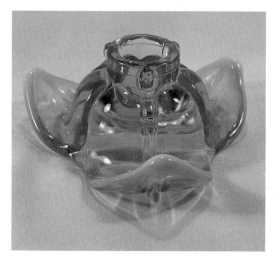

Duncan-Miller 1.875" x 4" #71-D 'American Way' single light candle holder. Pink or blue opalescent: $45-50 each; white milk glass: $35-40 each.

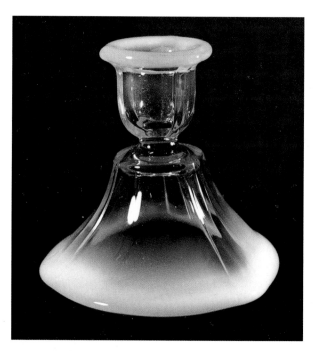

Duncan-Miller 3.75" #50 single light candle holder. Blue opalescent: $75-80 pair; pink, green, amber: $40-45 pair.

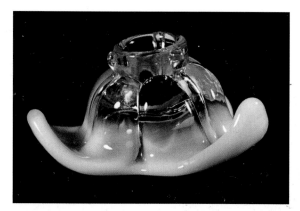

Duncan-Miller 2" x 4" #71-D 'American Way' single light candle holder. Blue opalescent: $45-50 each.

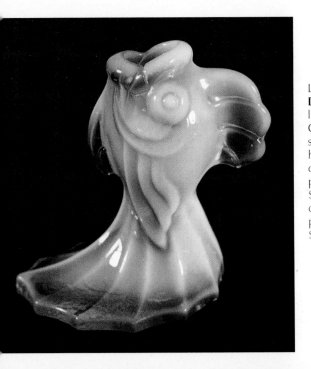

Left:
Duncan-Miller 4.75"
line #128 'Sculptured
Glass': 'Tropical Fish'
single light candle
holder. Blue opales-
cent: $950-1000 pair;
pink opalescent:
$1200-1250 pair;
crystal: $450-500
pair; crystal satin:
$550-600 pair.

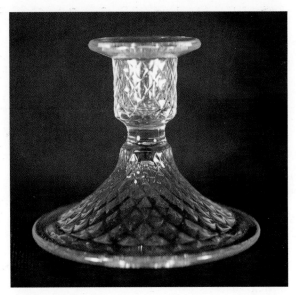

Duncan-Miller 3.125" 'Quilted Diamond' single light
candle holder. Pink, green: $50-55 pair; amber, crystal:
$40-45 pair; cobalt: $60-65 pair.

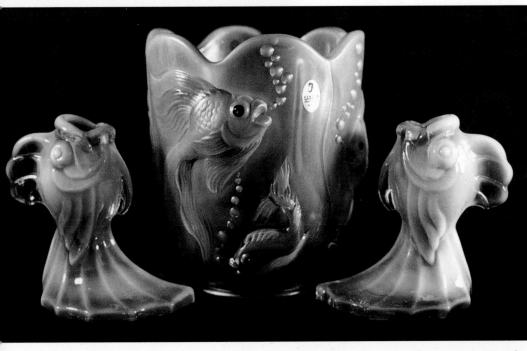

Duncan-Miller and **Fenton** table
center with **Duncan Miller** 4.75"
'Tropical Fish' candle holders and
6.625" **Fenton** vase (from an old
Duncan-Miller mold). Blue
opalescent candle holders and
multicolor opalescent vase.

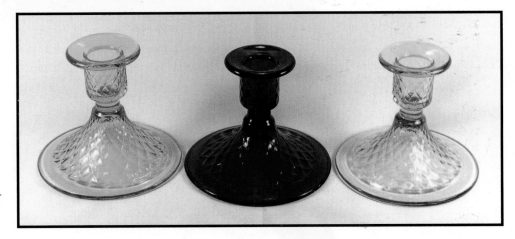

Duncan-Miller 3.125" 'Quilted
Diamond' single light candle holders.
Amber: $40-45 pair; cobalt: $60-65
pair; green: $50-55 pair.

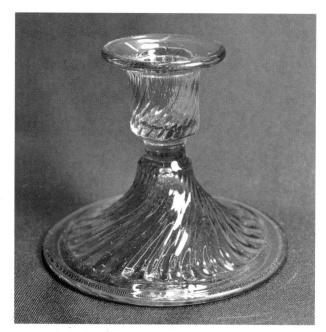

Duncan-Miller 3.5" #40/40-1/2 'Colonial Spiral' single light candle holder. Green, pink, amber: $30-35 each; crystal with amber stain: $45-50 each; crystal: $15-20 each. (Mid 1920s).

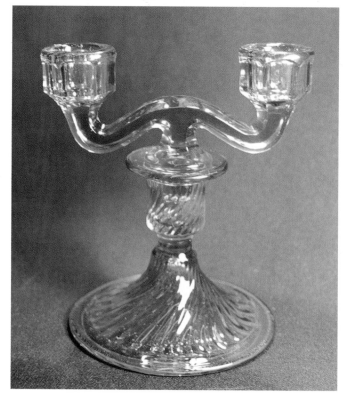

Duncan-Miller 3.5" #40/40-1/2 'Colonial Spiral' single light candle holder with candle arm (maker unknown). Green.

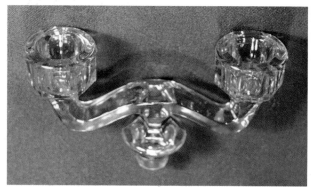

Unknown candle arm (maker unknown). Green.

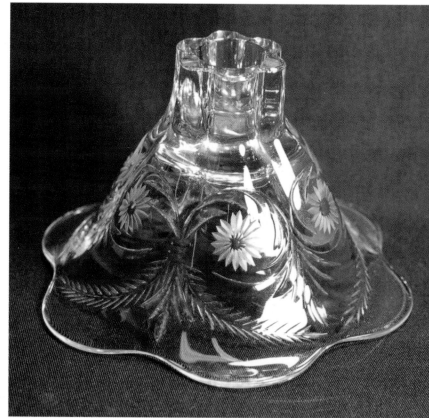

Duncan-Miller 3.375" x 5.5" #115 'Canterbury' single light candle holder. Crystal with #622 'Tristan' rock crystal cutting: $175-185 pair.

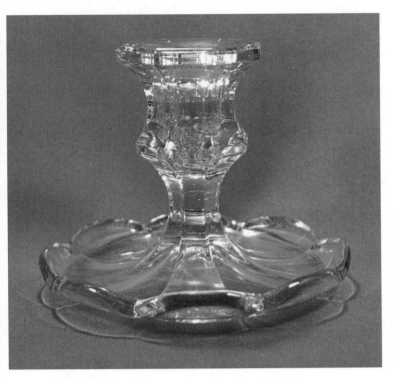

Duncan-Miller 3.685" #68 single light candle holder with fluted base. Crystal: $30-35 pair.

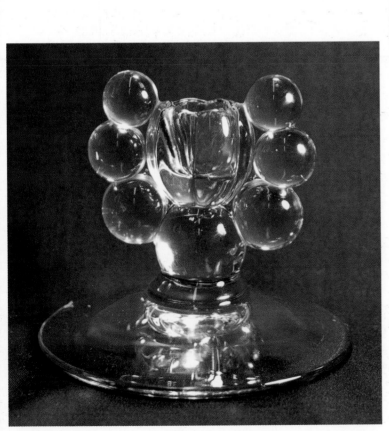

Duncan-Miller 4.75" 'Symphony' single light candle holder. Crystal: $25-30 pair. This candle holder was part of a complete table line. It was produced for a short period of time, and is not **Duncan-Miller's** usual quality of glassware.

Duncan-Miller 4" #121 'Teardrop' single light candle holder. Crystal: $35-40 pair. (c. 1935-1955).

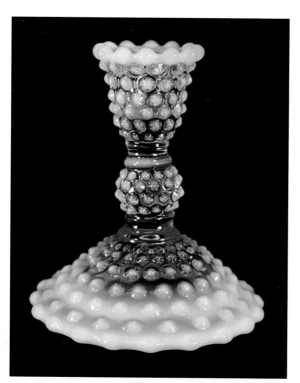

Duncan-Miller 4.25" 'Hobnail' single light candle holder. Blue or pink opalescent: $30-35 each; crystal: $15-20 each; blue, pink, amber, crystal opalescent, white milk glass (#718-25): $25-30 each.

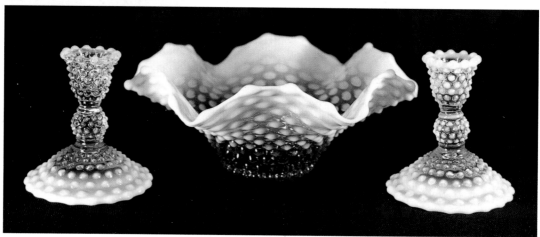

Duncan-Miller console set with 4.25" single light 'Hobnail' candle holders and 9" bowl. Blue opalescent: $120-130.

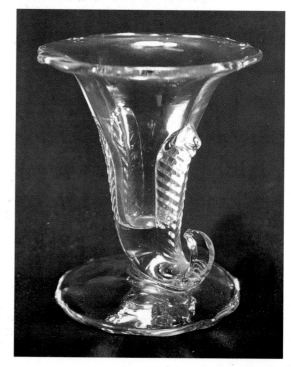

Duncan-Miller 4.25" #117 'Three Feathers' single light cornucopia candle holder/vase. Crystal: $60-65 pair.

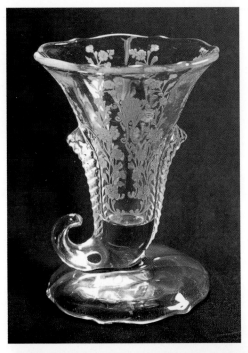

Left:
Duncan-Miller 4.5" #117 'Three Feathers' single light cornucopia candle holder/vase. Crystal with 'First Love' etching: $115-125 pair.

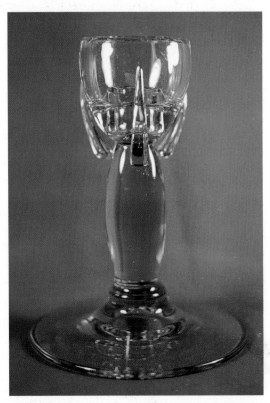

Duncan-Miller 6.5" single light candle holder. Pink, green, black: $70-75 pair; crystal with cutting: $55-60 pair; cobalt: $100-110 pair.

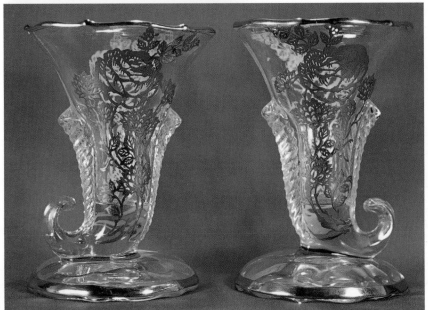

Duncan-Miller 4.5" #117 'Three Feathers' single light cornucopia candle holders/vases with silver deposit: $70-75 pair.

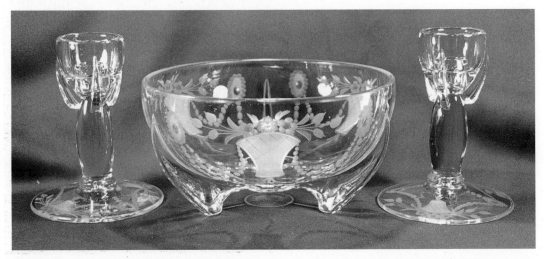

Duncan-Miller table center with 6" single light candle holders and 4.5" x 8.875" bowl. Crystal with cutting: $100-110.

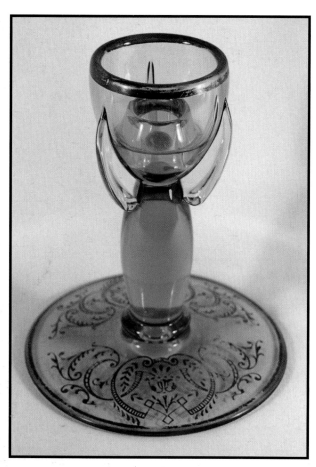

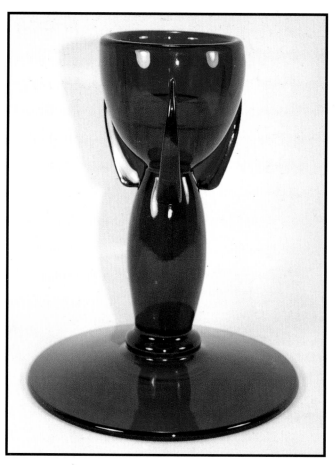

Duncan-Miller 5.75" single light candle holder. Green with silver deposit: $80-85 pair. (c. 1920s) **Note**: this line was also made for **Lotus**.

Duncan-Miller 5.75" single light candlestick. Cobalt: $100-110 pair.

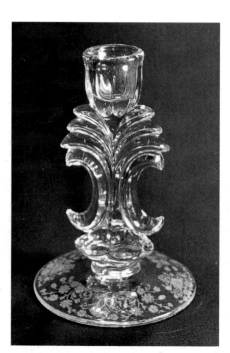

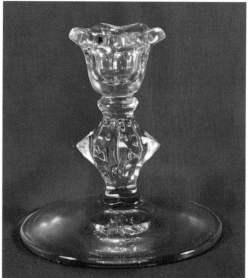

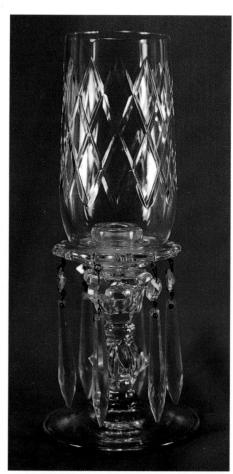

Duncan-Miller 4" #75 'Diamond' single light candle holder. Crystal: $35-40 pair. (1906)

Duncan-Miller 6" #115 'Canterbury' single light candle holder. Crystal with 'First Love' etching: $50-55 each.

Duncan-Miller 7.5" single light hurricane lamp with 4" candle holder and 5.25" globe with bobeche and 6 prisms. Crystal: $115-125 each.

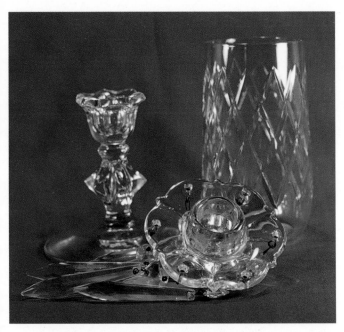

Duncan-Miller 7.5" #75 'Diamond' single light hurricane lamp with 4" candle holder and 5.25" globe with bobeche and 6 prisms: $115-125 each.

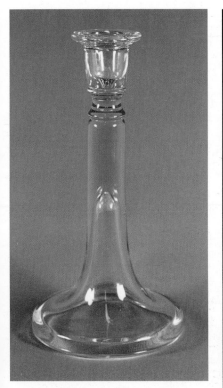

Duncan-Miller 8.5" #36 single light candle holder. Crystal: $90-95 pair.

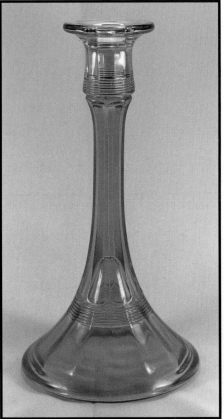

Duncan-Miller 9" #83 'Tavern' single light candle holder. Lilac/amethyst iridescent: $100-110 pair; crystal: $90-95 pair; crystal with decoration: $95-100 pair. Also comes in 6" and 7.5".

Duncan-Miller 11.5" #120 'Monticello' single light candle holder with bobeche and prisms. Crystal: $200-225 pair.

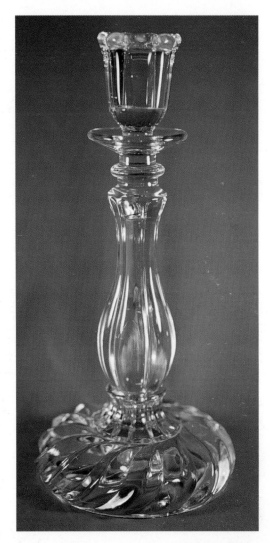

Duncan-Miller 10.625" #358 single light candle holder. Crystal: $60-65 each. (Early 1890s-1904).

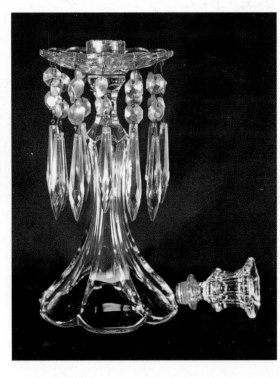

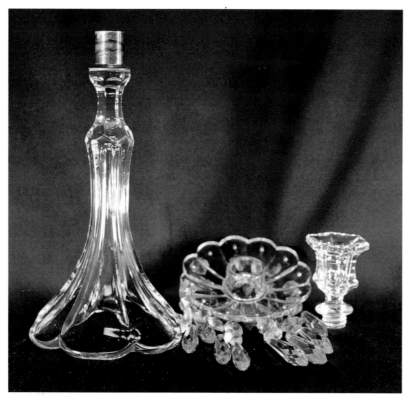

Duncan Miller 11.75" #120 'Monticello' single light candle stick. Crystal with 12-prism bobeche: $200-225 pair.

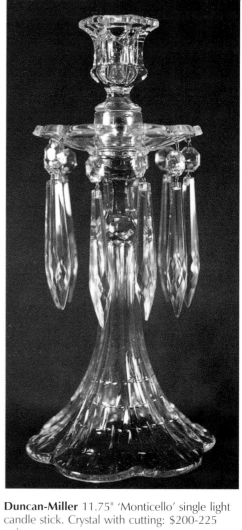

Duncan-Miller 11.75" 'Monticello' single light candle stick. Crystal with cutting: $200-225 pair.

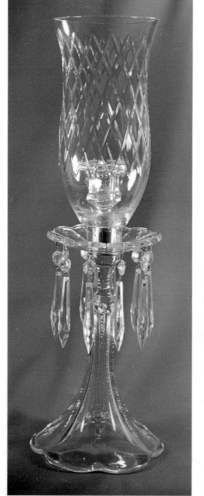

Duncan-Miller 16.5" single light hurricane lamp. Crystal with cutting on base and globe, bobeche and 10 prisms: $200-225 each.

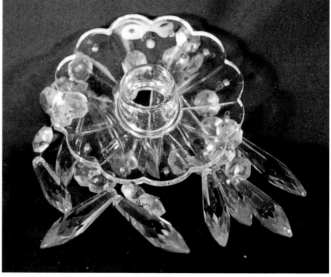

Duncan Miller 4.75" diameter bobeche with 12 double drop prisms: $30-35 each.

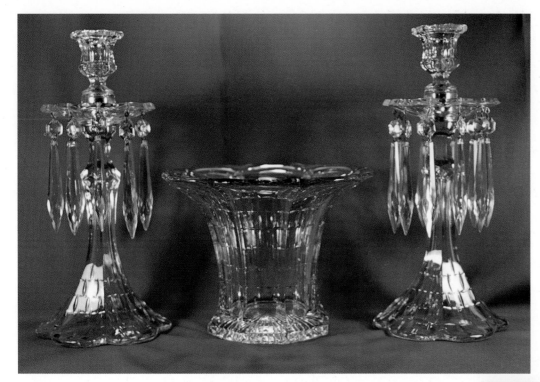

Duncan-Miller table center with 11.5" single light candle holders and 6.25" x 8.25" bowl. Crystal with cutting: $275-300.

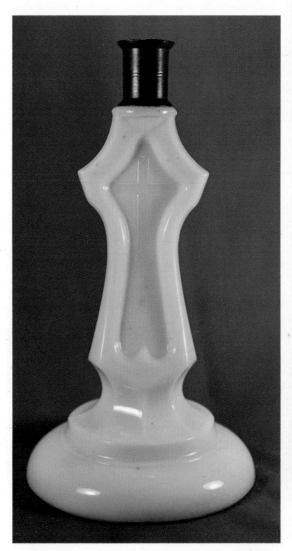

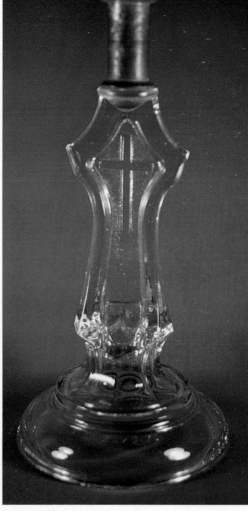

Right:
Duncan-Miller 10.25" 'Roman' single light candle holder. White milk glass with 1.375" metal candle cup: $175-200 each. (First produced in early 1870s). From and old **Ripley & Company** mold.

Far Right:
Duncan-Miller 10.75" 'Roman' single light candle holder. Crystal with 2" metal candle cup: $175-200 each.

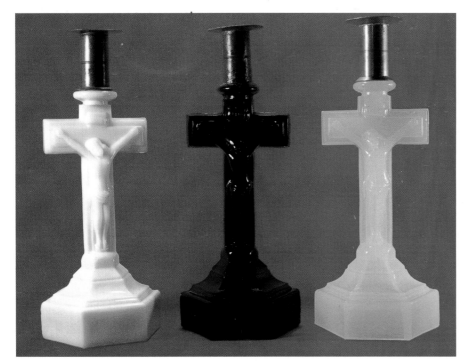

Duncan-Miller 9.75" 'Crucifixes' with 2" metal candle cups. White milk glass: $225-250 each; cobalt: $300-350 each; white opaline and crystal: $225-250 each.

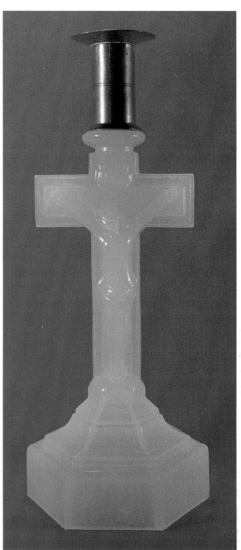

Duncan-Miller 9.75" 'Crucifix' single light candle holder. Opaline with 2" metal candle cup: $225-250 each.

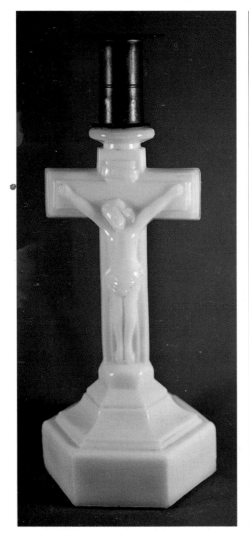

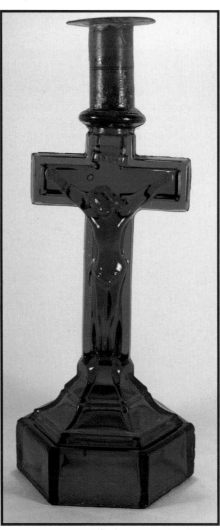

Duncan-Miller 9.75" 'Crucifix' single light candle holder. White milk glass with 2" candle cup: $225-250 each.

Duncan-Miller 10" 'Crucifix' single light candle holder. Cobalt with 2" metal candle cup: $300-350 each.

52

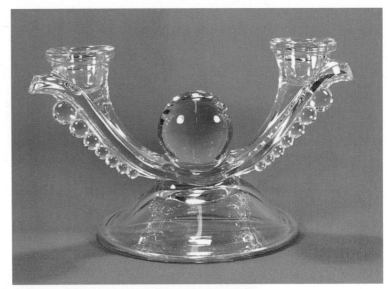

Duncan-Miller 4" x 8.25" #301 'Tear Drop' double light candle holder. Crystal: $55-60 pair. (c. 1936-1955).

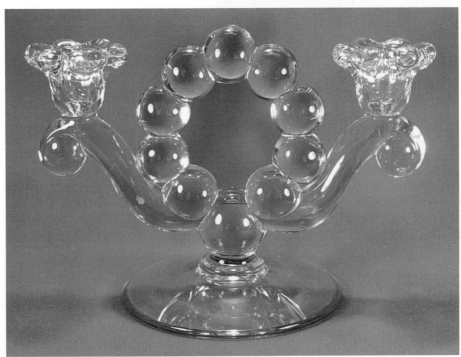

Duncan Miller 6" x 9" #301-122 'Tear Drop' double light candle holder. Crystal: $55-60 pair.

Duncan-Miller 6.75" x 7.75" #111 'Terrace' double light candle holder. Crystal with cutting: $275-300 pair.

53

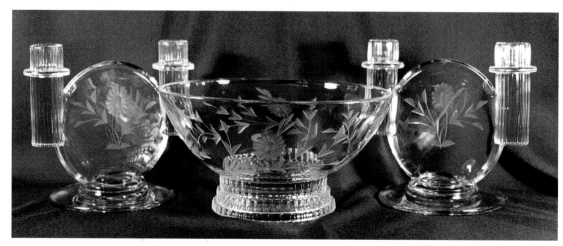

Duncan-Miller #111 'Terrace' table center with 6.75" x 7.75" double light candle holder and 9.5" bowl with cutting: $325-350.

Duncan-Miller 13" x 14.5" double light candelabrum. Crystal with bobeches and prisms: $175-200 each. (c. 1950).

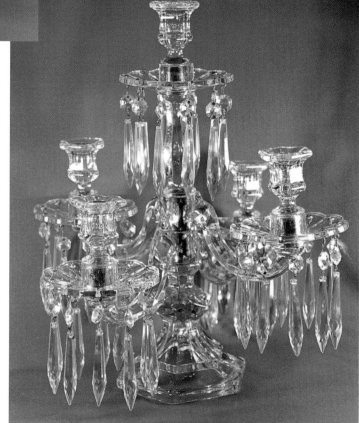

Duncan Miller 15.5" x 14" #320 series, five light candelabrum. Crystal only: $400-450 each.

Fenton Art Glass Company

Williamstown, West Virginia, 1906 to present. Iridescent or 'Carnival' glassware, art glass, and giftware.

Fenton 1.5" x 5" #5672 'Block & Star' single light flared candle bowl. White milk glass only: $25-30 pair. (1955-1956).

Fenton 1.873" x 4.25" #5670 'Block & Star' single light candle holder. Small candle bowl with handle. White milk glass (1955-1956): $25-30 pair; turquoise pastel (1955-1957): $45-50 pair.

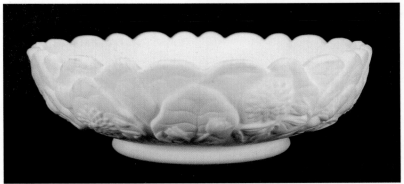

Fenton 2.375" x 8.5" #8478 'Water Lily' single light candle bowl. White satin glass: $15-20 each.

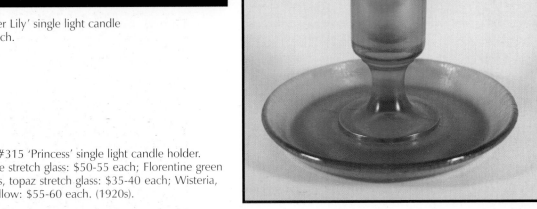

Fenton 3" #315 'Princess' single light candle holder. Celeste blue stretch glass: $50-55 each; Florentine green stretch glass, topaz stretch glass: $35-40 each; Wisteria, Chinese yellow: $55-60 each. (1920s).

Fenton 3" #315 'Princess' single light candle holder. Vaseline stretch glass: $35-40 each. (1920s).

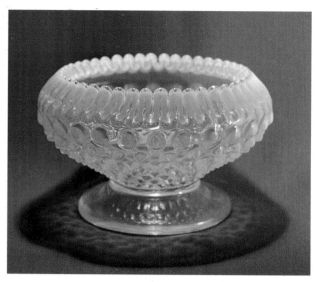

Fenton 3.5" x 5.75" #3770 'Ribbon' single light hobnail candle bowl. Topaz opalescent: $65-70 each. (1950s).

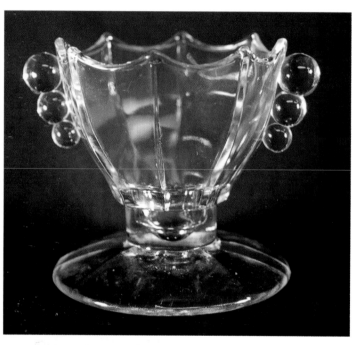

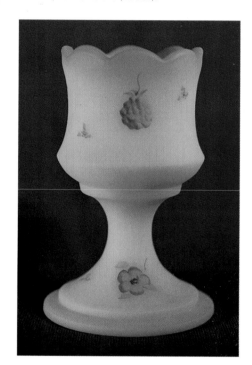

Fenton 4.375" 'Berries & Blossoms' footed votive. Opal satin with pink flowers: $25-30 each. (1980s).

Fenton 3.5" #349 single light candle holder with ball handles. Crystal: $40-45 each; Ming (crystal satin only) (1935-1936), San Toy (crystal satin only) (1936-): $45-50 each; Wisteria (crystal satin only) (1937-1938): $70-75 each. **Note:** The number 349 was also assigned to a 10" candlestick.

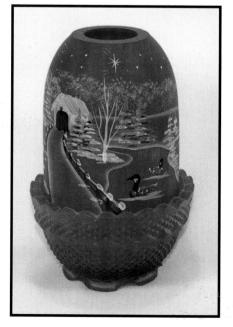

Fenton 4.75" snow scene fairy lamp. Red Christmas edition: $70-75 each. (1990s).

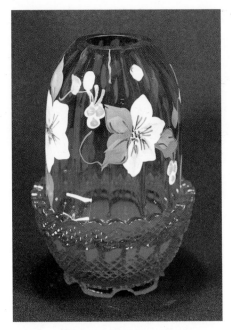

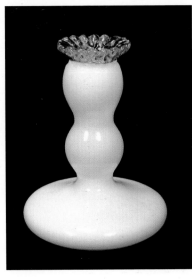

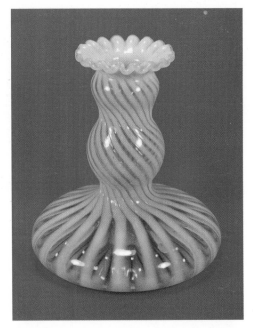

Fenton 4.75" fairy lamp. Red with floral decoration, teal/white opalescent, red with landscape: $65-70 each. (1990s).

Fenton 4.75" #1523 'Gold Crest' single light candle holder. White opalescent with amber or gold crest, crystal: $30-35 each; ivory: $35-40 each; peach or rose crest: $40-45 each; emerald or aqua crest: $70-75 each; 'Blue Ridge': $150-160 each.

Fenton 4.5" #1523 'Spiral Optic' single light candle holder. Blue opalescent swirl, green, topaz: $70-75 each; French opalescent: $25-30 each; pink, cranberry: $90-95 each; 'Blue Ridge': $115-125 each.

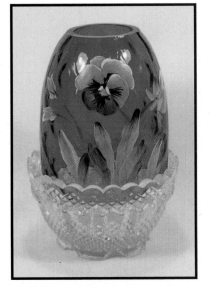

Fenton 4.5" single light fairy lamp. Cranberry/floral with crystal base: $65-70 each. (1990s).

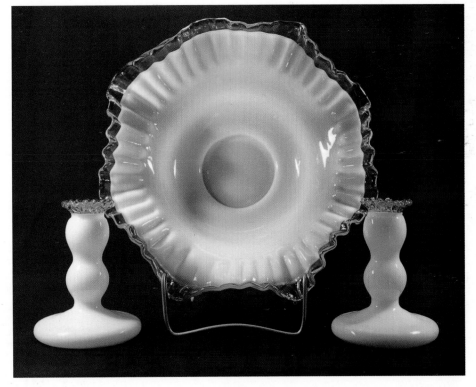

Fenton console set with 4.75" #1523 'Gold Crest' single light candle holders and 9" bowl: $110-120.

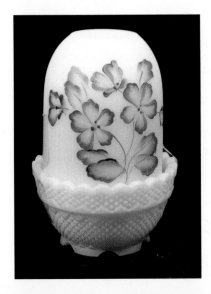

Fenton 4.75" snow scene fairy lamp. White floral, amber frosted, red Christmas edition: $65-70 each. (1990s).

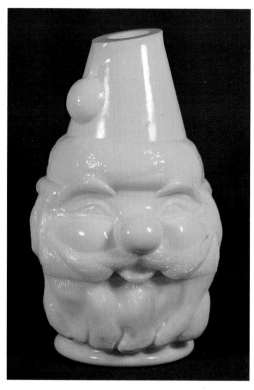

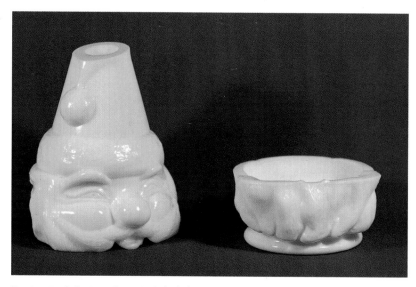

Fenton 5.5" #5106 'Santa' single light two-piece fairy light. White milk glass: $45-50 each.

Fenton 5.5" #5106 'Santa' single light two-piece fairy light. Issued in 1988 and is usually shown with 'Holly Berry' decoration. White milk glass: $45-50 each; white milk glass with decoration: $55-60 each; custard: $65-70 each; ruby: $80-85 each.

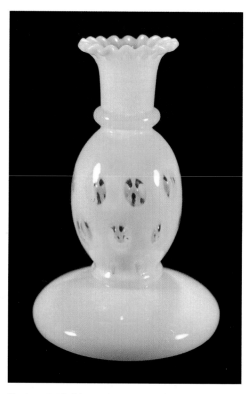

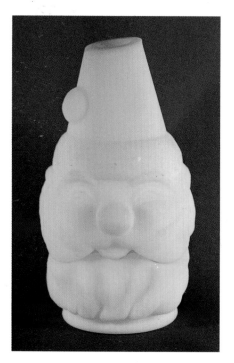

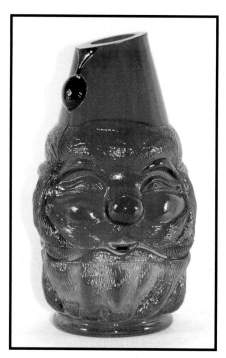

Fenton 5.5" #1524 (1940s) or #1470 (1950s) 'Coin Dot' single light candle holder. French opalescent: $55-60 each; blue opalescent: $75-80 each; cranberry: $100-110 each; lime opalescent: $110-120 each.

Fenton 5.5" #5106 'Santa' single light two-piece fairy light. Ruby: $80-85 each.

Fenton 5.5" #5106 'Santa' single light two-piece fairy light. Custard: $65-70 each.

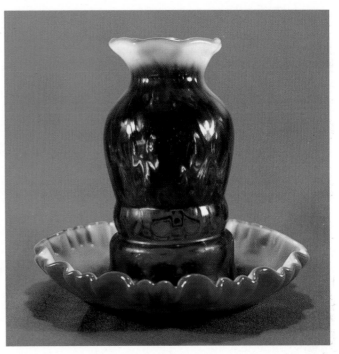

Fenton 5.625" single light fairy light. Cranberry opalescent: $125-140 each. (1983). This is a special item made for the "Fenton Art Glass Collectors of America, Inc."

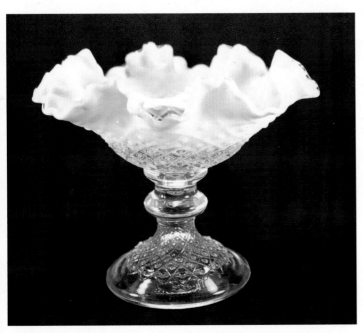

Fenton 6.25" #1948 'Diamond Lace' single light candle/epergne. French opalescent: $35-40 each; blue opalescent: $55-60 each. (c. 1950-1957).

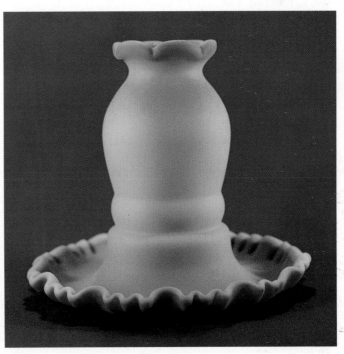

Fenton 5.625" #7392-BR single light fairy light. Acid Burmese: $250-275 each. Introduced in 1970.

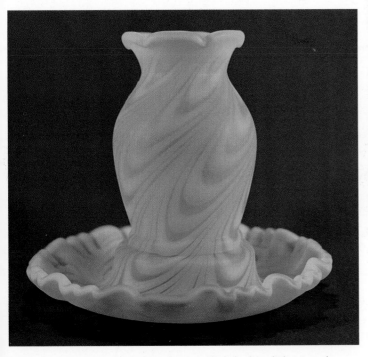

Fenton 5.5" #2092 'Swirled Feather' single light fairy light. French satin: $175-190 each; green satin opalescent, blue satin opalescent: $300-325 each; cranberry satin opalescent: $350-375 each. (1953-1955).

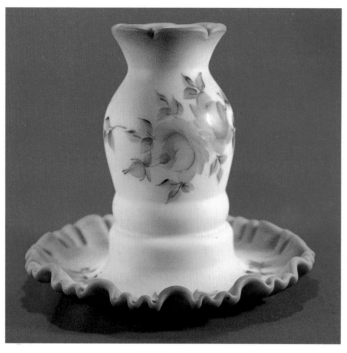

Fenton 6" #7392-RB single light fairy light. Acid Burmese with hand painted rose decoration: $250-275 each. (1970-1972).

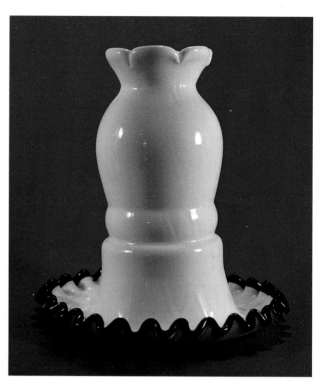

Fenton 6.5" #7392-BC single light fairy light. White milk glass with black crest: $175-190 each. (Early 1970s). Black crests were specialty items not in the regular line.

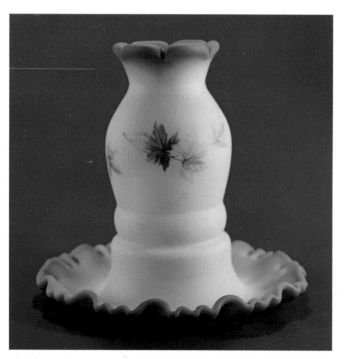

Fenton 6.125" #7392-BD single light fairy light. Acid Burmese with hand painted maple leaf: $250-275 each. (1970-1971).

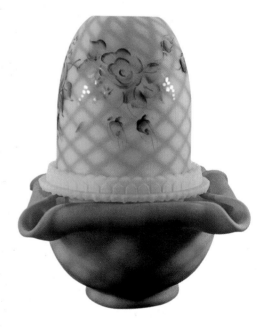

Fenton 6.625" x 5.125" single light three-piece fairy light. Acid Burmese: $165-180 each.

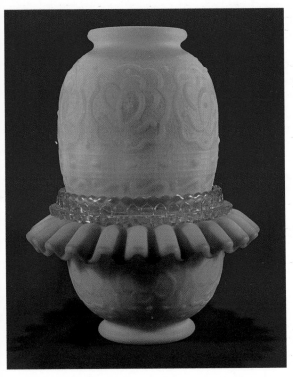

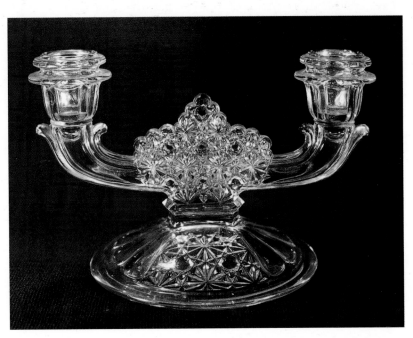

Fenton 6.5" #8404 'Persian Medallion' single light three-piece fairy light. Acid Burmese: $150-165 each; velva rose (1980): $80-85 each.

Fenton 4.5" x 7.125" # 1900 'Cape Cod' double light candle holder. Sapphire blue with panels on base: $80-85 pair; crystal: $65-70 pair. (1937-1938).

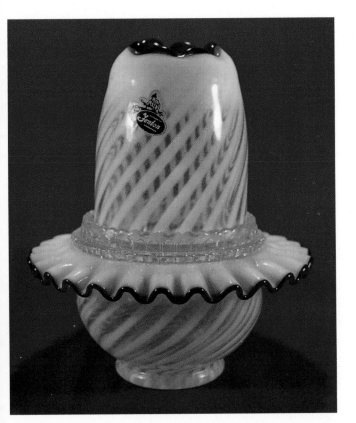

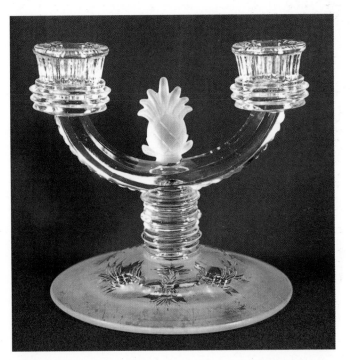

Fenton 8.125" 'Blue Ridge' three-piece single light fairy light with 2.625" base, 1.5" x 4" insert and 3.875" globe. White opalescent swirl with cobalt crest: $180-200 each. (1985, 80th Anniversary edition).

Fenton 5" #2000 'Pineapple' double light candle holder. Frosted crystal with cutting: $70-75 each; rose satin: $85-90 each; ruby: $150-165 each; royal blue: $180-195 each. (c. 1938-1939).

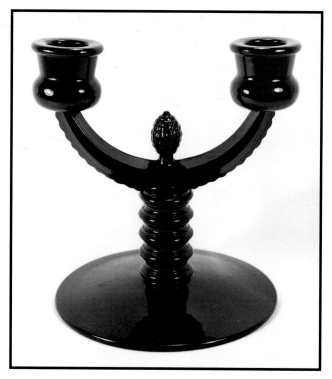

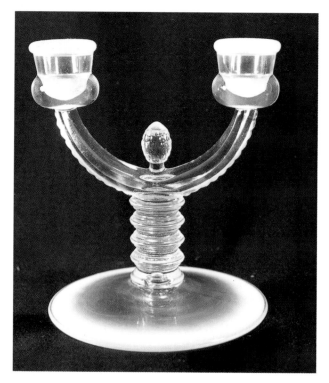

Fenton 5" #2318 double light candelabra. Black: $70-75 each; jade green: $65-70 each. (c. 1933).

Fenton 6" #2318 double light candelabra. French opalescent, moonstone: $60-65 each; jade green: $65-70 each; black: $70-75 each; ruby: $100-110 each; lilac :$150-165 each. (c. 1933).

Fostoria Glass Company

Moundsville, West Virginia, 1887 to 1983. Purchased by **Lancaster Glass**. Dinnerware, pressed ware, and gift items.

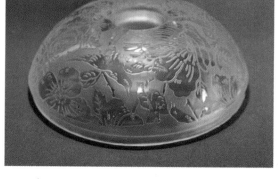

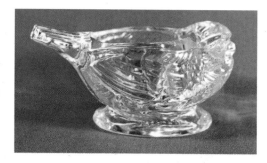

Fostoria 1.875" x 3" #312 bird single light candle holder. Crystal (1935-42): $20-25 each; ruby (1981-1982): $30-35 each. Crystal candle holders are marked 'Fostoria.'

Fostoria 1.75" x 4.25" #2372 single light candle block with #289 'Paradise' brocade etching. Mother-of-pearl iridescence (#71) on brocade etching, green, orchid: $60-65 pair.

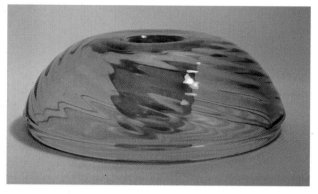

Fostoria 3.5" x 4.25" #2372 'Spiral Optic' candle block. Amber: $40-45 pair; crystal: $30-35 pair; rose, green: $45-50 pair.

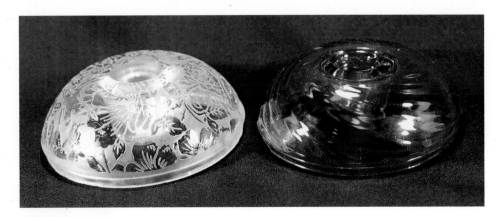

Fostoria 3.75" x 4.25" #2372 single light candle blocks. Crystal with #289 'Paradise' brocade etching: $60-65 pair; green #2372 'Spiral Optic': $40-50 pair.

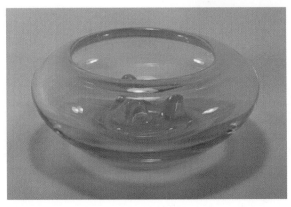

Fostoria 1.75" x 4.5" #2685 'Seascape' single light candle holder. Carribee blue, coral sand: $35-40 each. (1954-1959).

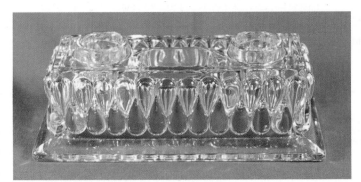

Fostoria 2.25" x 6.5" #2592 'Myriad' double light candle holder. Crystal only: $95-100 pair. (1942-1944).

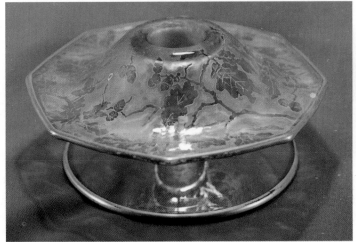

Fostoria 2.375" x 5.5" #2375-1/2 'Fairfax' single light candle holder. Mother-of-pearl iridescent with #290 'Oak Leaf' brocade etching and gold trim, rose, green: $110-120 pair; crystal: $95-100 pair. (c. 1928-1930).

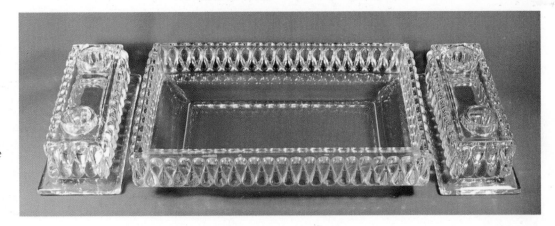

Fostoria #2592 table center with 2.25" x 6.5" 'Myriad' double light candle holders and rectangular 'Lily Pond' bowl. Crystal only: $150-165. (1942-1944).

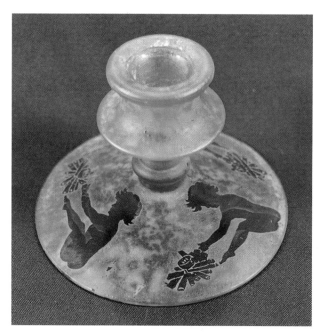

Fostoria 3.125" # 2324 single light candle holder with #288 'Cupid' brocade etching. Blue, green, ebony: $120-130 pair. (c. 1927-1928).

Fostoria 5" #2481 single light candle holder. Crystal with 'Midnight Rose' etching: $140-150 pair. (c. 1933-1938).

Fostoria 3" #2324 single light candle holder with #287 'Grape Brocade' etching. Green: $65-70 pair; blue or orchid: $75-80 pair. (c. 1927-1929).

Right:
Fostoria 5.5" #2470-1/2 three-footed single light candle holder with 'Midnight Rose' etching. Crystal: $120-130 pair. (c. 1933-1945).

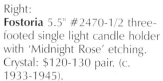
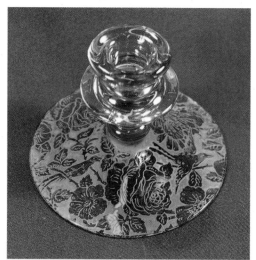

Fostoria 3.125" #2324 single light candle holder with #289 'Paradise' brocade etching. Green, orchid: $65-70 pair. (c. 1927-1929).

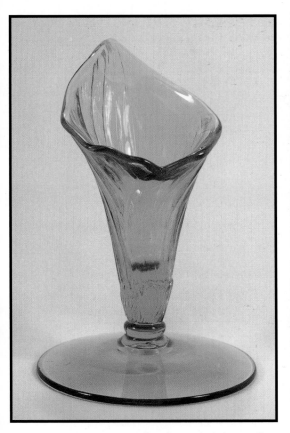

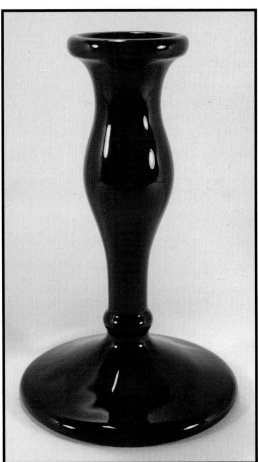

Fostoria 6.125" #2269 single light candle holder. Black, blue, green: $60-65 each; crystal, amber: $40-45 each.

Fostoria 5.875" #2352 'Calla Lily' single light candle holder/vase. Amber and crystal: $50-55 pair; blue, green, orchid: $70-75 pair. (c. 1920s).

Fostoria 6" FL 05/756 'Flame' two-way single light candle vase. Green with floral pattern, crystal, brown: $15-20 pair. (c. 1978-1980).

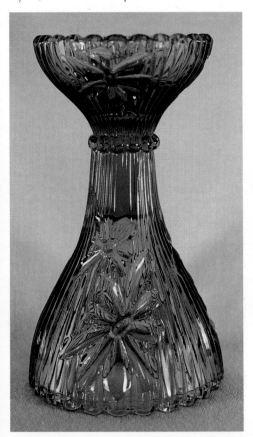

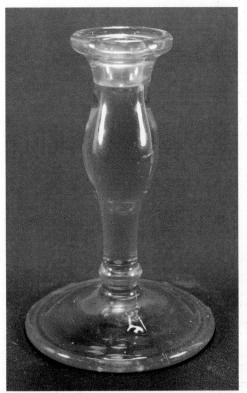

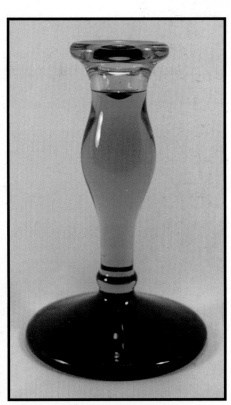

Fostoria 6" #2269 single light candlestick. Vaseline: $65-70 each; crystal with etchings, paint, or gold decoration: $55-60 each. (c. 1920s).

Fostoria 6.125" #2269 single light candle holder. Rose amber with blue painted onto bottom of base: $55-60 each.

65

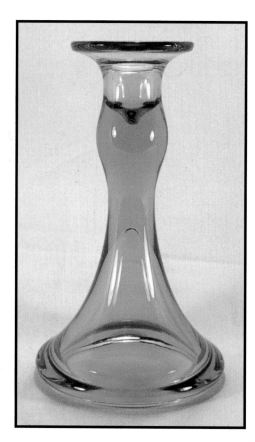

Fostoria 6.25" #2275 single light candle holder. Rose amber: $35-40 each; green, blue: $45-50 each; canary: $55-60 each.

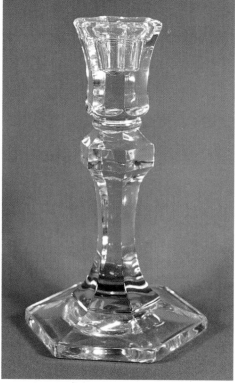

Fostoria 7" #CA 12/323 single light candle holder. Crystal only: $30-35 each. (c. 1982).

Fostoria 7" #4024 single light candle holder. Regal blue with crystal foot: $70-75 pair; crystal, silver mist (crystal with satin foot): $30-35 pair (more with cuttings); empire green, burgundy: $70-75 pair. (c. 1933-1943). Used mainly for cuttings and etchings, especially crystal.

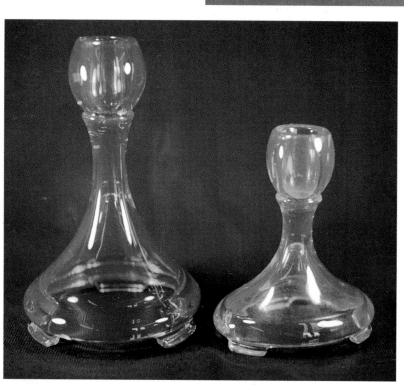

Fostoria 7" #2297 and 5" #2299 oval art deco single light candle holders. Vaseline: $90-95 pair (both sizes). (c. 1920s).

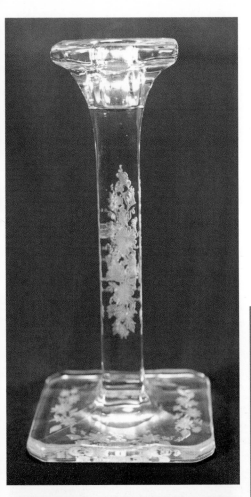

Fostoria 7.75" #1218 single light candlestick. Crystal with deep etched 'A': $75-80 each. (c. 1920-1925).

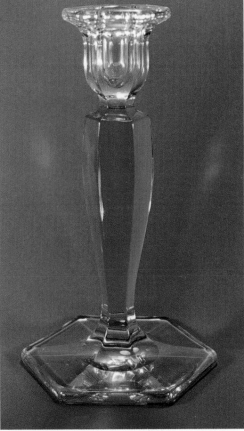

Fostoria 8.25" six-sided single light candle holder. Vaseline or canary: $75-80 pair.

Fostoria 8" #1485 single light candlestick. Crystal: $45-50 each. Also comes in 9.5": $45-50 each; and 11" and 11.5": $55-60 each. (c. 1920s-1930s).

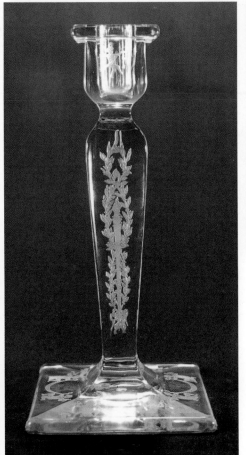

Fostoria 8" #1856 single light candlestick with 'Cupid' deep etching. Crystal only: $85-90 each. (c. 1920-1925).

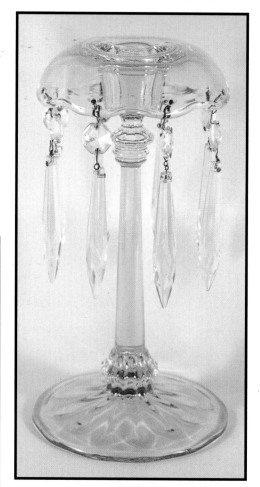

Fostoria 8.5" #2436 single light lustre candle holder. Wisteria, crystal with wisteria base, crystal with topaz base: $90-95 each; crystal with ebony base: $80-85 each; crystal with rose or green base: $70-75 each; crystal: $55-60 each. (c. late 1920s-1930s).

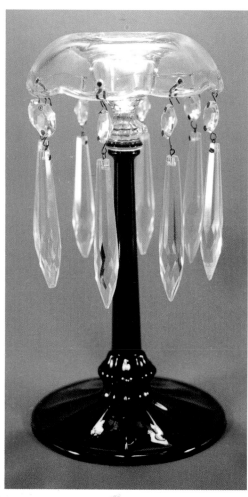

Fostoria 8.25" #2436 single light lustre candle holder. Crystal with ebony base: $80-85 each; crystal with rose or green base: $70-75 each; crystal: $55-60 each; wisteria, crystal with wisteria base, crystal with topaz base: $90-95 each. (1920s-1930s).

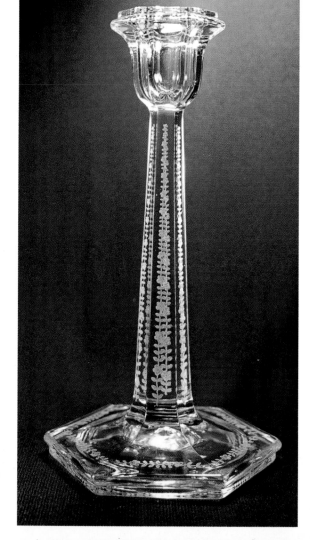

Fostoria 9.25" #1963 single light candle pillar. Crystal with deep etching: $80-85 each. (1920-1925).

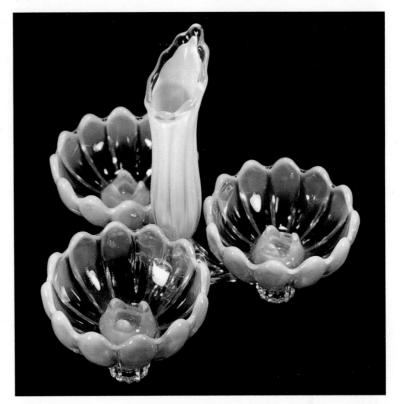

Fostoria 10" x 9.5" 'Table Charms.' Set #1 triple light candle center. Pink or other color opalescent: $140-165; crystal: $100-125.

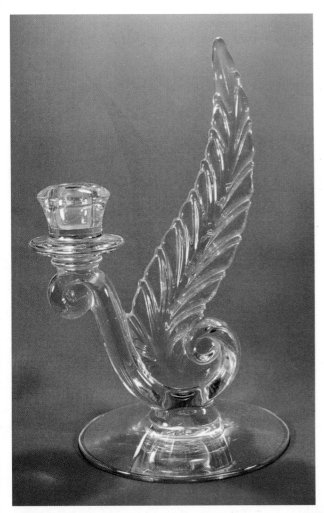

Fostoria 9.25" #2636 'Plume' single light candlestick. Crystal only: $80-85 each. (1950s).

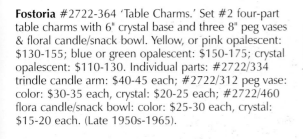

Fostoria #2722-364 'Table Charms.' Set #2 four-part table charms with 6" crystal base and three 8" peg vases & floral candle/snack bowl. Yellow, or pink opalescent: $130-155; blue or green opalescent: $150-175; crystal opalescent: $110-130. Individual parts: #2722/334 trindle candle arm: $40-45 each; #2722/312 peg vase: color: $30-35 each, crystal: $20-25 each; #2722/460 flora candle/snack bowl: color: $25-30 each, crystal: $15-20 each. (Late 1950s-1965).

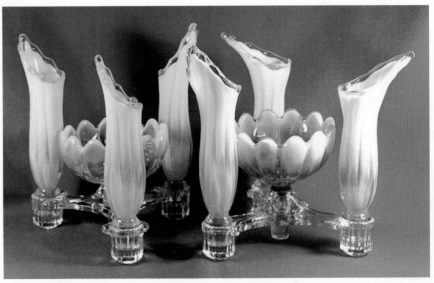

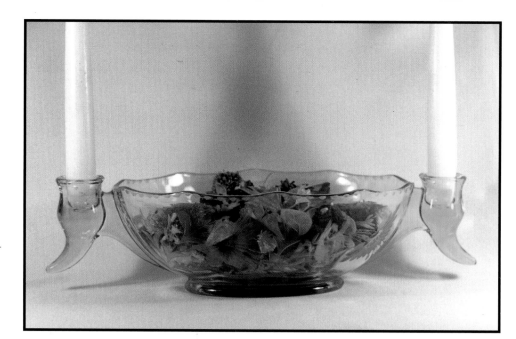

Fostoria 3.375" x 13.25" #2415 'Combination Bowl' double light candle bowl. Topaz or any color with etching or cutting: $240-260 each.

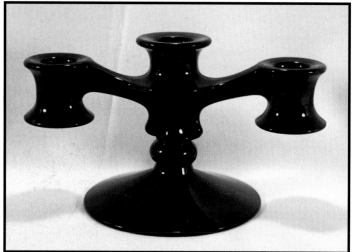

Fostoria 4" #2383 triple light candle holder. Ebony, green, rose: $50-55 each; crystal, amber: $45-50 each; topaz, azure: $55-60 each. (c. 1930s).

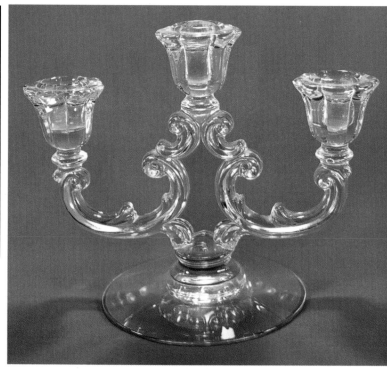

Fostoria 7" #2482 triple light candelabra. Crystal: $45-50 each; topaz: $60-65 each. (c. 1936-1970).

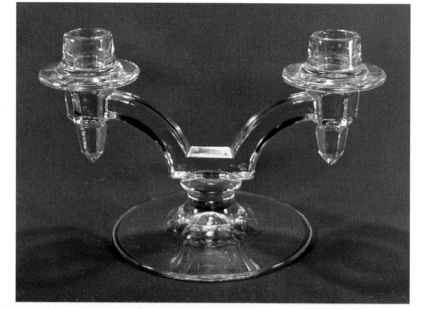

Fostoria 5.25" #332 'Raleigh' double light candle holder. Crystal only: $40-50 pair. (1939-1966).

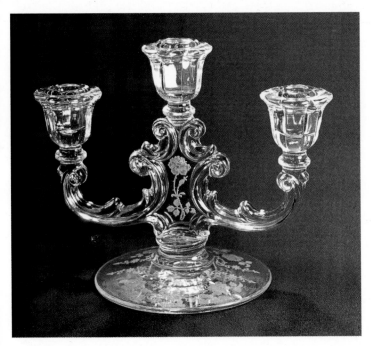

Fostoria 7" x 8.5" #2482 triple light candle holder. Crystal with #316 'Midnight Rose' etching: $75-80 each. (c. 1933-1947).

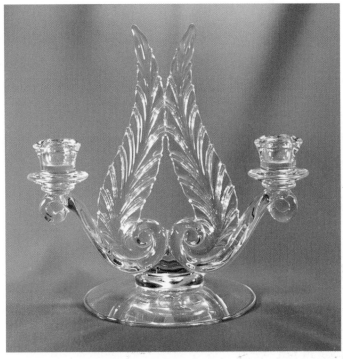

Fostoria 9.5" x 10" #2336 'Plume Duo' double light candle holder. Crystal only: $100-110 each. (1950s).

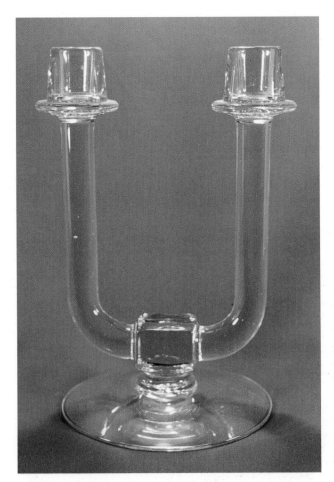

Fostoria 8.5" #2527 'Nocturne' double light candlestick. Crystal: $55-60 each. (c. 1950s).

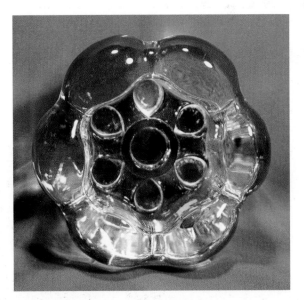

Fostoria #2640 'Flower Garden.' Block is 1.375" x 5".

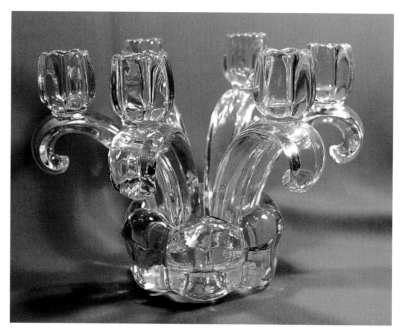

Fostoria 6.75" x 9.5" 'Flower Garden' seven-piece, six light candle holder. Crystal: $140-150.

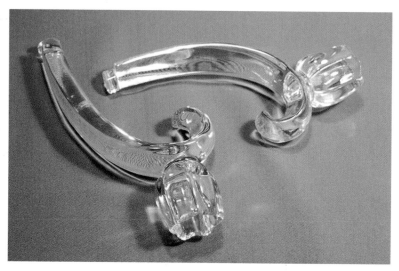

Fostoria #2640 'Flower Garden.' Candle peg is 5.5".

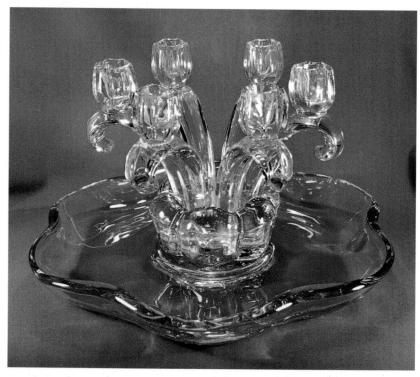

Fostoria 7.625" x 14" #2640 'Flower Garden' eight piece, six light candle holder with 2" x 14" raised center flower floater/liner. Crystal: $185-200.

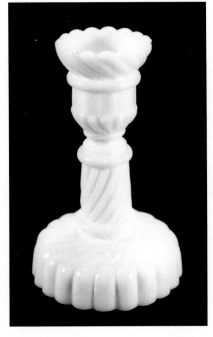

France

Portieux and Vallerysthall, both having originated in the 1700s, merged in 1872 to become Vallerysthall et Portieux. They separated in the mid-1950s, and Portieux closed in the mid-1980s. Vallerysthall is still in production, but on a small scale.

France (Portieux) 1" x 3.25" single light drip plates. Blue milk glass: $20-25 pair.

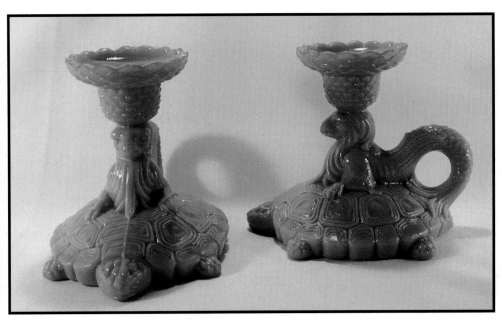

France (Portieux) 3.25" 'Swirl' child's single light candlestick. White milk glass: $20-25 each.

France (Portieux) 4.5" x 5.5" 'Tortue' single light candle holder. Blue milk glass, white milk glass: $225-250 each. (Early 1900s). Hard to find.

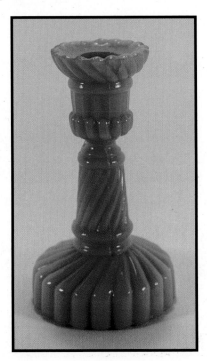

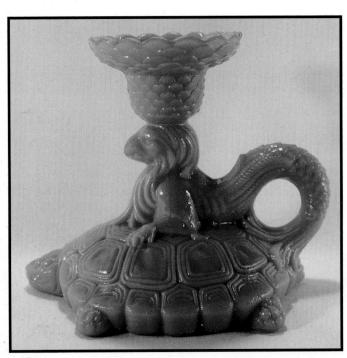

Left:
France (Portieux) 3.375" 'Swirl' child's single light candlestick. Blue milk glass: $45-50 each; green milk glass: $50-55 each; amber: $35-40 each.

Right:
France (Portieux) 4.5" x 5.5" 'Tortue' single light candle holder. Blue milk glass: $225-250 each. (Early 1900s). Hard to find.

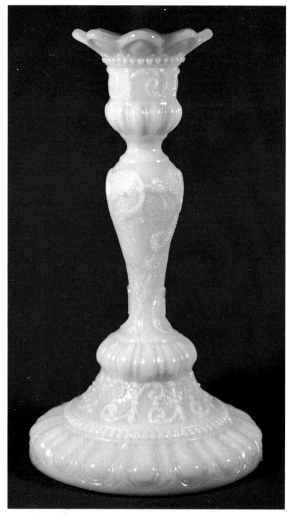

France (Portieux) 7.75" 'Chimere' single light candle holder. White milk glass, blue milk glass: $65-70 each. (1930s). Hard to find.

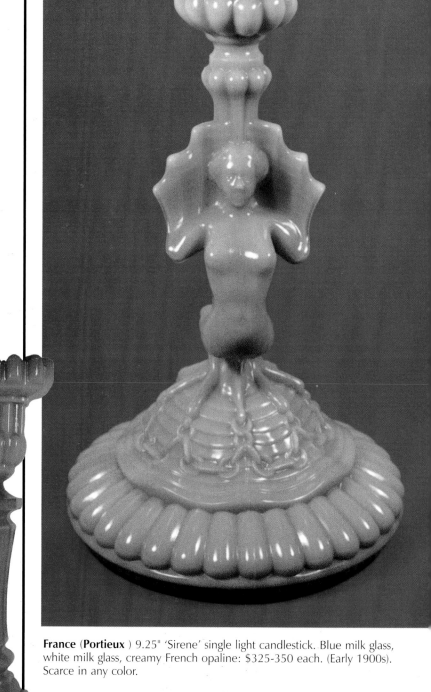

France (Portieux) 7.875" 'Carre' single light candle stick. Blue milk glass, green milk glass, white milk glass: $55-60 each. (c. 1930s). Hard to find in blue and white; scarce in green. Also comes in 7" and 10".

France (Portieux) 9.25" 'Sirene' single light candlestick. Blue milk glass, white milk glass, creamy French opaline: $325-350 each. (Early 1900s). Scarce in any color.

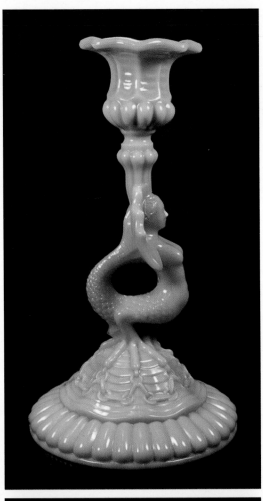

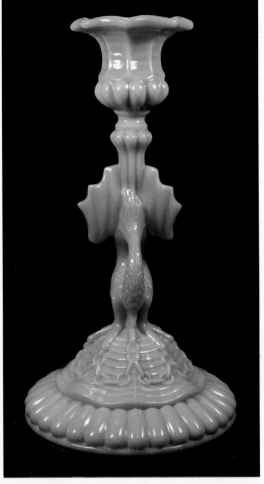

A.H. Heisey & Company

Newark, Ohio, 1896 to 1958. Some molds were purchased by **Imperial Glass Company**. Elegant stemware and tableware.

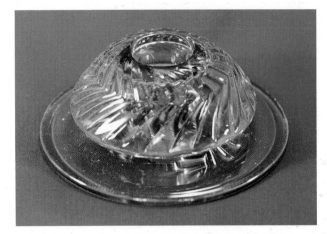

Heisey 1.625" #122 'Zig-Zag' single light candle holder. Flamingo: $75-80 pair; crystal: $35-40 pair; moongleam: $90-95 pair; Hawthorne: $110-120 pair. (1927-1929). Marked.

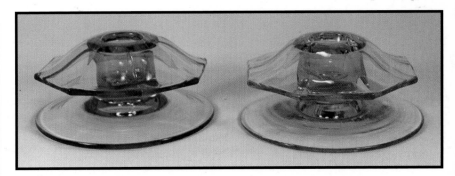

Heisey 2" #1252 'Twist' single light candle holder. Moongleam: $100-110 pair; flamingo: $95-100 pair; crystal: $45-50 pair; marigold: $160-170 pair. (1929-1933). Marked.

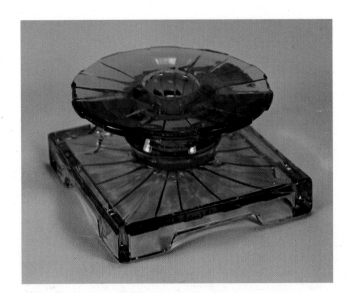

Heisey 2" x 3.625" #132 'Sunburst' single candle holder. Moongleam: $100-110 pair; crystal: $45-50 pair; flamingo: $90-95 pair; marigold: $190-200 pair. (1929-1936). Marked.

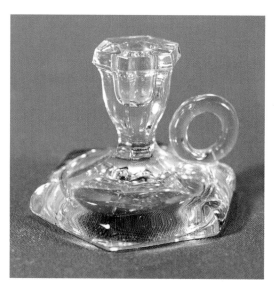

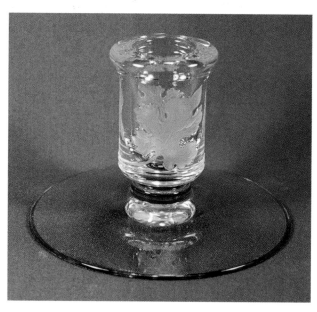

Heisey 2" #31-Toy 'Jack-Be-Nimble' single light candlestick. Crystal: $90-95 pair; moongleam, flamingo, sahara: $250-275 pair. (1908-1944). Marked. Reissued (unmarked) by **Imperial** in 1981.

Heisey 2.75" #116 'Oak Leaf' single light candle holder. Crystal/flamingo with frosted leaf: $100-110 pair; crystal: $60-65 pair; moongleam: $75-80 pair; crystal/moongleam: $110-120 pair; flamingo: $65-70 pair. hawthorne: $190-200 pair. (1926-1929). Sometimes marked. The leaf is often frosted.

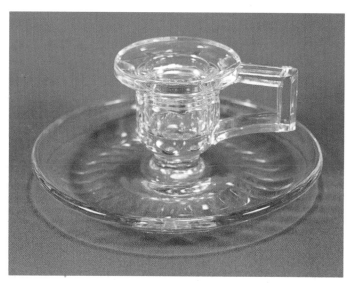

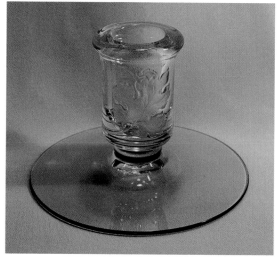

Heisey 2.125" #600 'Square-Handled' single light chamber stick. Crystal only: $80-85 pair (1939-1945). Marked.

Heisey 2.875" #116 'Oak Leaf' single light candle holder. Crystal top with frosted leaf and moongleam base: $110-120 pair.

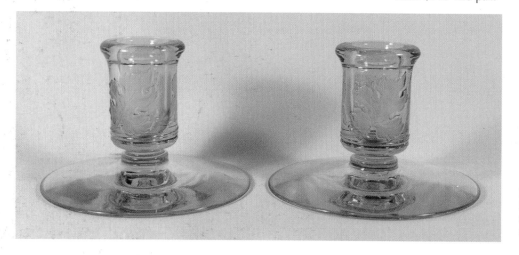

Heisey 2.875" #116 'Oak Leaf' single light candle holder. Flamingo top with frosted leaf and crystal base: $100-110 pair.

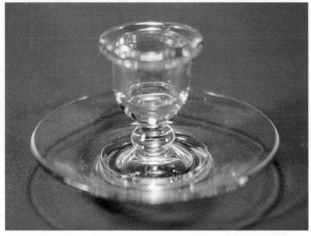

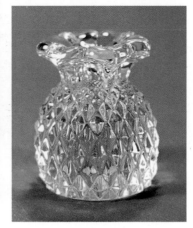

Heisey 3.25" #1567 'Plantation' single light candle block. Crystal: $230-245 pair. (1948-1957). Not marked.

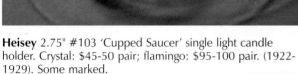

Heisey 2.75" #103 'Cupped Saucer' single light candle holder. Crystal: $45-50 pair; flamingo: $95-100 pair. (1922-1929). Some marked.

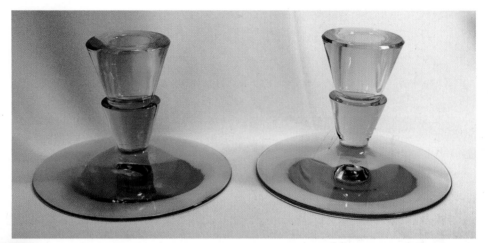

Heisey 3.25" #128 'Liberty' single light candle holders. Marigold: $225-250 pair; moongleam: $105-115 pair; flamingo: $100-110 pair; crystal: $50-55 pair. (1929-1929). Some marked.

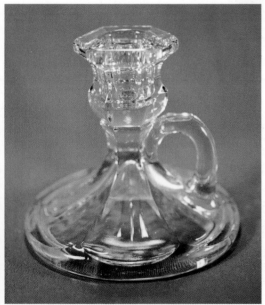

Heisey 4" #150 'Banded Flute' single light chamber stick. Crystal: $50-55 pair. (1907-1930). Usually marked. Also used in bedroom sets.

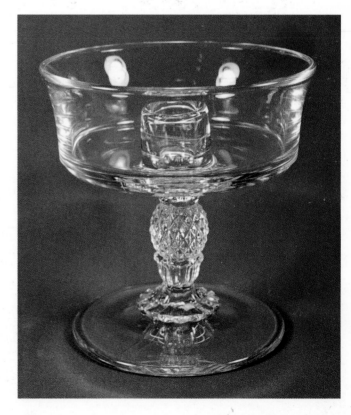

Heisey 5.125" #1567 'Plantation' footed epergne candle holder. Crystal only: $300-325 pair. (1949-1953). Also made in 7" (1949-1950). Marked.

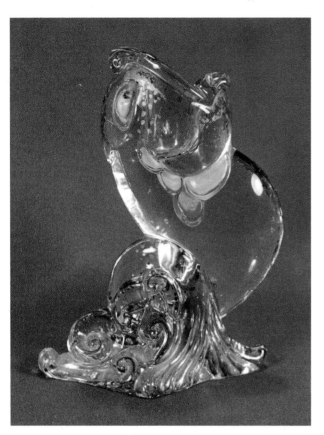

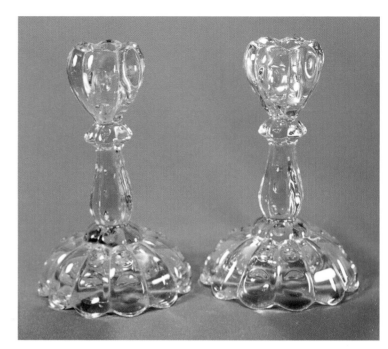

Heisey 6.25" #1404 'Old Sandwich' single light candlestick. Saraha: $275-300 pair; crystal: $110-120 pair; moongleam: $325-350 pair; flamingo: $425-450 pair; cobalt: $575-600 pair. (1931-1937). Usually marked.

Heisey 5.5" #1550 'Dolphin' single light candle holder. Crystal only (1942-1948): $225-250 each. Not marked. Painted decorations are by other companies. Reissued and marked by **Imperial** in 1982. Many **Heisey** collectors prefer the dolphin exclusive of colors.

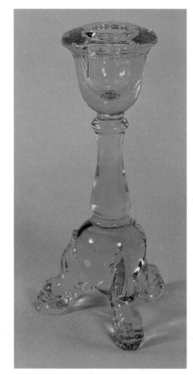

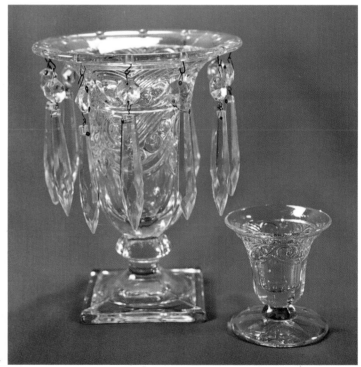

Heisey 6.125" #1401 'Empress' single light candle holder. Sahara: $250-275 pair; crystal: $190-210 pair; alexandrite: $525-550 pair; flamingo: $245-265 pair; moongleam: $350-375 pair. (1929-37). Usually marked. Reissued by **Imperial** in 1981-1982.

Heisey 9.75" #1405 'Ipswich' footed center piece with single light candle/vase and 'A' prisms. Crystal: $300-325 pair; flamingo, moongleam: $800-850 pair; sahara: $700-750 pair; cobalt: $1150-1200 pair (1932-1944). Footed center piece usually marked; candle/vase sometimes marked. Candle/vase sometimes sold alone as a mini-vase or candle holder.

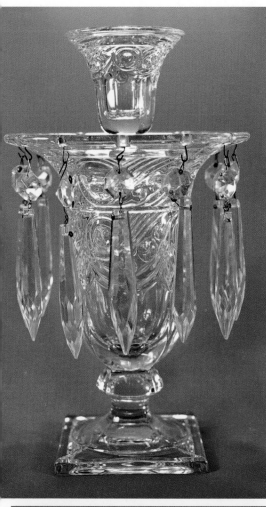

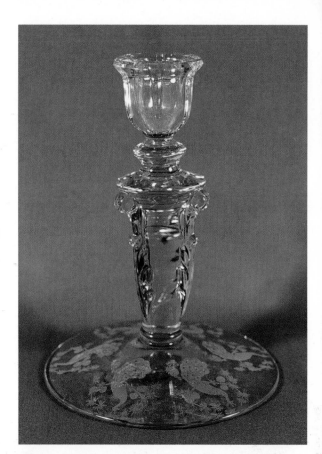

Left:
Heisey 9.75" #1405 'Ipswich' footed center piece with single light candle/vase and 'A' prisms. Crystal: $300-325 pair. (1932-1944).

Right:
Heisey 6.375" #135 'Empress' line #1401 single light candle holder. Crystal only with #366 'Peacock' etching: $165-175 pair. (1939-1957). Some marked. Blank used for various cuttings and etchings.

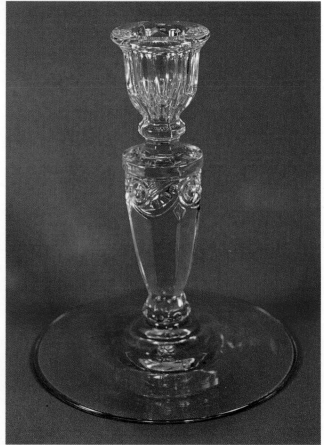

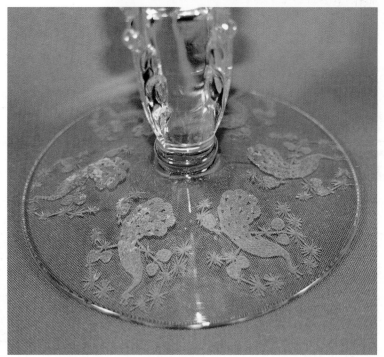

Heisey close up of #366 'Peacock' plate etching shown above.

Heisey 6.125" #1405 'Ipswich' single light candlestick. Crystal: $350-400 pair; flamingo, moongleam: $600-650 pair; Sahara: $500-550 pair; cobalt: $850-900 pair. (1932-1936). Marked.

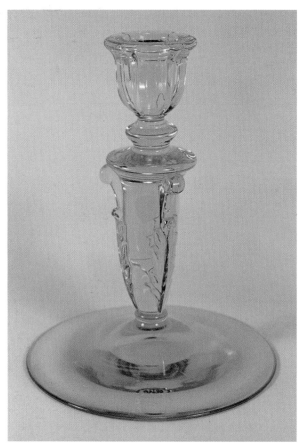

Heisey 7.5" #22 'Windsor' single light candlestick. Crystal only: $95-100 pair. (1907-1933). Usually marked. Also comes in 9" and 11".

Heisey 6.375" #135 'Empress' line #1401 single light candle holder. Sahara: $225-250 pair; alexandrite: $750-800 pair; cobalt: $850-875 pair; crystal: $100-110 pair; flamingo: $200-225 pair; marigold: $350-375 pair; moongleam: $300-325 pair. (1929-1937). Some marked.

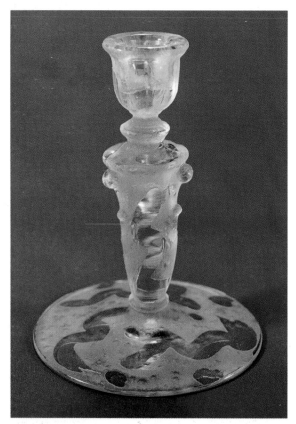

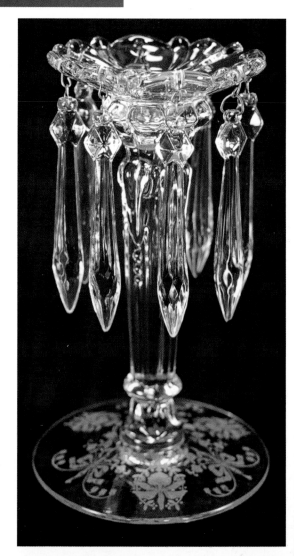

Left:
Heisey 6.25" #135 'Empress' single light candle stick. Crystal only with #9009 'Arctic' etching: $95-100 pair. (1929-1937).

Right:
Heisey 8.125" #1509 'Queen Ann' single light candelabrum with 'A' prisms. Crystal only with #1507 'Orchid' etching: $280-290 pair. (c. 1938-1957) Not marked. Reissued by **Imperial** in 1958-1971. Blank often used for various cutting and etchings. This is one of only two lustres made by **Heisey**; it was sold with and without prisms.

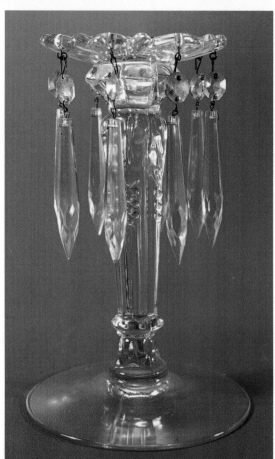

Heisey 8.125" #1509 'Queene Anne' single light lustre with prisms. Crystal only: $225-235 pair. (1939-1957). Not marked.

Heisey 7" and 11" #2 'Old Williamsburg' single light candlesticks. Crystal: 7": $125-135 pair; 11": $165-175 pair; moongleam (7" only; 1903-1957): $640-650 pair. Some marked. (7": 1903-1957; 11": crystal only; 1902-1931). 7" reissued by **Imperial** in 1958-1982.

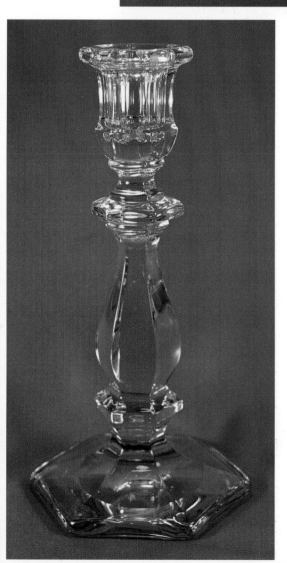

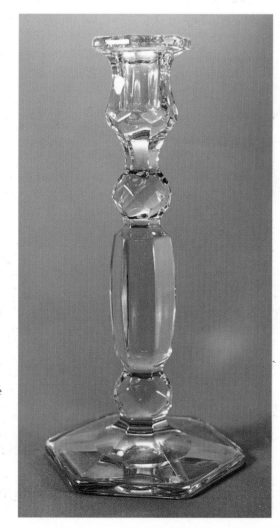

Left:
Heisey 9" #2 'Old Williamsburg' single light candle holder. Crystal only: $150-160 pair. (1901-1935; 1943). Some marked.

Right:
Heisey 9.25" #1 'Georgian' single light candle stick. Crystal: $175-185 pair; flamingo: $575-625 pair. (1900-1931). Also 7" crystal only (1906-1909) and 11" crystal only (1906-1931). **Paden City** made a pressed copy in crystal and colors; these have a rayed pattern pressed into the base.

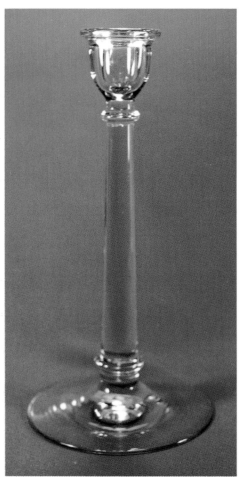

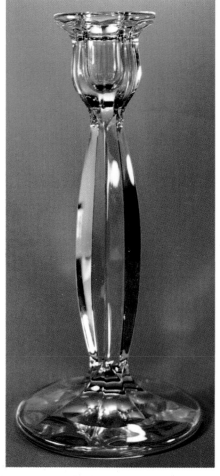

Heisey 9.25" #100 'Centennial' single light candlestick. Crystal: $170-180 pair; moongleam: $250-275 pair; flamingo: $230-250 pair. (1922-1929). Also in 6" crystal: $150-160 pair; 6" vaseline (very rare): $600-625 pair; and 7" crystal: $225-250 pair. Usually marked. Hard to find.

Heisey 9.75" #29 'Sandford' single light candlestick. Crystal: $140-150 pair. Some marked. (1912-1929). Also made in 7" and 11". Hard to find.

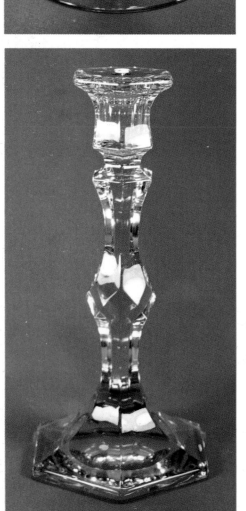

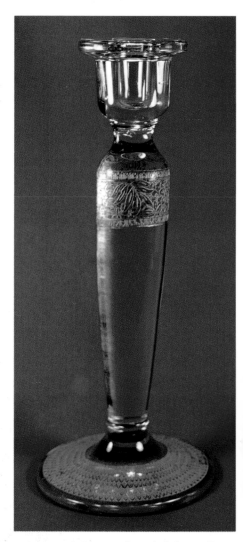

Left:
Heisey 8.875" #4 'Essex' single light candlestick. Crystal only: $150-160 pair; crystal with full cutting: $230-250 pair. (1902-1921). Usually not marked. Used for full cuttings in 1908-1917. **Paden City** made an identical candlestick with a rayed pattern pressed into the base.

Heisey 10.5" #71 'Oval' single light candlestick. Crystal only with gold: $290-300 pair. (1921-1929). Marked. Often used for cuttings.

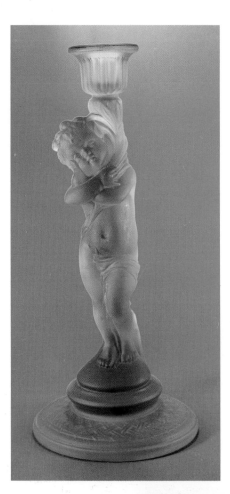

Left:
Heisey 11.5" #111 'Cherub' single light candlestick. Flamingo frosted: $1200-1250 pair; crystal: $475-500 pair; moongleam: $1290-1350 pair. Made in both transparent and satin colors; more often found in satin. (1926-1929). Not marked.

Right:
Heisey 12.125" #1503 'Crystolite' single light hurricane lamp. Square hurricane block #1503 (4" x 2.625") and globe #4061 (10.75"). Crystal with cutting on globe: $250-275 pair. Usually not marked. (Block made 1938-1953). The 10" globe is made by cutting 2" from the bottom of a 12" globe to make a larger opening.

Below Left:
Heisey 11.75" #300-1 'Old Williamsburg' single light candlestick with crystal 'A' prisms. Sahara: $500-550 pair; crystal: $325-350 pair. (Crystal, 1902-1953; Sahara, 1930s). Some marked.
Imperial reissued 9" and 10" in crystal in 1958-1979.

Below right:
Heisey close up of 12.125" #1503 'Crystolite' single light hurricane lamp with #450 'Chintz' plate etching on globe. Crystal: $250-275 pair.

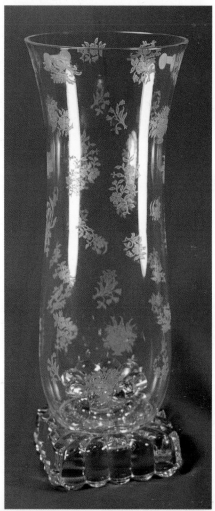

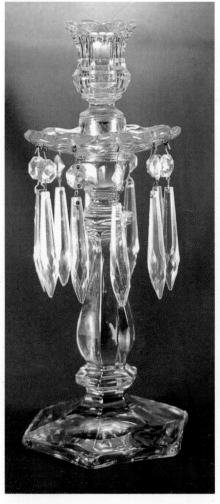

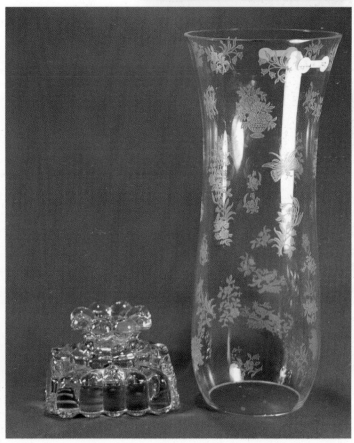

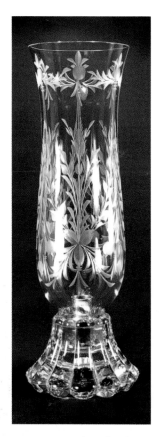

Heisey 14.75" #1503 'Crystolite' two-piece single light hurricane lamp. Round block with #300 globe (12"). Crystal with #917 'Sarasota' cutting: $400-450 pair. Some marked. Can also be found with #300, 9" globe and #4060, 6" globe. Reissued by **Imperial** in 1971 with a lighter weight base in crystal and satin using a #1951 globe.

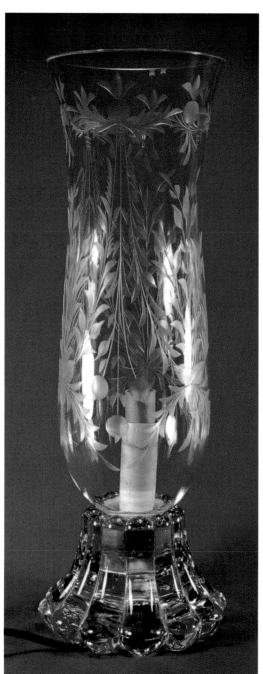

Heisey 14.75" #1503 'Crystolite' electrified two-piece single light hurricane lamp. Crystal with #917 'Sarasota' cutting: $850-900 pair. (1931-1941). Some marked.

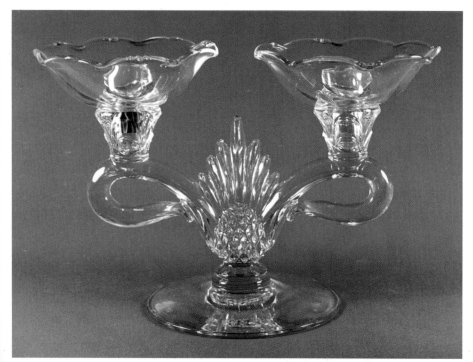

Heisey 7.25" x 11.25" #1567 'Plantation' double light candle holder with two #1519 'Waverly' 6" epergnette pegs. Crystal only: $275-300 pair; epergnette pegs: $45-50 pair. (1949-1957). Usually not marked.

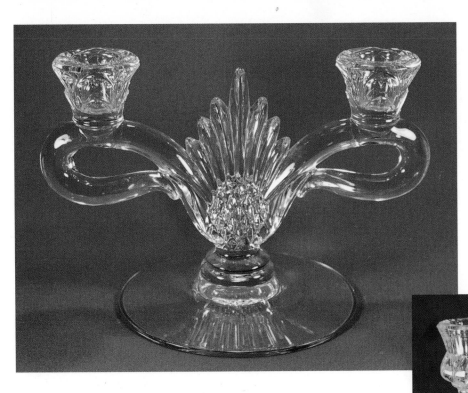

Heisey 5.625' x 8.75" #1567 'Plantation' double light candle holder. Crystal only: $225-250 pair. Usually not marked.

Heisey 7.25" #1567 'Plantation' triple light candelabra with bobeches and 'A' prisms. Crystal only: $375-400 pair. Usually not marked. (1948-1953). This bobeche uses only five prisms. Also found without a raised lip for the bobeche.

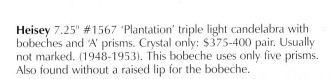

Heisey 6.5" #136 'Triplex' triple light candelabra. Sahara: $275-300 pair; crystal: $150-160 pair; flamingo, moongleam: $375-400 pair; cobalt: $665-695 pair. (1931-1936). Usually not marked.

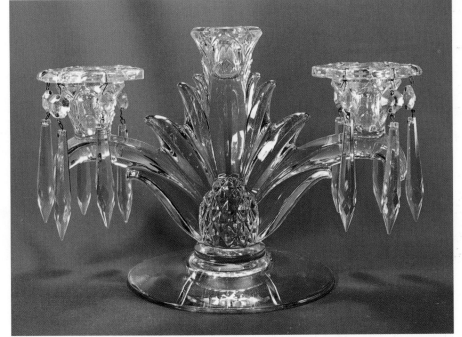

Heisey 6.5" #136 'Triplex' triple light candle holder. Moongleam: $375-400 pair.

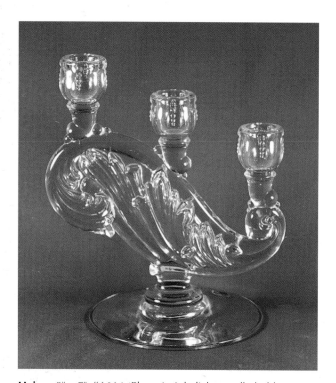

Heisey 8" x 7" #1614 'Plume' triple light candle holder. Crystal only: $850-900 pair. Marked. (1950-1953). Hard to find.

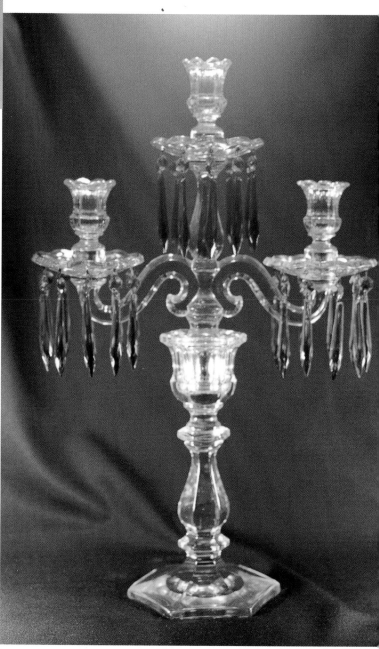

Heisey 20" #300-3 'Old Williamsburg' triple light candelabra with 'A' prisms. Sahara with dark amber prisms: $925-950 pair; crystal: $495-525 pair. (1901-1944). Some marked. (Prisms, 1957).

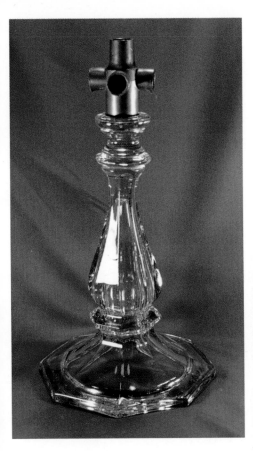

Heisey 16.25" #300 'Old Williamsburg' base. Crystal base: $450 each; custom metal: $200 each. **Note**: Original metal parts are lead and do not wear well.

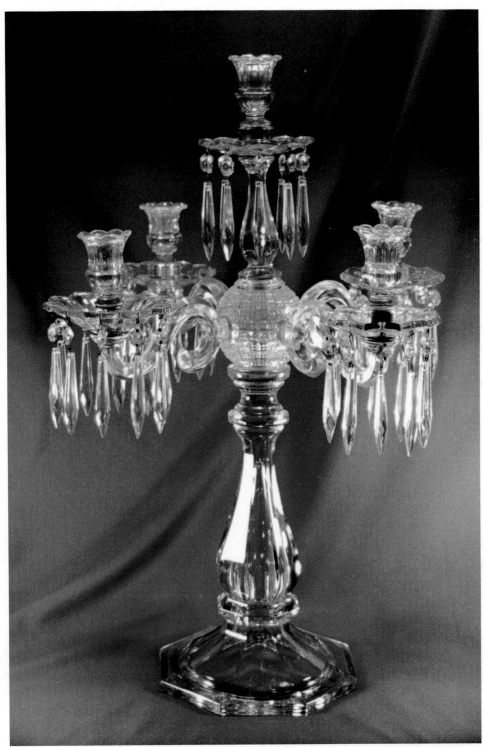

Heisey 24.5" #300-5 'Old Williamsburg' five light candelabra with 'A' prisms. Crystal: $1550-1600 each. (1901-1944). Usually marked.

The Hocking Glass Company

Lancaster, Ohio, 1905 to 1937; became **Anchor Hocking Glass Corporation** in 1937, and **Anchor Hocking Corporation** from 1969 to present. Dinnerware, pressed ware, and gift items.

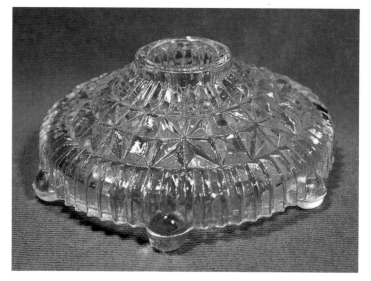

Hocking 1.25" 'Stars & Bars' single light candle holder. Prescut crystal: $6-10 pair. (1941-1960s).

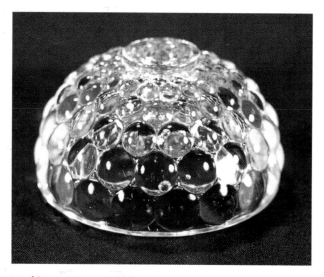

Hocking 2" x 3.5" 'Bubble' single light candle holder. Crystal: $16-20 pair; green: $45-50 pair.

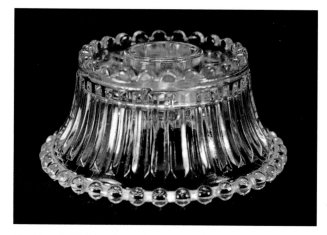

Hocking 3.125" hurricane base. Crystal: $8-10 pair; with globe: $20-25 pair; white milk glass with globe: $25-30 pair.

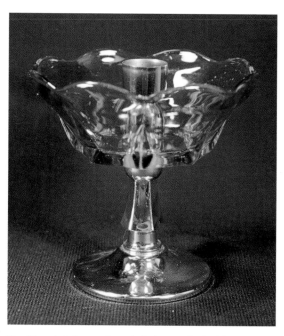

Hocking 4.25" x 4.5" single light candle holder on plastic pedestal with plastic candle cup. Amber: $8-10 pair; crystal: $6-8 pair; royal ruby: $12-15 pair.

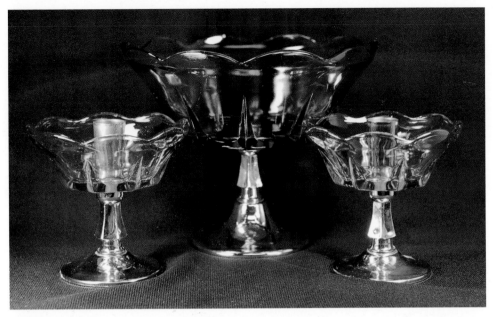

Hocking console set with 4.25" single light candle holders and bowl, all on plastic pedestals. Amber: $15-20; crystal: $10-15; royal ruby: $25-30. Console sets were made from **Hocking** bowls by an unknown company.

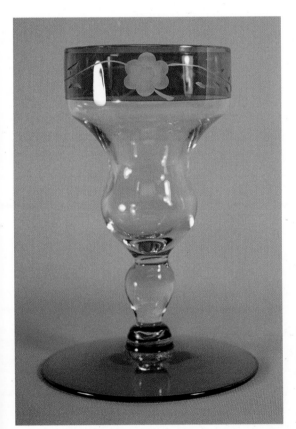

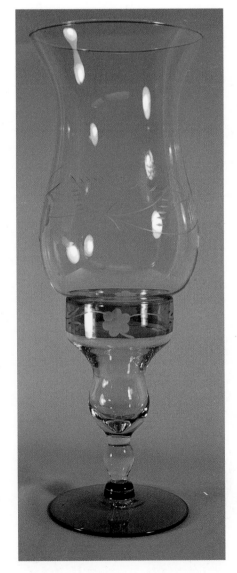

Left:
Hocking 4.75" single light candle holder. Crystal with blue flash and cuttings on candle holder: $40-45 pair.

Right:
Hocking 9.75" single light candle lamp (4.75" candle holder with 5.625" globe). Crystal with blue flash and cuttings on candle holder and globe: $55-60 pair.

Hocking for **Hilyard's Gift Shop** (Bremen, Ohio)9.5" single light candle lamp. Crystal with ruby flash and cutting: $70-75 pair. (1950s). Made by **Hocking**. Decorated by **Hilyard**. Mid-Atlantic Glass Co. also used this mold.

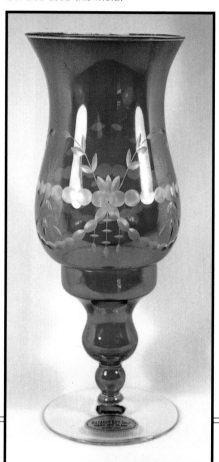

Hocking for **Hilyard's Gift Shop** (Bremen, Ohio). 4.25" candle holder with 5.875" globe. Crystal with ruby flash and cutting: $70-75 pair. (1950s). Made by **Hocking**. Decorated by **Hilyard**. Mid-Atlantic Glass Co. also used this mold.

Home Interior

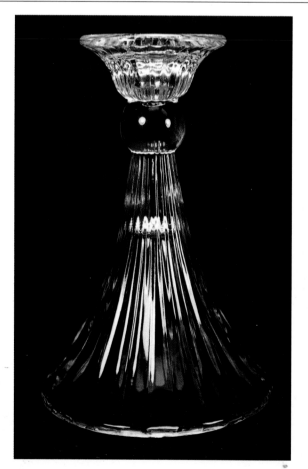

Home Interior 6" single light candle holder. Crystal: $15-18 pair.

90

Imperial Glass Company

Bellaire, Ohio, 1901 to 1973. Sold to **Lenox, Inc.** Closed 1984. Tableware, pressed ware, and slag glass.

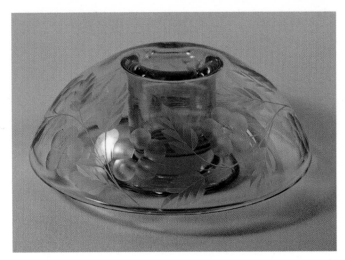

Imperial 2" #718R rolled edge candle holder with #19 'Appiano' floral cutting. Green with cutting, Rose Marie: $60-65 pair; amber: $50-55 pair. Part of a three or five piece console set.

Imperial 1.25" x 3.25" single light candle holder/flower frog. Crystal: $12-14 each.

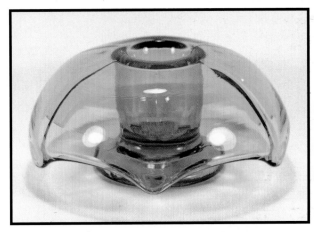

Imperial 2" x 4.375" #727R six-paneled mushroom single light candle holder. Amber, green, rose: $40-45 pair; crystal: $35-40 pair. (1935-1940). Used for console sets.

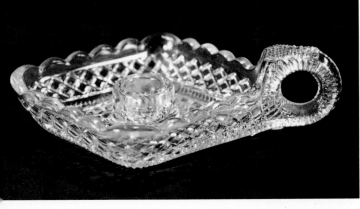

Imperial 1.625" x 6.5" #81 'Aladdin Lamp' single light candle nappy. Crystal, #1950/81 white milk glass: $35-40 pair; glossy purple slag: $40-45 pair. Milk glass, 1950-1960; slag, 1962. Also comes footed in crystal and white milk glass.

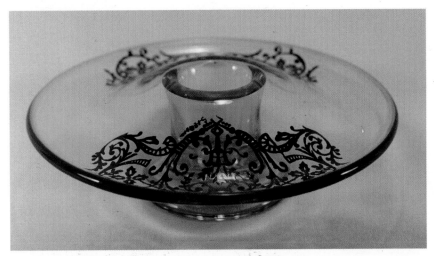

Imperial 1.8875" #718L single light rolled edge candle holder. Light green with silver deposit, rose, amber: $40-45 pair. (1920s). Part of a three piece console set. Modified later for 'Candlewick.'

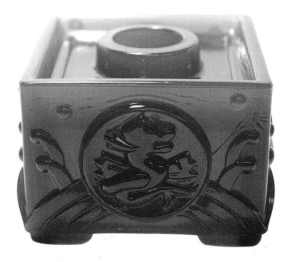

Imperial 2.125" x 3.375" #5020 'Shen' single light candle block. Dynasty jade, opaque blue: $45-50 pair. (c. 1949). From the 'Cathay' line. Reissued in the 1960s in frosted cranberry and frosted verde; reissued and marked 'LIG' in 1980-1983 in opaque jade green.

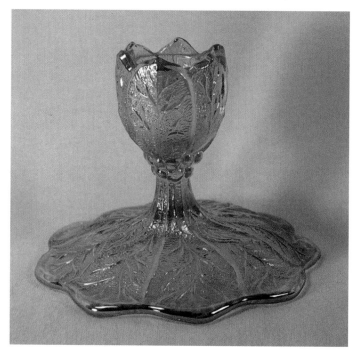

Imperial 3" #3800/72 single light candle holder. Meadow green carnival, pink carnival, amethyst carnival, sunset ruby: $35-40 pair. From a **Cambridge** mold.

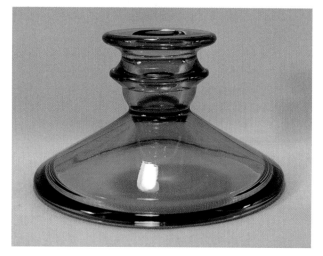

Imperial 2.375" single light candle holder. Amber: $15-20 pair; green, rose: $20-25 pair. (1920s).

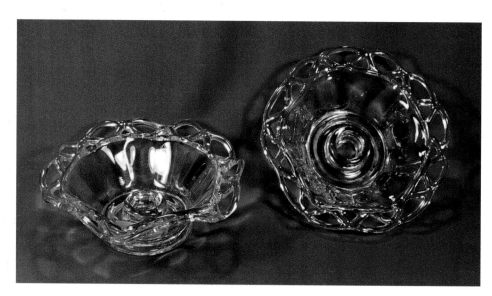

Imperial 2.5" x 6.125" #78C 'Crocheted Crystal' single light candle bowl. Crystal, milk glass: $40-45 pair. (c. 1940s-1950s). Used in console sets with #708C 10" bowl.

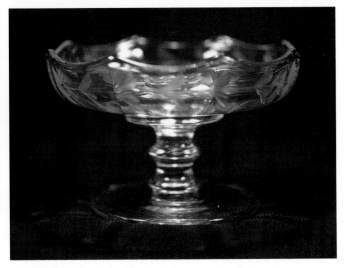

Imperial 3.125" #727 single light footed candle dish. Crystal with 'Noel' cutting: $45-50 pair; rose pink, green, ritz blue: $50-55 pair; stiegel green, ruby: $70-75 pair. (c. 1930s).

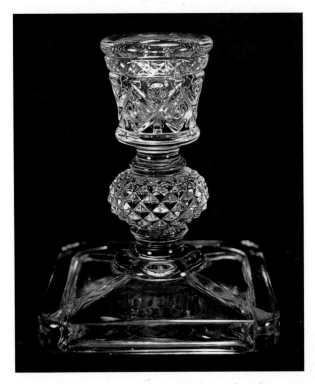

Imperial 4" #81 'Cape Cod' single light candlestick. Crystal: $30-35 each. (c. 1932-1984).

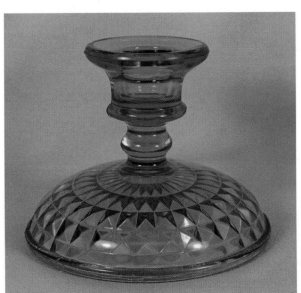
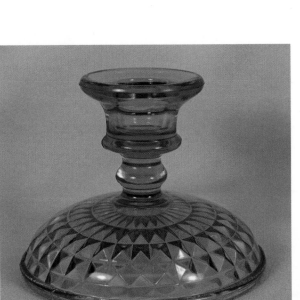

Imperial 3.5" #637/3 'Diamond Quilted' single light candle holder with domed base. Green, pink: $25-30 pair; light blue, black: $40-45 pair. (1920s-1930s).

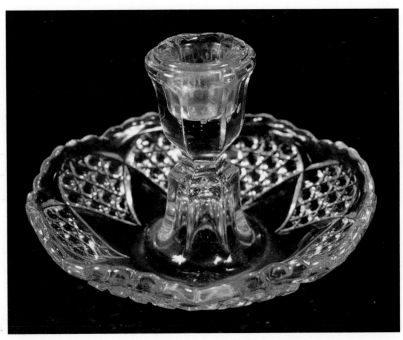

Imperial 4" #9 single light candlestick with saucer. Crystal: $40-45 each. (c. Early 1900s).

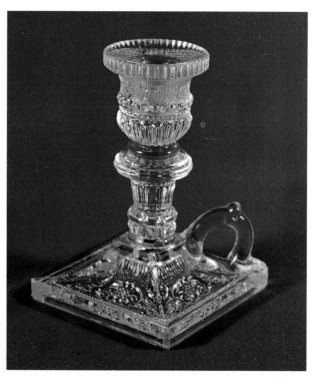

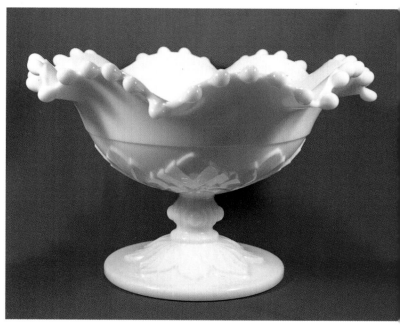

Imperial for the **Smithsonian Institute** 5.25" x 3.75" #71790 square based chamber stick. This is a reproduction of an early Smithsonian piece. Crystal: $45-50 each. (1976-1981). Marked 'SI'.

Imperial 5.5" #1950/196 'Candlewick' single light footed candle/epergne bowl. White milk glass: $55-60 each. (1950s).

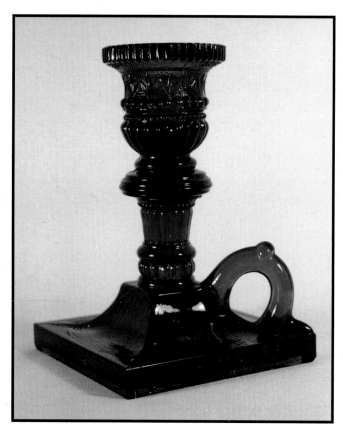

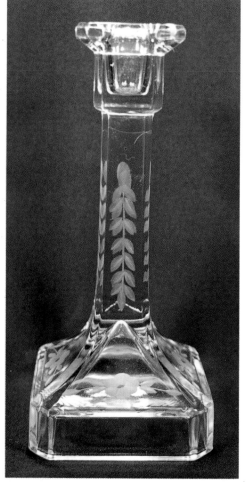

Imperial for the **Smithsonian Institute** 5.25" x 3.75" #71790 square based chamber stick. Ultra blue: $45-50 each.(1980-1981). Marked 'SI.'

Imperial 7" #6247 single light candlestick. Crystal with cutting: $70-75 pair. (1925-1935).

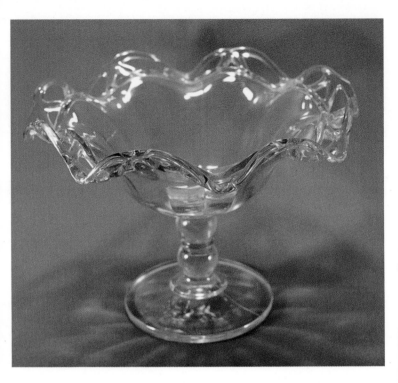

Imperial 7.125" x 10" 'Crocheted Crystal' single light candle/epergne base. Crystal: $60-65 each. (First made in 1943).

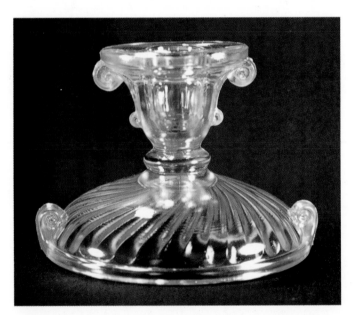

Imperial 3.375" 3130/1 'Double Scroll' single light low candle holder with swirl base. Yellow iridescent: $30-35 pair. (1980s). Marked on bottom.

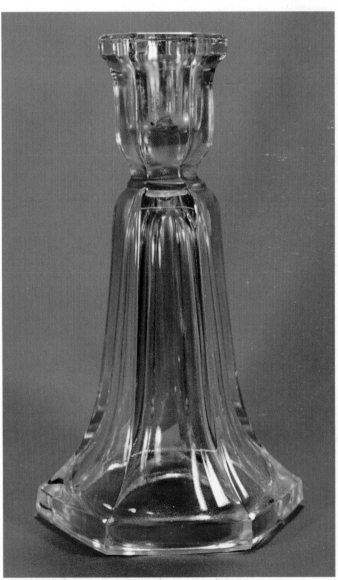

Imperial 7.25" #700 'Panel' single light skirted flute. Rubigold iridescent; $70-75 pair; amber, crystal: $45-50 pair; nugreen, mulberry: $60-65 pair. (1920s). Crystal was reissued in 1950.

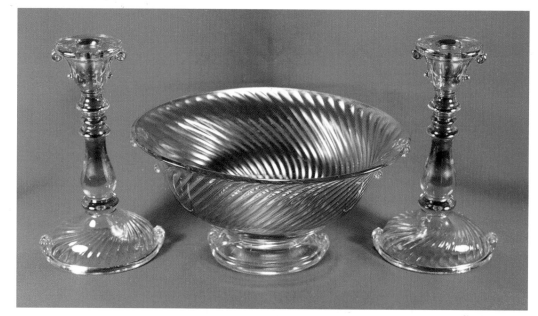

Imperial 8.5" #313 'Double Scroll' single light candle holders with swirl optic pattern. Crystal with rubigold iridescence: $50-55 each; green, rose, amber: $35-40 each. (c. 1920s). Console set with 10.5" bowl: $165-180.

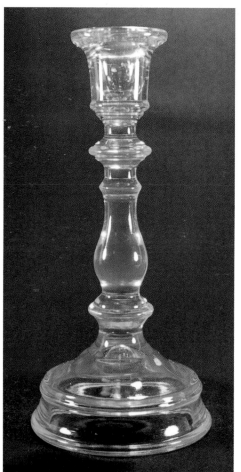

Left:
Imperial 8.375" #635 'Premium' single light candlestick. Vaseline: $55-60 each; peacock iridescent, marigold iridescent, nuruby iridescent: $45-50 each.

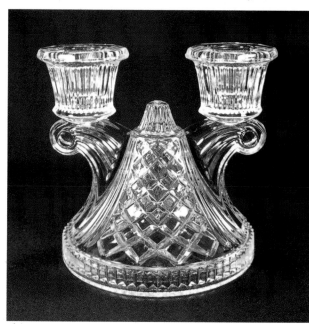

Imperial 4.5" 'Cristolbrite' double light candle holder. Crystal: $35-40 pair. In June, 1936, Butler Bros. Catalog.

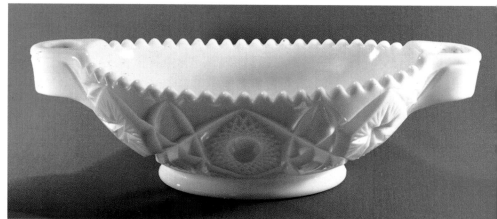

Imperial 3.75" x 6.5" x 12.125" #607 double light candle bowl. White milk glass (#150/607), crystal (1957): $45-50 each. (c. 1950-1979).

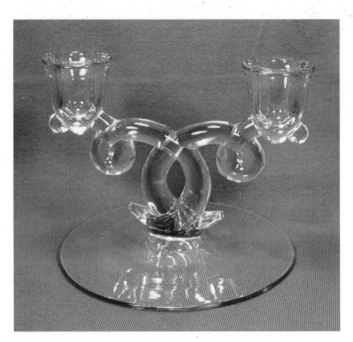

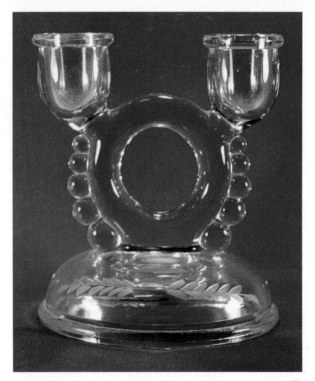

Imperial 5" #1540 'Lariat' double light candle holder. Crystal: $45-50 pair. A reissue of **Heisey** #1540.

Imperial 5.125" double light candle holder. Crystal with cutting: $50-55 pair. This is a version of #169 that has been adapted to be used with 'Candlewick'.

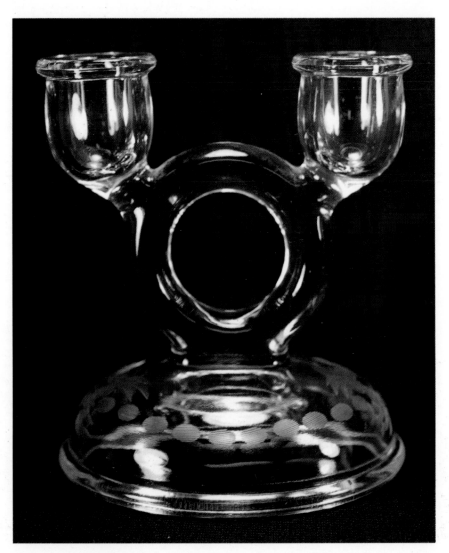

Imperial 5.125" #169 double light candle holder. Crystal with cutting: $45-50 pair. Used for cuttings. Usually in a console set.

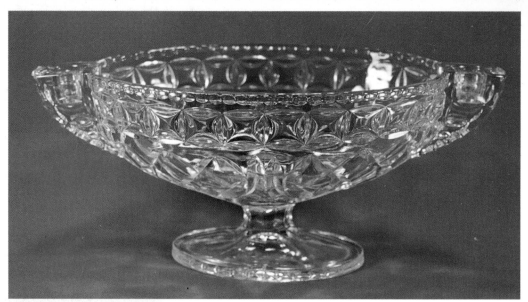

Imperial 5.625" x 13" double light candle bowl. Crystal: $40-45 each.

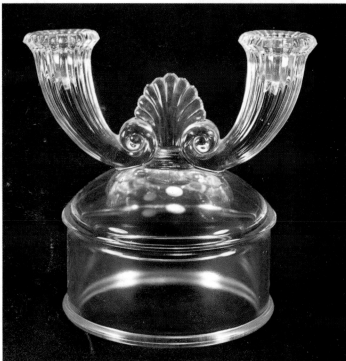

Imperial 6.5" #280/100 'Corinthian' or 'Imperial Tiara' double light candle holder applied to an inverted candy box. Crystal: $70-75 each. (1940-1945).

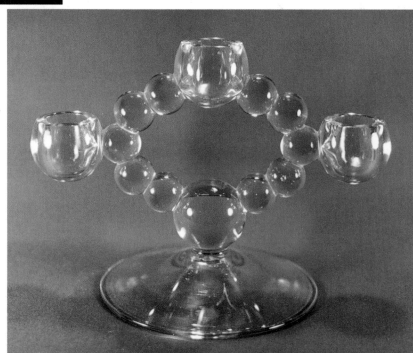

Imperial 5.5" #400/147 'Candlewick' triple light candle holder. Crystal with older domed base: $45-50 each. (1943-1965).

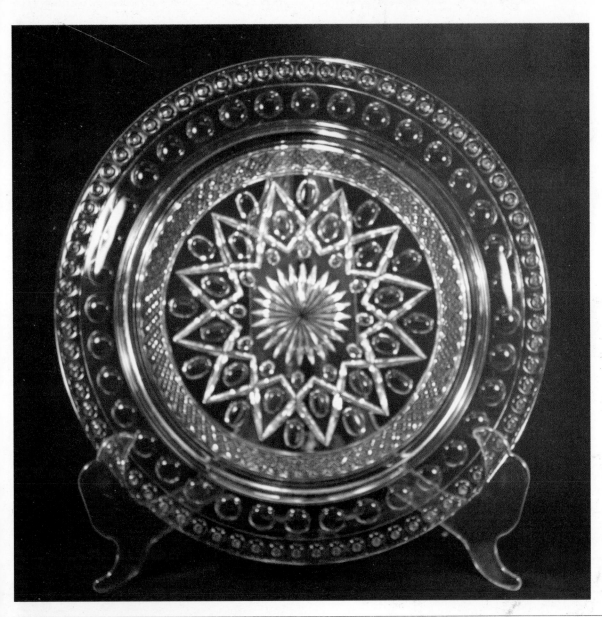

Imperial 13" #160/72 'Cape Cod' 72-light birthday plate. Crystal: $350-375 each. (1932-1984).

Indiana Glass Company

Dunkirk, Indiana, 1907 to present. Tableware and gift items.

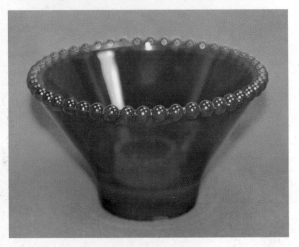

Right:
Indiana 3.75" single light candle holder. Crystal: $15-20 pair. (c. 1920s).

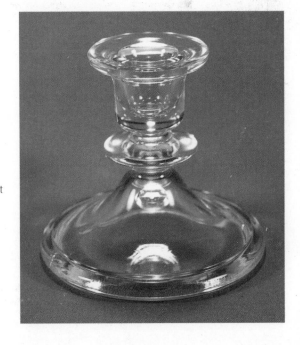

Indiana 2.375" single light votive. Ruby red: $8-12 pair.

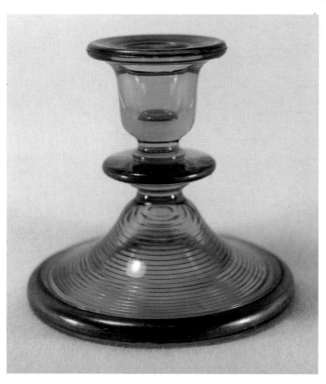

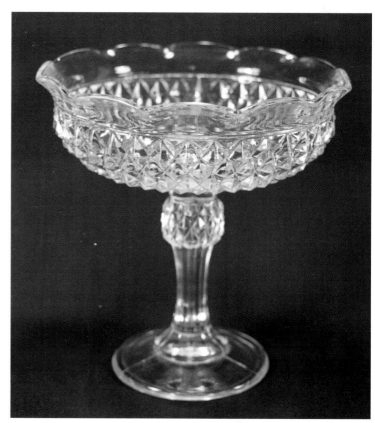

Indiana 3.75" 'English Threading' single light candle holder. Amber with silver deposit, pink, green: $40-45 pair; crystal: $35-40 pair. (1920s).

Indiana 7" 'Diamond Sawtooth' or 'Diamond Point' pedestaled single light candle bowl. Crystal: $20-25 each.

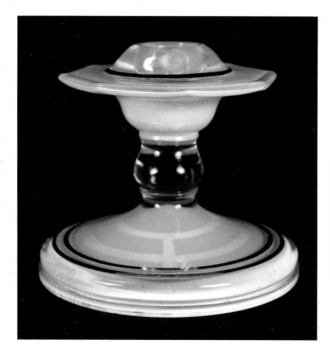

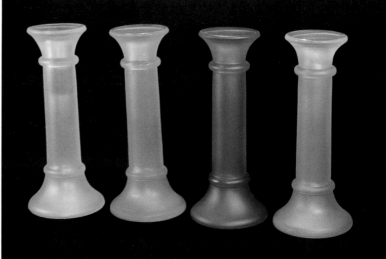

Indiana 7" single light candles/vases. Frosted colors: #12079 sun yellow, #12078 mango orange, #12076 aqua essence, #12077 coral splash, white: $8-12 pair. (1990s).

Indiana 3.75" #603 single light candle holder. Crystal with fired on white and yellow decoration and silver trim: $30-35 pair. (1920s).

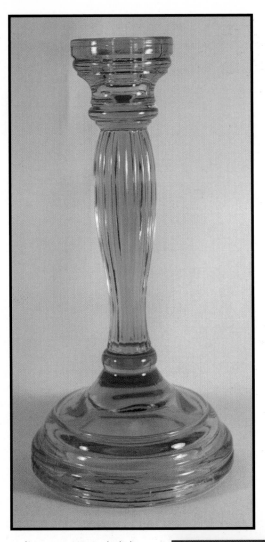

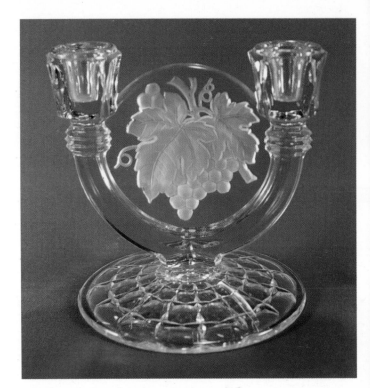

Indiana 5.25" grape panel double light candle holder. Crystal with intaglio etched panel and pressed colonial design on base: $55-60 pair. (1942). Better glass for department stores.

Indiana 8.375" single light ribbed candlestick. Blue, amber: $35-40 pair. (1920s). (Three-part mold).

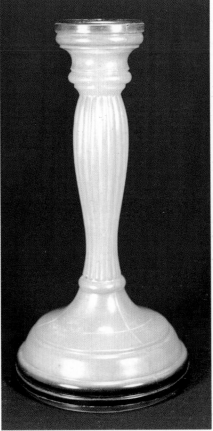

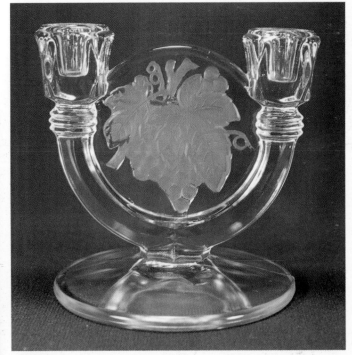

Indiana 5.25" grape panel double light candle holder. Crystal with intaglio etched panel and plain base: $45-50 pair. (1942).

Indiana 8.375" single light ribbed candlestick. Crystal with fired on colors: green, yellow, tan, orange, and blue, all with black trim: $25-30 pair. (1920s). Three-part mold. From #4 console set.

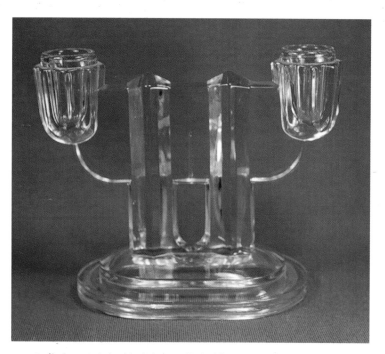

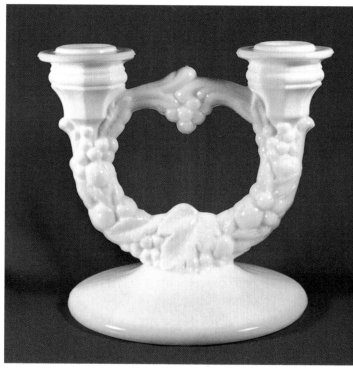

Indiana 5.25" double light candle holder. Crystal: $70-75 pair. (1942). Highly polished better glass for department stores.

Indiana 5.5" x 6.25" 'Garland' double light candle holder. White milk glass: $30-35 each. (1935-1950s).

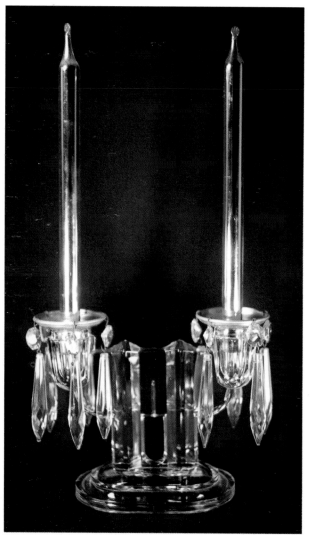

Indiana 5.5" x 6.25" 'Garland' double light candle holder. Crystal with amber stain, crystal with multicolored decoration: $35-40 each. (1935-1950s). The amber candle holders are part of a luncheon set with plates of the same treatment.

Indiana 5.25" double light candle holder with bobeches and prisms. Crystal: $100-110 pair. (1942).

Jeannette Glass Company

Jeannette, Pennsylvania, 1889-1983. Pressed ware.

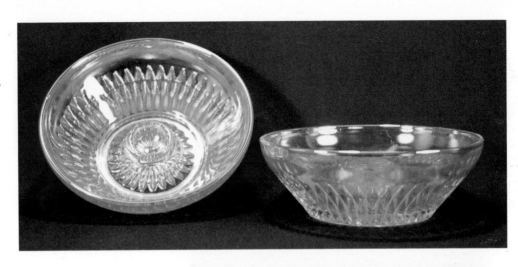

Jeannette 1.625" x 4.75" 'Anniversary' single light candle holder. Iridescent: $25-30 pair; crystal: $20-25 pair. (Late 1960s-early 1970s).

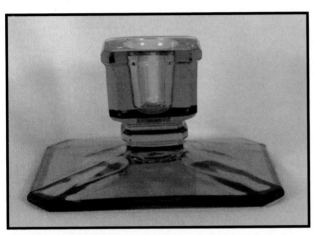

Jeannette 2.5" #127-137 single light rectangular candle holder. Green, amber: $40-45 pair. (1920s). Used in console sets.

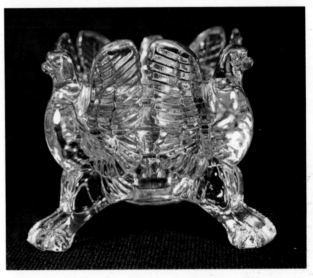

Jeannette 3.125" #3423 'Eagle' single light candle holder. Crystal with gold: $45-50 pair; shell pink: $85-90 pair.

Jeannette 2.5" x 4.875" #X-67 single light candle holder. Dark amber: $25-30 pair; green: $30-35 pair. (1926). Used in console sets.

Jeannette 3.25" 'Crackle' single light candle holder. Marigold iridescent: $40-45 pair. (1930s).

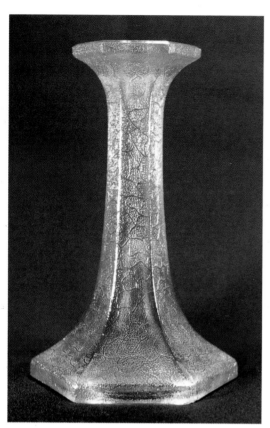

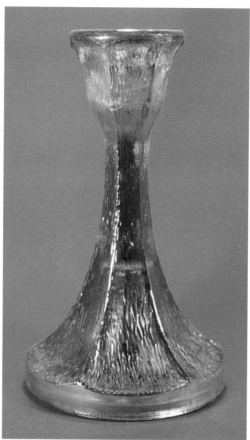

Far left:
Jeannette 7" #5132 'Crackle' single light candlestick. Marigold iridescent: $40-45 pair. (1930s).

Left:
Jeannette 6.5" #5201 'Tree Bark' single light candle holder. Marigold iridescent: $35-40 pair. (c. 1920s).

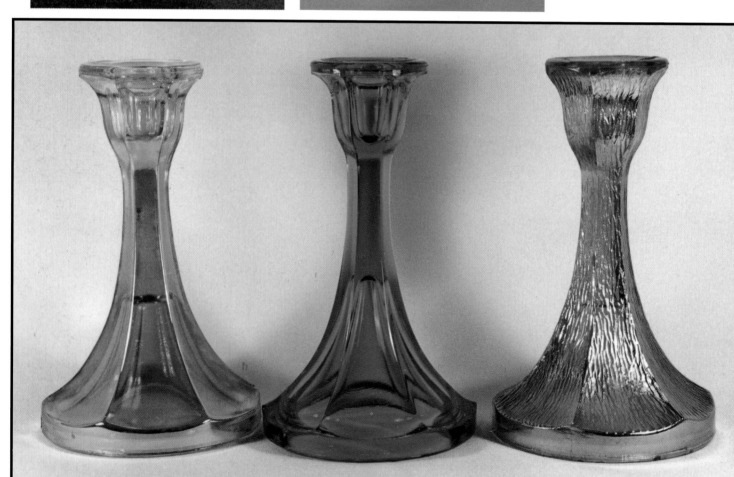

Jeannette 6.375" #5201 single light candle pillars. Marigold (both styles): $35-40 pair; blue: $30-35 pair.

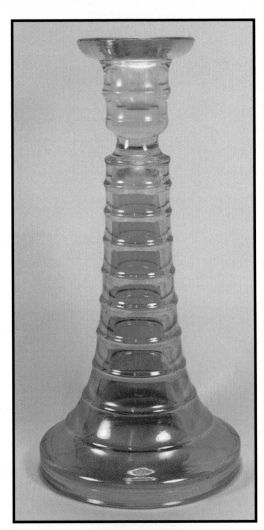

Jeannette 9" #5179 'Twelve Rings' single light candle-stick. Marigold iridescent: $45-50 pair. (1920s).

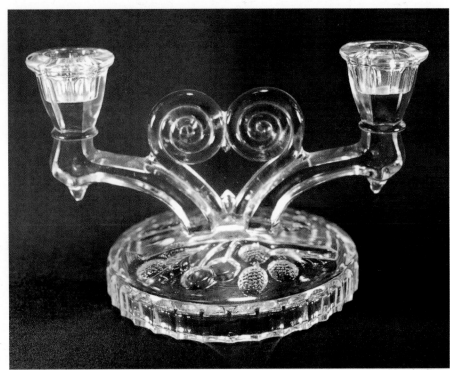

Jeannette 4.5" double light candle holder. Crystal with pressed cherries and berries design: $30-35 pair. (c. 1940-1950).

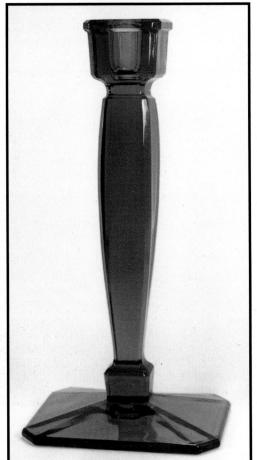

Jeannette 4.75" 'Cosmos' triple light candle holder. Crystal: $45-50 pair. (c. 1940-1950).

Jeannette 9.125" #127/99 single light candle holder. Dark amber: $40-45 pair; green: $45-50 pair. (1926). Used in console sets.

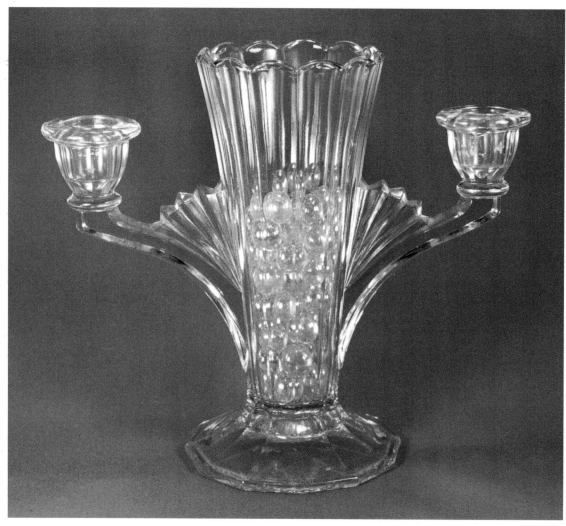

Jeannette 8" combination two light candle holder and vase. Crystal: $70-75 each. (c. 1935-1940).

John E. Kemple Glass Works

East Palestine, Ohio, 1945 to 1970. Milk glass, pressed glass, and novelties.

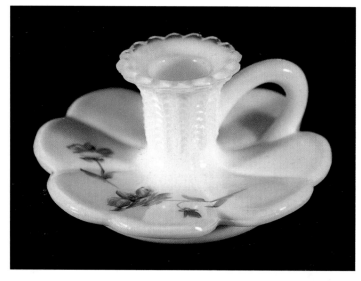

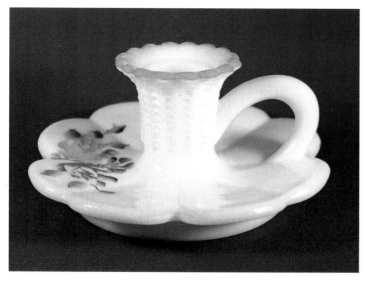

Kemple 2.125" x 4.75" 'Narcissus' single light candle holder with handle. White milk glass with hand painted blue and red floral decoration: $40-45 pair.

Kemple 2.125" x 4.75" 'Narcissus' single light candle holder with handle. White milk glass with hand painted orange and red floral decoration: $40-45 pair.

Kemple 2.5" 'Quintec' single light candle holder. Green, amberina, amber, blue: $35-40 pair; white milk glass: $30-35 pair. (1960s).

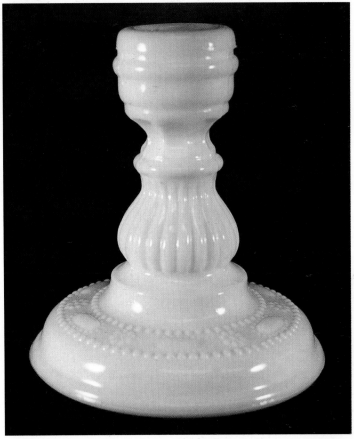

Kemple 4.25" #420 'Lace & Dewdrop' single light candle holder. White milk glass: $20-25 each; blue opaque: $25-30 each. Also made in 6" #431 white milk glass: $25-30 each.

Kemple/Wheaton 3.25" #70 'Toltec' single light candle holder. Blue, green, amber, amberina, gray: $40-45 pair; white milk glass: $35-40 pair.

Lenox, Inc.

Lenox 0.5" ball-edge candle dish. Blue: $4-6 each.

Lenox 0.5" ball-edge candle dish. Red frosted, red, blue: $4-6 each; white milk glass, crystal: $2-4 each.

Lenox 3.5" two-part base and votive. Red, blue: $10-12 each; white milk glass, crystal: $8-10 each.

L.E. Smith Glass Company

Mt. Pleasant, Pennsylvania, 1907 to present. Black glass.

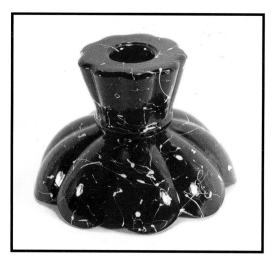

L.E. Smith 2.625" x 4" single light candle holder. Veined onyx: $10-15 each. Three part mold.

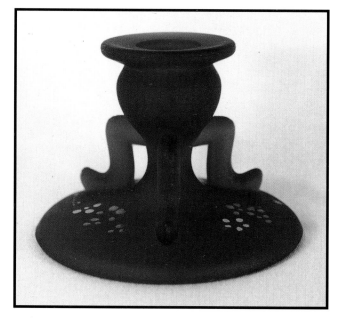

L.E. Smith 3" #1402 single light candle holder with candle insert: Blue satin or black amethyst with floral hand decoration: $30-35 pair; crystal: $20-25 pair. From an old **Greensburg** mold.

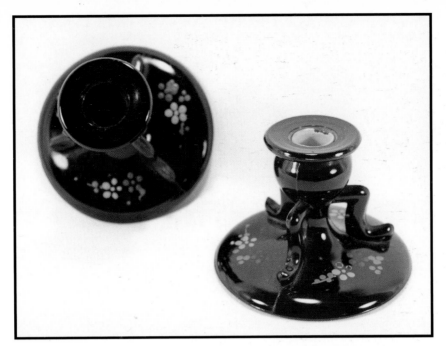

L.E. Smith 3" #1402 single light candle holder with candle insert. Black amethyst with floral hand decoration: $30-35 pair. From an old **Greensburg** mold.

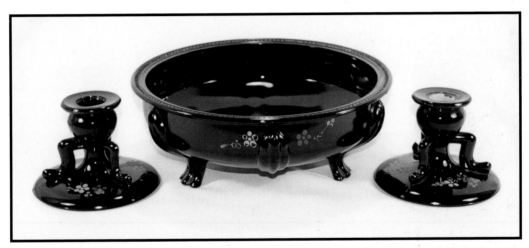

L.E. Smith console with 3" #1402 single light candle holders and bowl. Black amethyst with floral hand decoration: $65-70. From an old **Greensburg** mold. One candle holder has a candle insert.

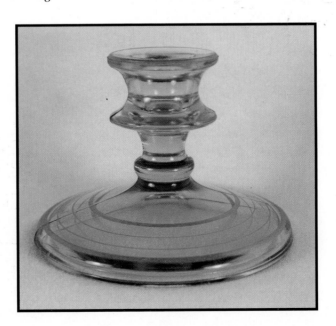

L.E. Smith 3.25" single light candle holder. Pink, green, amber: $25-30 pair.

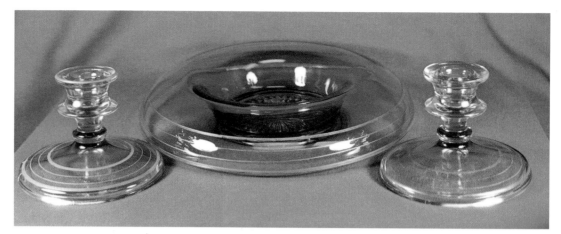

L.E. Smith console. Pink with gold trim: $55-60.

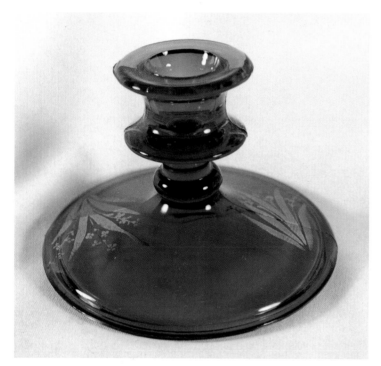

L.E.Smith 3.125" low single light candle holder. Cobalt with silver 'Lily of the Valley' deposit: $45-50 pair; amethyst, black: $40-45 pair.

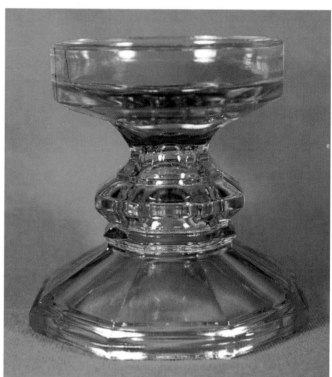

L.E. Smith 4" two-way single light candle holder/hurricane base. Pink: $12-16 each.

L.E.Smith 3.25" line #707 'Melba' or 'Pebbled Rim' low single light candle holder. Pink, green, amber, amethyst, black: $40-45 pair. (Early 1930s).

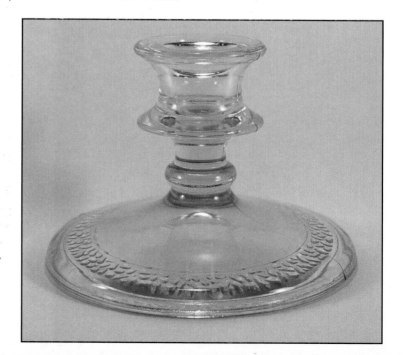

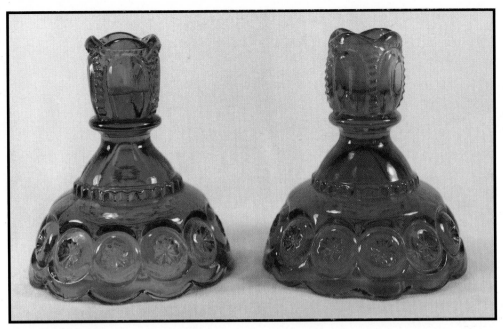

L.E. Smith 4.5" #5231 'Moon & Stars' single light candle holders. Colonial blue, red: $30-35 pair; cobalt, cobalt carnival: $35-40 pair; white milk glass, pink iridescent, crystal, green: $25-30 pair.

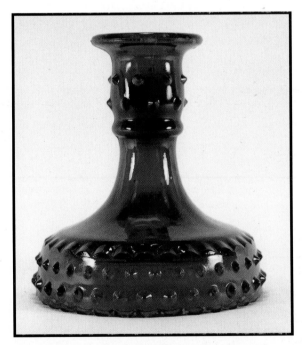

L.E. Smith 4.875" single light hobnail candlestick. Red, cobalt: $35-40 pair; green, pink, white milk glass: $30-35 pair. (1990s).

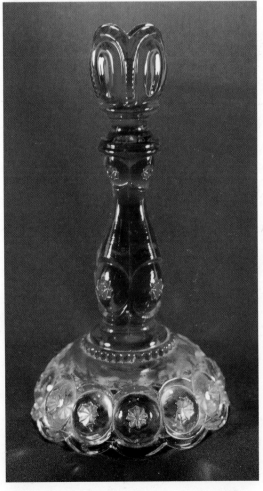

L.E. Smith 9.125" #5211 'Moon & Stars' single light candlestick. Amberina, amber, crystal, green, pink, pink iridescent, blue: $40-45 pair.

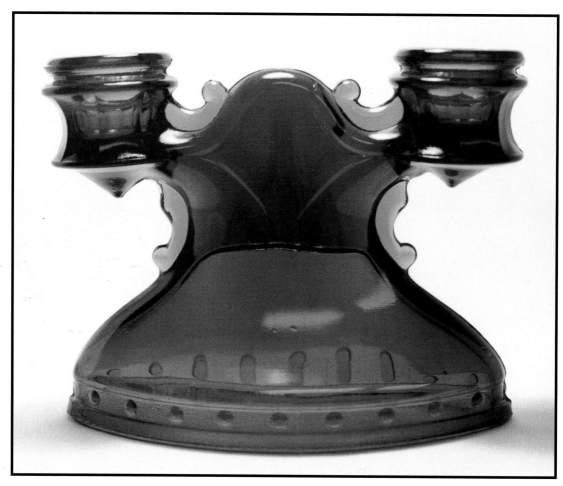

L.E. Smith 4.5" x 6" 'Mt. Pleasant' double candle holder. Amethyst, black amethyst, cobalt: $50-55 pair; green, pink: $35-40 pair; crystal: $30-35 pair.

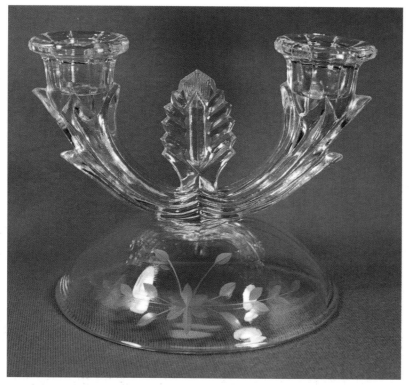

L.E. Smith 5" #982 double light candle holder. Crystal with cutting: $35-40 each. (1930s).

L.G. Wright Glass Company

New Martinsville, West Virginia, 1937 to 1999. Colonial and Victorian reproductions of lamps and glassware.

L.G. Wright (by **Fenton**) 2.5" #22-8 'Daisy & Button' single light candle holder. Vaseline opalescent: $50-55 each.

L.G. Wright 2.75" x 5.5" #6221 single light candle bowl. Amberina: $25-30 each.

L.G. Wright 4" x 7.75" #5202 'Moon & Star' single light candle bowl. Blue: $35-40 each.

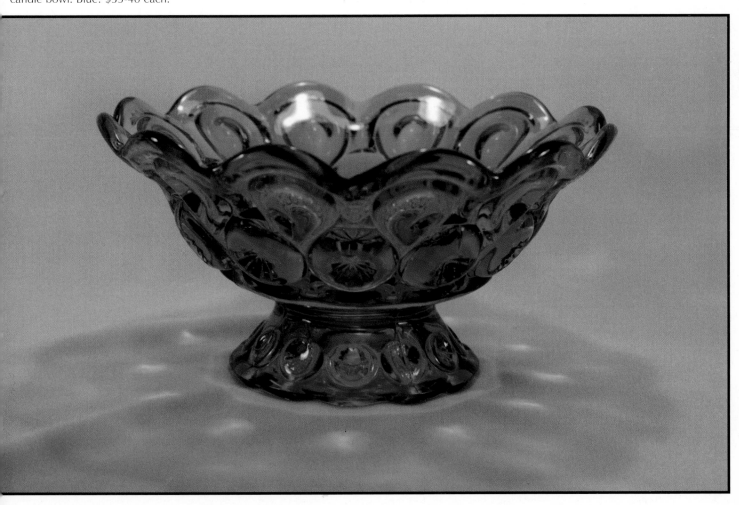

Macbeth-Evans Glass Company

Charleroi, Pennsylvania, 1899 to 1937. Merged with **Corning Glass**. Tableware.

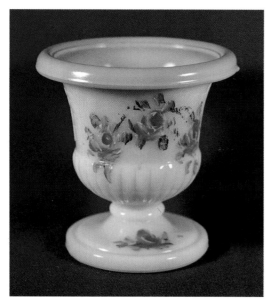

McBeth-Evans 3.125" 'Bianca' vase. This is now commonly used as a single light votive. White milk glass with fired on green interior & hand painted floral decor on exterior: $15-20 pair; white milk glass with fired on interior colors: green, blue, yellow: $12-16 pair.

McKee Glass Company

Jeannette, Pennsylvania, 1900 to 1951. Tableware, kitchen ware, and gift items.

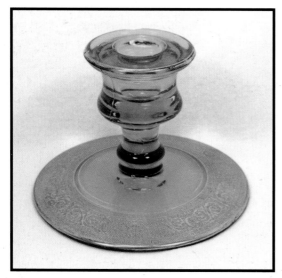

McKee 3.25" single light candle holder. Amber with gold: $25-30 pair.

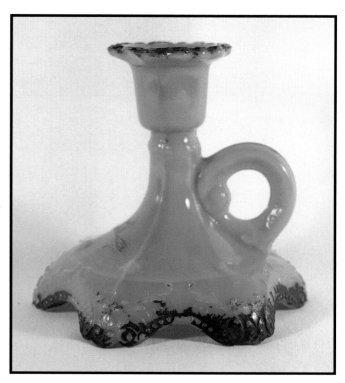

McKee 4" 'Cinderella' single light chamber stick with handle. Blue milk glass with gold decoration: $30-35 each.

McKee 8.375" single light candlestick. Crystal with cutting: $45-50 each. (1910-1931).

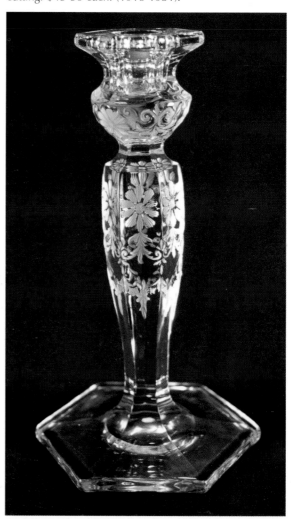

Morgantown Glass Works

Morgantown, West Virginia, late 1800s to 1903, became **Economy Tumbler Company**; 1929 to 1937, became **Morgantown Glass Works** again; 1939 to 1965, became **Morgantown Glassware Guild**; purchased by **Fostoria Glass Company** in 1965. Pressed ware, blown ware, and blanks for many other companies.

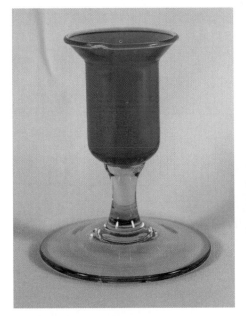

Morgantown 3" #80 'Modern' single light candle holder. Gypsy fire candle bowl with topaz stem and base: $40-45 pair.

Morgantown 3.5" x 4.5" #1303 single light hurricane base. Green, ebony: $30-35 pair; ruby: $35-40 pair. Paper label.

Morgantown 6.25" #80 'Modern' single light candle holder. Light lime, burgundy, peacock blue: $55-60 pair. (c. late 1960s-1980s).

Morgantown 4.25" #8 'Bravo' single light candle holder. Pineapple, thistle, peacock blue, moss green: $50-60 pair. (c. 1960s).

Morgantown 4.125" #7643 'Jacobi' single light candle holder. Cobalt candle bowl with crystal stem and base: $100-115 each; crystal: $90-95 each. (c. 1930s).

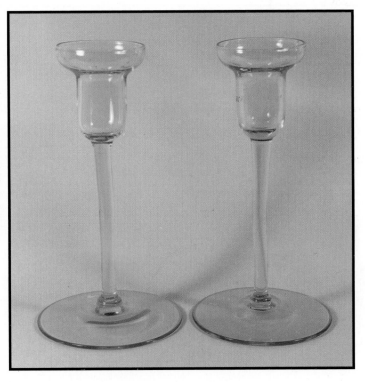

New Martinsville

New Martinsvillle, West Virginia, 1901 to 1944. Sold and reorganized as **Viking Glass Company**. Innovative table lines and gift items.

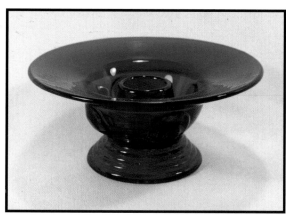

New Martinsville 2" x 7.75" #37 'Moon Drops' straight edge single light candle holder. Cobalt, ruby: $45-50 each; crystal: $30-35 each. (1932-1937).

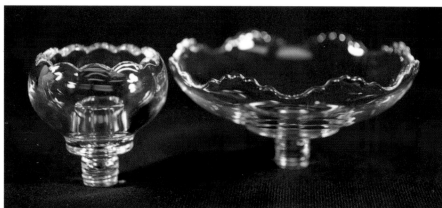

New Martinsville 2.25" x 3" central candle peg and 2" x 6" flower peg. Crystal candle peg: $20-25 each; crystal flower peg: $15-20 each. Central peg and flower peg are threaded.

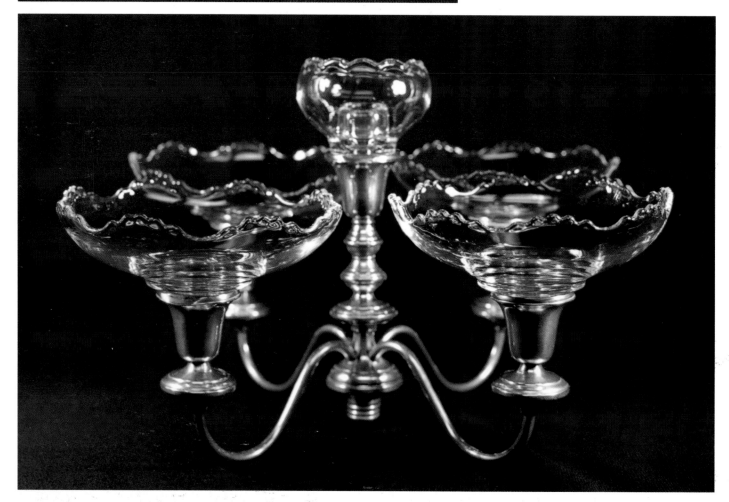

New Martinsville 2.25 x 3" central candle peg and four 2" x 6" flower pegs in a sterling silver base: $120-140.

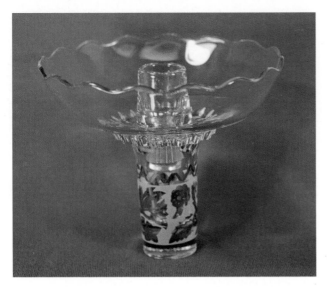

New Martinsville 2.5" x 5.75" scalloped edge candle peg. Crystal: $15-20 each.

New Martinsville 2.375" #33 'Modernistic' single light candle holder. Light blue satin, pink satin, green satin, pink, blue, green: $30-35 each. (1920s). Some were decorated.

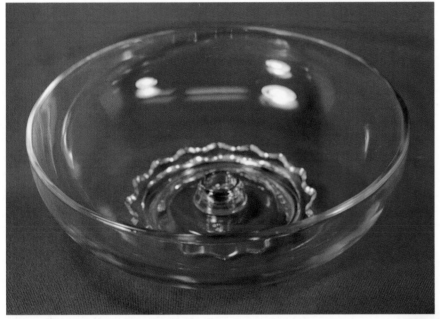

New Martinsville 2.5" x 8" single light candle bowl. Crystal: $20-25 each.

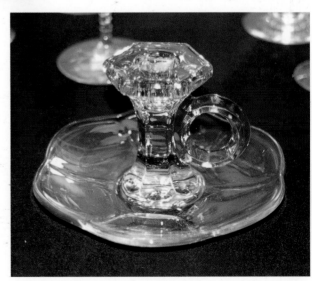

New Martinsville 3.25" x 6.25" #18 single light chamber stick. Crystal: $35-40 each; cobalt: $45-50 each. (1920s). Also used as a hurricane base.

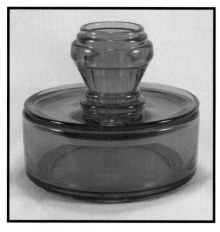

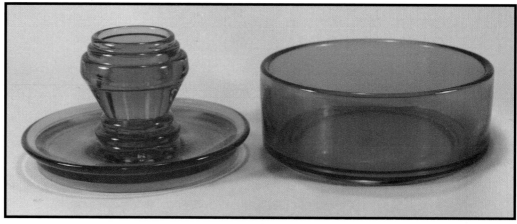

New Martinsville 4" #10-3 powder box with single light candle holder. Blue: $90-95 each.

New Martinsville 4" #10-3 powder box with single light candle holder. Blue, crystal, amber, green, amethyst: $90-95 each. (1920s). Some with hand painted decoration.

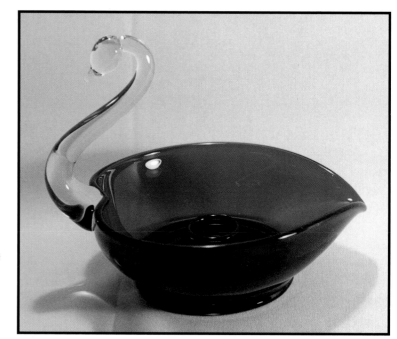

New Martinsville 4.5" x 6.25" #3974 'Swan' single light candle holder. Emerald green with crystal neck and head: $45-50 each; ruby with crystal: $60-65 each.

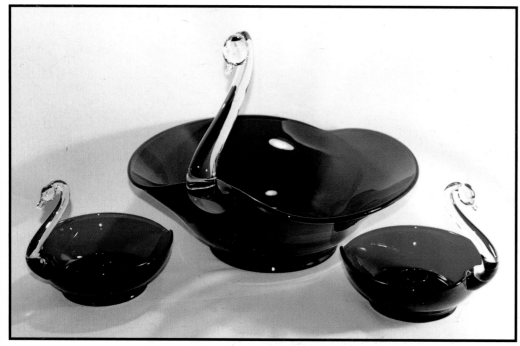

New Martinsville table center with 4.5" x 6.25" 'Swan' single light candle holders and 11" 'Swan' console bowl. Emerald with crystal: $140-150.

118

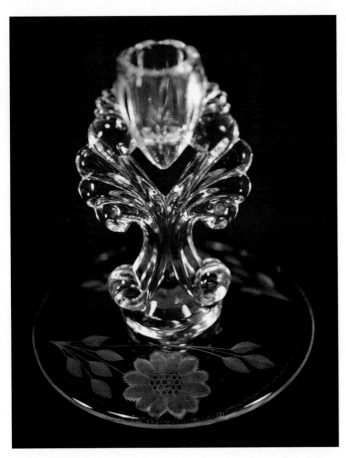

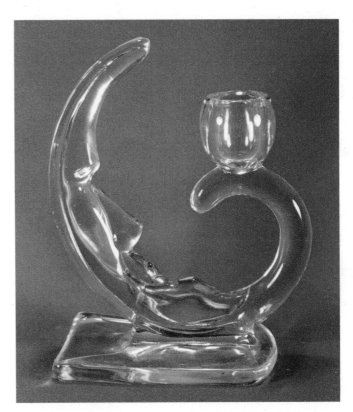

New Martinsville 5.125" #4554 'Janice' line # 4500 single light candle holder. Crystal with cutting: $35-40 each; emerald, light blue, amethyst: $50-55 each; cobalt, ruby: $55-60 each. (1926-1944). Used for several etchings. Reissued by **Viking** in the 1980s.

New Martinsville 6.75" 'Man-in-the-Moon' single light candle holder. Crystal: $250-275 pair.

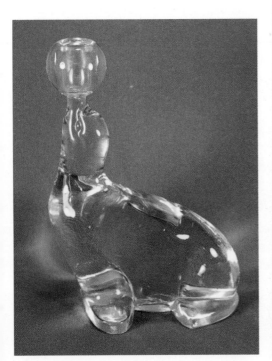

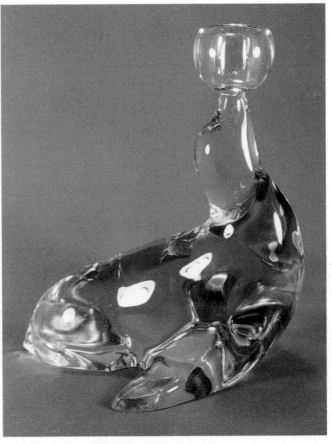

New Martinsville 4.5" #453 single light baby 'Seal' candlestick. Crystal only: $150-175 pair. (1938-1951).

New Martinsville 6.5" #452 single light large 'Seal' candlestick. Crystal only: $200-225 pair. (1938-1951).

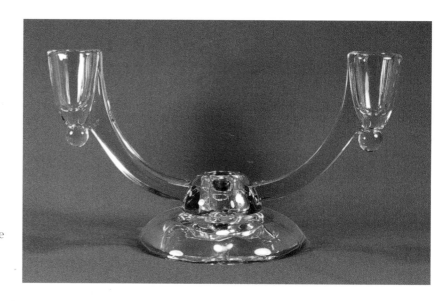

New Martinsville 5.125" #453 double light candle holder. Crystal: $20-25 each. (1938-1944).

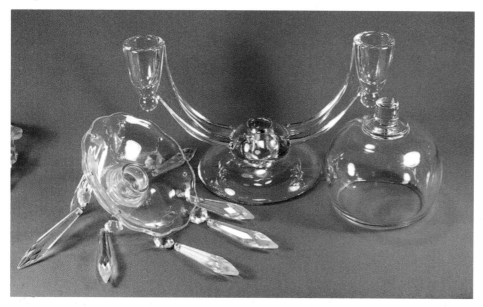

New Martinsville 5.125" #453 double light candle holder with ivy bowl and bobeches. Crystal: $90-95 each. (1938-1944).

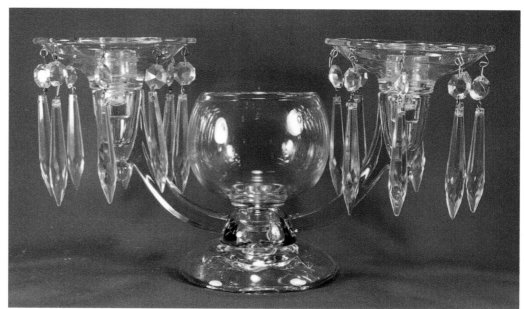

New Martinsville 5.125" #453 double light candelabrum with ivy bowl and bobeches. Crystal: $90-95 each. (1938-1944).

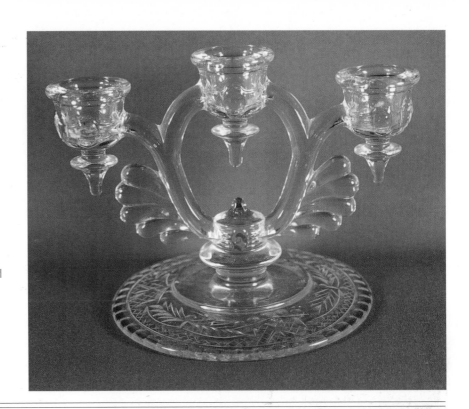

New Martinsville 4.875" x 7" #37-3 'Moondrops' triple light candle holder. Crystal with rock crystal cutting: $45-50 each. (1932-1940). Used for several etchings and rock crystal cuttings.

H. Northwood & Company

Wheeling, West Virginia, 1901 to 1925. Iridescent ware and lighting.

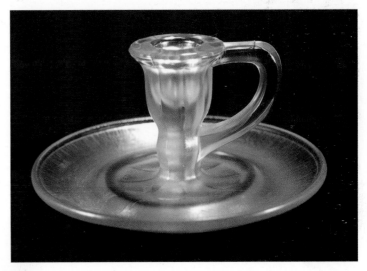

Northwood 3" x 5" #675 single light chamber stick. Topaz stretch glass, blue stretch glass: $90-95 each; Chinese coral, jade green, russet: $60-65 each; russet iridescent: $70-75 each. (c. 1920s).

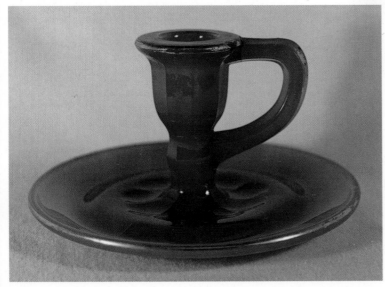

Northwood 3" x 5.5" #675 single light chamber stick. Jade with gold, Chinese coral: $60-65 each. (c. 1920s). Three-part mold.

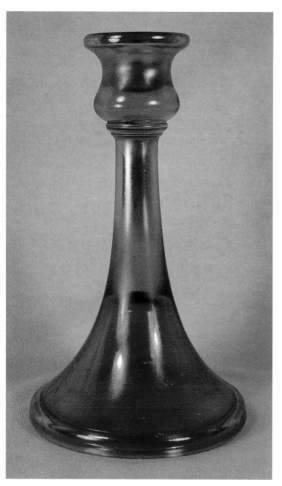

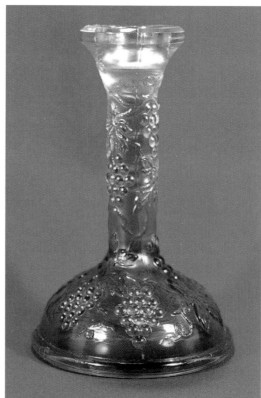

Northwood 5.5" 'Grape and Cable' single light candle holder. Crystal with marigold iridescence: $85-100 each. **Note**: the iridescence on this candle holder is too uneven to command the top price.

Northwood 6.5" #719 single light candlestick. Marigold iridescent: $80-85 pair; topaz iridescent: $85-90 pair; jade: $75-80 pair; black, blue iridescent, Chinese coral: $90-95 pair. (c. 1920s).

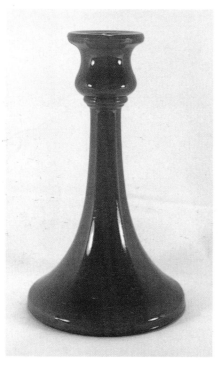

Northwood 6.5" #719 single light candlestick. Chinese coral: $90-95 pair.

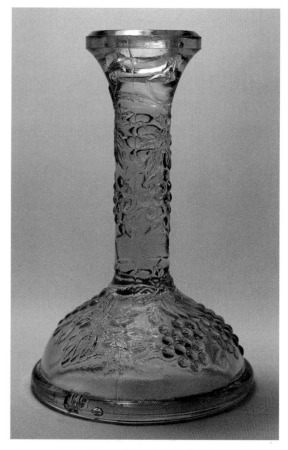

Unknown 5.5" 'Grape & Cable' single light candlestick. Light green: $15-20 pair. This is a **reproduction** by an unknown company and is shown here for comparison.

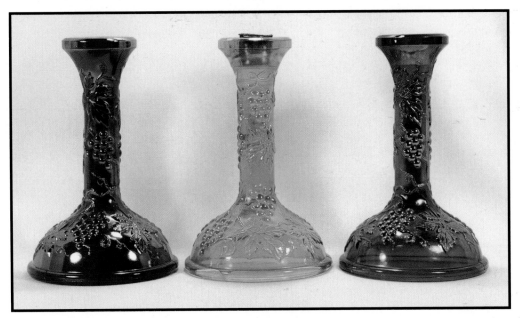

Northwood 5.5" 'Grape and Cable' single light candle holders. All are iridized. Amethyst: $190-225 each; marigold, green: $150-175 each.

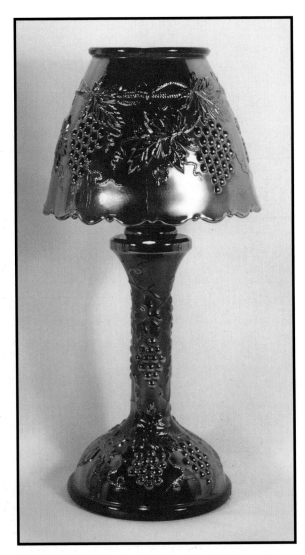

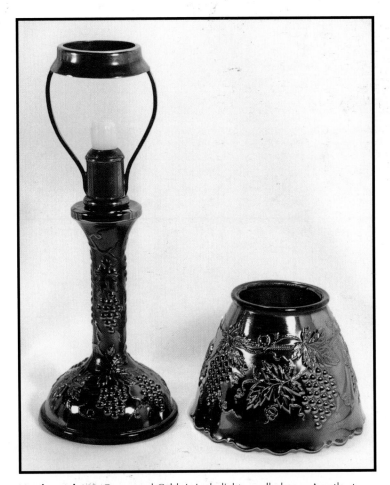

Northwood 10" 'Grape and Cable' single light candle lamp. Amethyst iridescent: $850-900 each. The shade and metal holder are the more difficult parts of the lamp to find.

Northwood 10" 'Grape and Cable' single light candle lamp. Amethyst iridescent: $850-900 each.

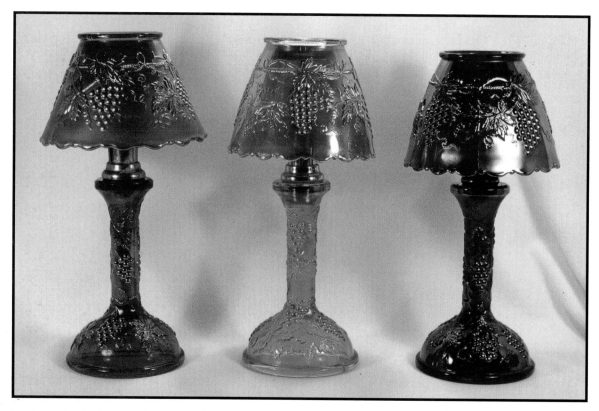

Northwood 10" 'Grape and Cable' single light candle lamps. Green iridescent, marigold iridescent, amethyst iridescent: $850-900 each. **Note**: Must be in mint condition with heavy and even iridescence to command this price.

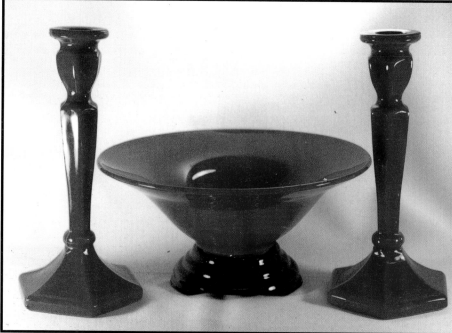

Northwood console with 8.5" #695 single light candlesticks and 9.5" #692 bowl on black base. Chinese coral: $250-275.

Northwood 8.5" #659 single light candlestick. Chinese coral: $60-65 each; jade green, jade blue: $45-50 each; rosita amber: $40-45 each; blue iridescent, topaz iridescent, russet iridescent: $75-80 each. Also made in #696 10.5".

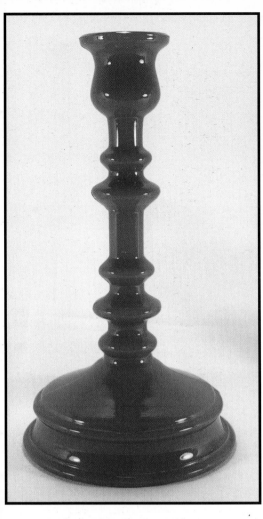

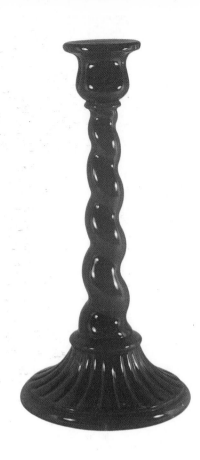

Left:
Northwood 8.75" #708 single light candlestick. Chinese coral: $130-140 pair; blue stretch: $120-130 pair; topaz stretch: $130-140 pair. (c. 1920s).

Right:
Northwood 10" #725 single light candlestick. Three-part mold. Green jade, blue iridescent: $60-65 each; rosita amber, black: $65-70 each; topaz: $80-85 each. (1919-1925).

Northwood console set with 8.75" #708 single light candlesticks and 3.25" x 9.625" #660 bowl on black stand. Chinese coral: $225-250.

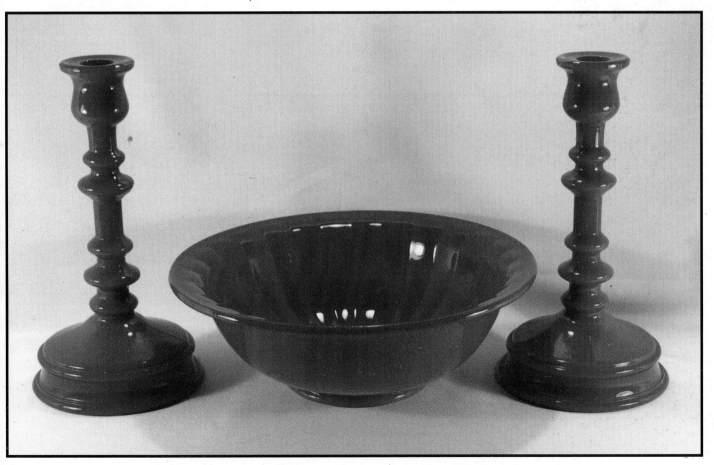

Paden City Glass Manufacturing Company

Paden City, West Virginia, 1916 to 1951. Pressed tableware and occasional ware.

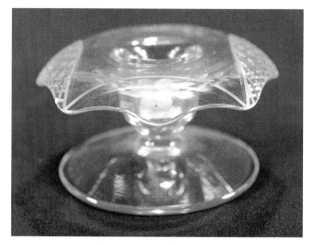

Paden City 2.25" #701 single light mushroom candle holder. Light green with cutting: $50-55 pair.

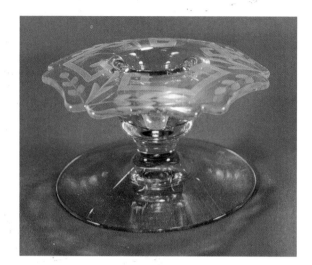

Paden City 2.25" #701 single light mushroom candle holder. Pink, crystal, and green (often with cuttings), satin colors: $50-55 pair; amber, crystal: $40-45 pair.

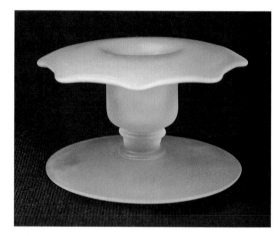

Paden City 2.375" x 4.25" #701 single light candle holder. Green satin, satin colors: $50-55 pair; amber: $40-45 pair.

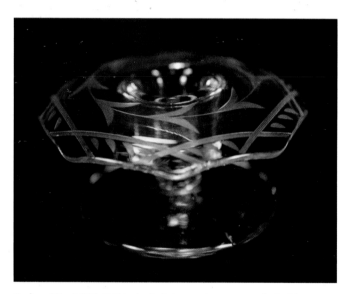

Paden City 2.25" #701 single light mushroom candle holder. Crystal with cutting: $40-45 pair.

Paden City console set with 2.375" x 4.25" #701 single light candle holders and bowl. Green satin: $100-110.

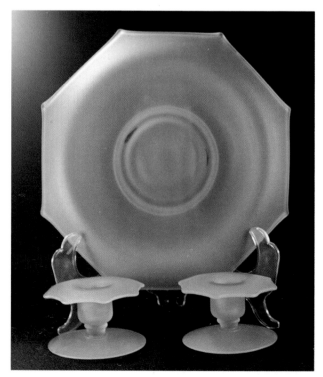

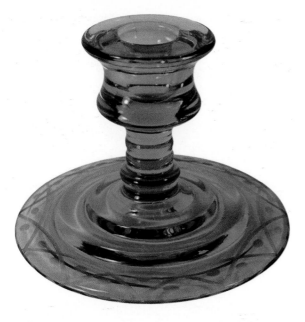

Paden City 3.5" line #192 'Party Line' or 'Penny Line' single light candle holder. Amber with cutting on base, green, pink: $30-35 pair; amber, crystal: $25-30 pair. (1928-1935).

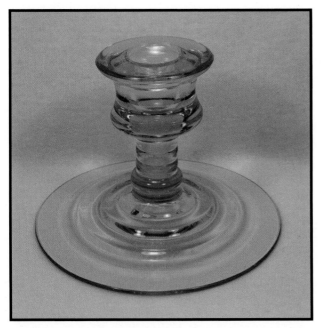

Paden City 3.5" line #192 'Party Line' or 'Penny Line' single light candle holder. Green, pink: $30-35 pair; crystal, amber: $25-30 pair. (1928-1935).

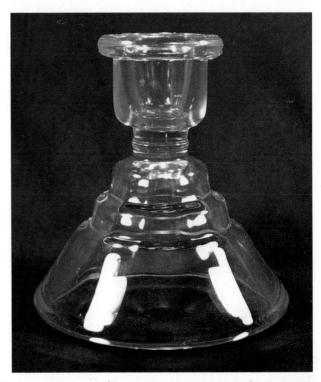

Paden City 4" #191 'Party Line' or 'Penny Line' three-ringed single light candle holder with domed base. Green, pink: $40-45 pair; amber, crystal: $30-35 pair. (1928-1935).

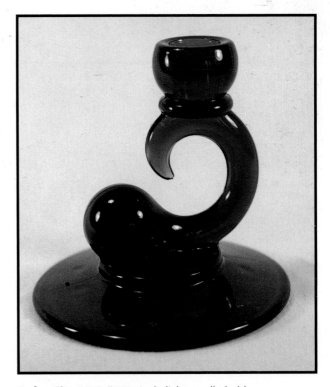

Paden City 4.75" #900 single light candle holder. Forest green: $70-75 pair; crystal with etching: $60-65 pair. (1940-1960).

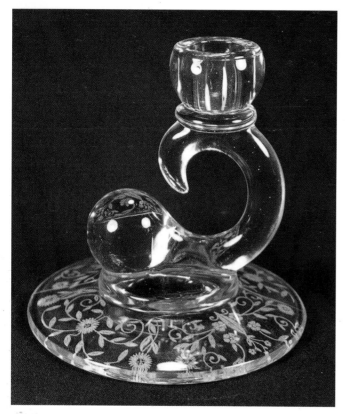

Paden City 4.75" #900 single light candle holder. Crystal with etching: $60-65 pair. (1940-1960).

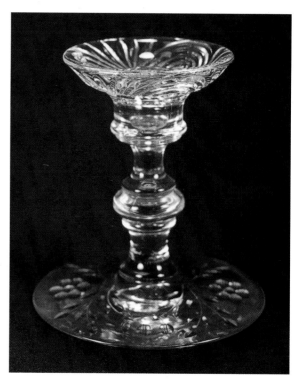

Paden City 4.875" #220 'Largo' single light candlestick. Crystal with cutting under base: $45-50 each. (1937-1950s).

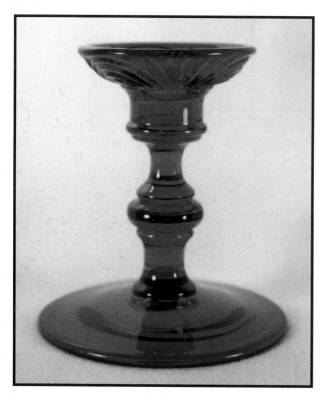

Paden City 4.875" #220 'Largo' single light candlestick. Red: $65-70 each; forest green, light blue: $55-60 each; crystal: $40-45 each. (1937-1950s).

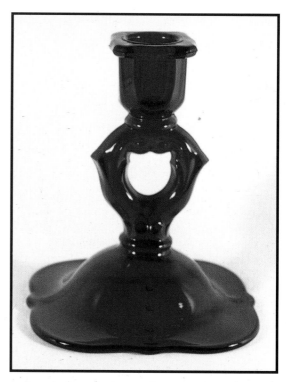

Paden City 5.25" #412 (square) 'Crows Foot' single light candle holder. Royal blue, ebony: $50-55 each; forest green, cherry glow, mulberry, yellow, primrose, opal: $40-45 each; ruby: $45-50 each.

128

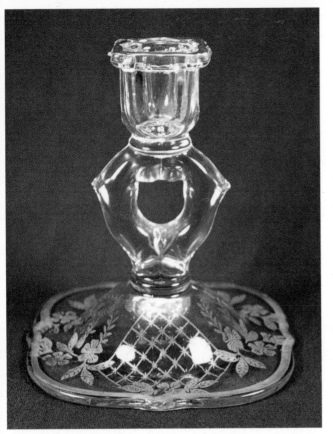

Paden City 5.25" #412 single light candle holder. Crystal with silver deposit: $40-45 each.

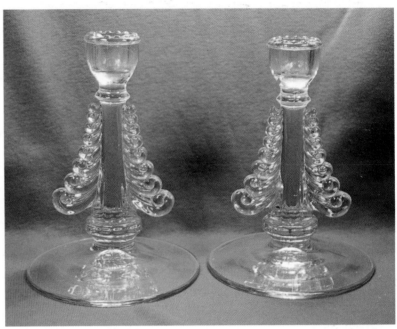

Paden City 6.375" #555 'Nerva' single light candle holders. Crystal: $20-25 each; ruby: $35-40 each. (1920s).

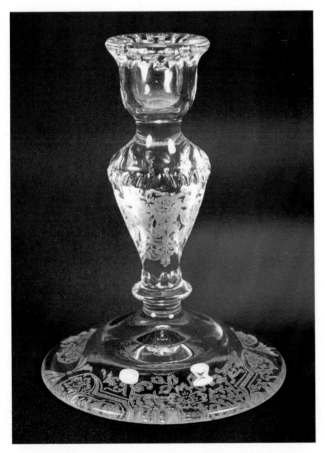

Paden City 5.25" #881 'Gadroon' single light oval candle holder. Crystal with etching under base and on body of candle holder: $60-65 pair; ruby: $90-95 pair. (c. 1930s).

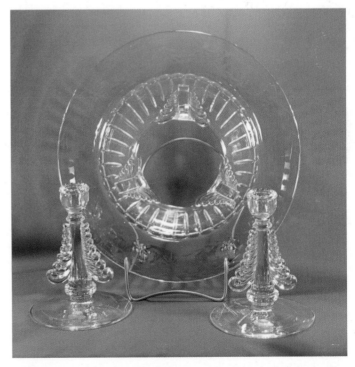

Paden City console set with #555 'Nerva' 6.375" single light candle holders and 9" bowl. Crystal with rock crystal cutting: $90-100.

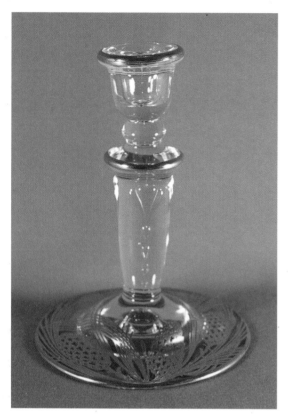

Paden City 6.5" #890 (round) 'Crows Foot' single light candle holder. Crystal with silver deposit on base and outer rings: $35-40 each.

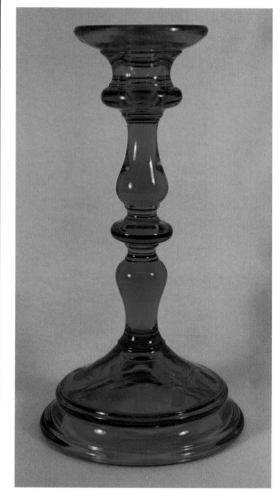

Paden City 8.375" #117 single light candlestick. Blue with cutting: $80-85 pair; amber: $65-70 pair; mulberry, green, blue, black: $75-80 pair. (1920s). Similar to U.S. Glass #76 candlestick.

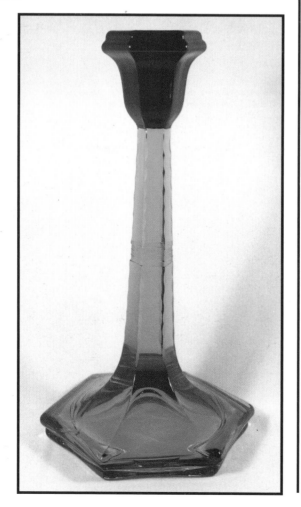

Paden City 7.125" #115 single light candle holder. Amber with cutting on column and black accent on candle bowl: $35-40 each. (1920s). Also in 9". Several companies had the 9" mold.

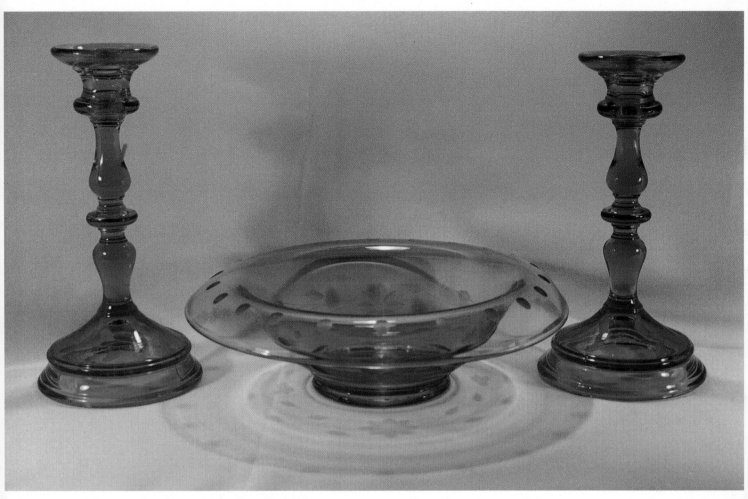

Paden City console set with 8.375" #117 single light candle-sticks and 10" rolled edge bowl. Blue with cutting: $120-130.

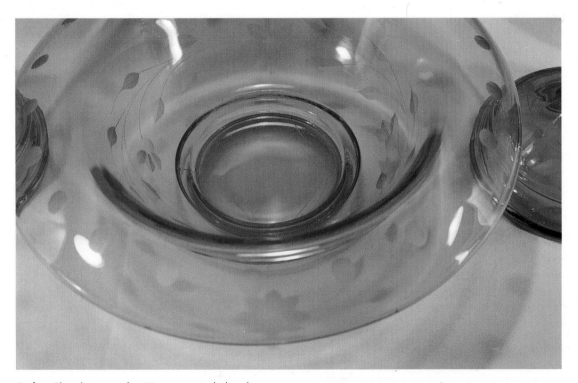

Paden City close up of cutting on console bowl.

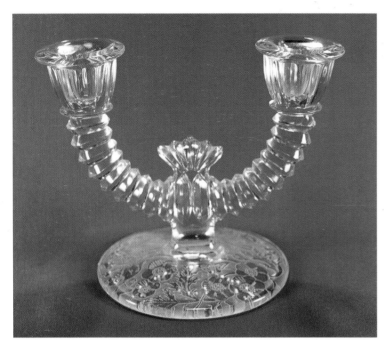

Paden City 4.875" double light candle holder. Crystal with brocade etching: $55-60 each.

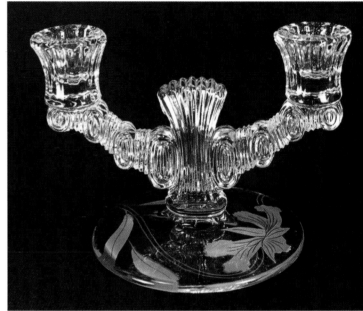

Paden City 5" 'Gadroon' double light candle holder. Crystal with morning glory color etching on base: $55-60 each.

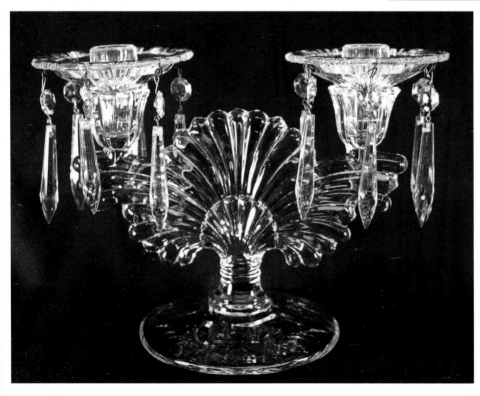

Paden City 5.75" x 8" (7" x 9.875" with bobeches) #221 'Maya' double light candelabra with rock crystal cutting on base. Crystal: $100-110.

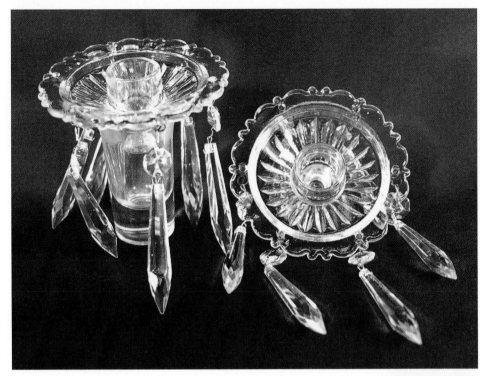

Paden City bobeches with 'A' prisms.
Crystal: $25-30 each.

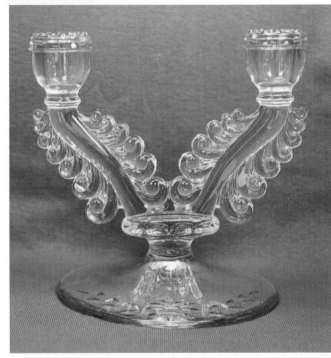

Paden City 6" #555 'Nerva' double light candle
holder. Crystal: $25-30 each; ruby: $55-60 each.

Paragon

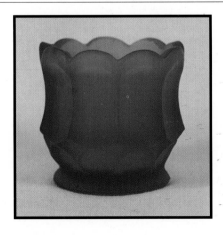

Paragon 2.5" single light votive.
Royal blue satin: $4-6 each.

Poland

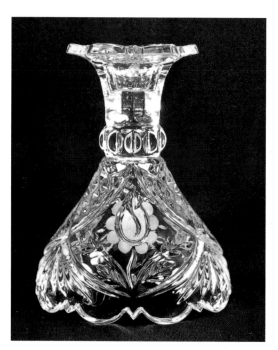

Poland 5.125" single light candlestick. Lead crystal with etching: $15-20 pair. (1990s).

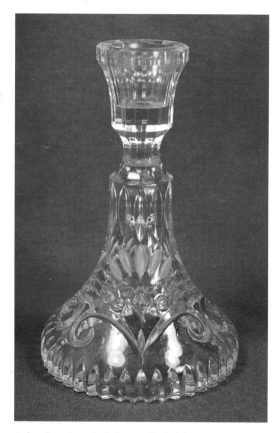

Poland 5.5" single light candle holder. Lead crystal with etching: $15-20 pair. (1990s).

Steuben Glass Works

Corning, New York, 1903 to 1918. Sold to **Corning Glass Works** in 1918 and continued production as the **Steuben Division**. Specialty art glass.

Steuben 11" single light candlestick. Iridescent gold: $1000-1200 each. (Signed Favrile).

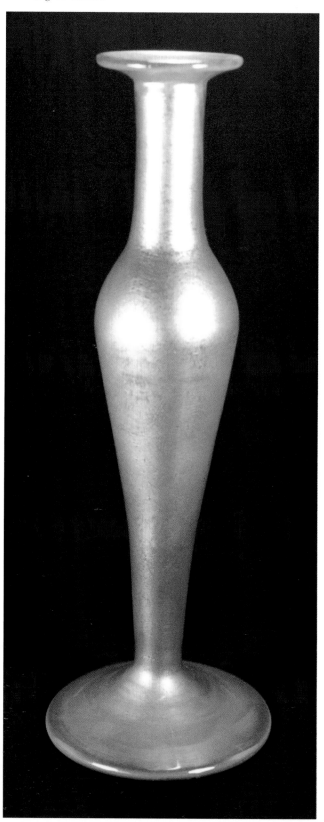

Summit Art Glass

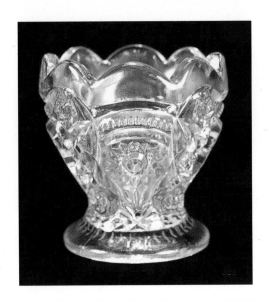

Summit Art Glass 2.625" single light votive. Crystal with white iridescence: $20-25 each. (1990s). Marked 'S' on bottom. From an old **Imperial** mold.

Sweden

Sweden 3.375" x 2" square single light candle pillar. Crystal: $15-20 pair. Paper 'Nybro' label.

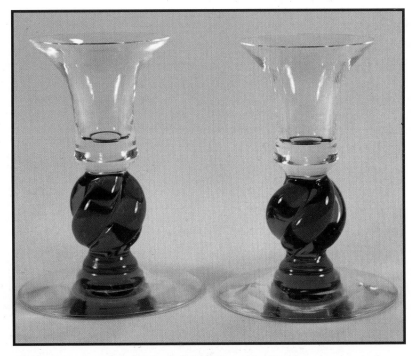

Sweden 4.875" single light candle holder. Crystal bowl with green stem and base: $45-50 pair. Paper 'Oriefors Sweden' label. Signed 'Tiffany and Company' on base.

Taiwan

Taiwan 3.75" mouse-on-clock votive. Frosted crystal: $5-7 each.

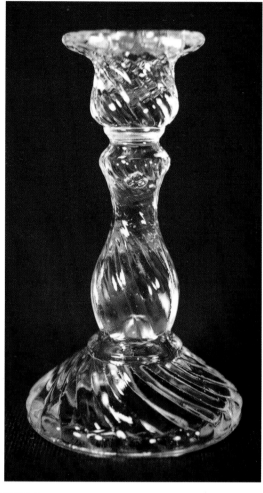

Taiwan 5.75" single light candlestick. Crystal: $5-7 each; pink, blue: $6-8 each. **Note**: This is a three-part mold. Also comes in 7.75".

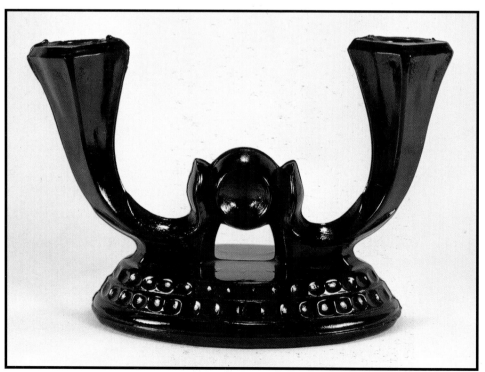

Taiwan 5" double light candle holder. Black, pink, crystal, white milk glass: $25-30 pair. Some are marked with a large diamond with an H in the center.

Thailand | Toscany

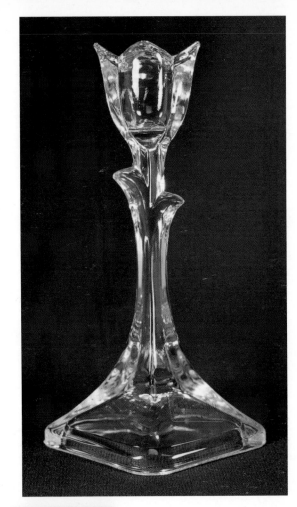

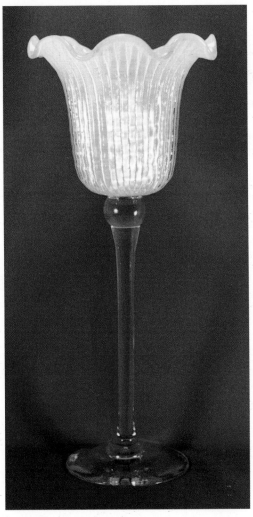

Toscany 7.75" single light candlestick. Lead crystal: $25-30 pair.

Thailand 11.75" single light votive. White and crystal cased glass: $25-30 each.

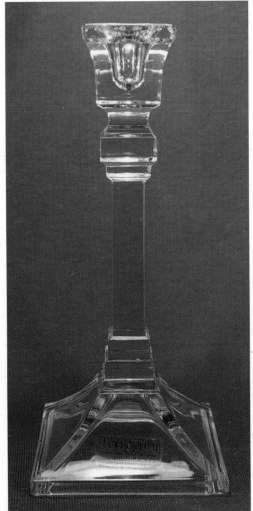

Toscany 7.75" single light candlestick. Lead crystal: $25-30 pair.

United States Glass Company/Tiffin

Pittsburgh, Pennsylvania, 1891 to 1938, moved main office to Tiffin, Ohio; 1951 to 1969, **Tiffin Glass** was the only remaining factory; 1980, final year of production. Dinnerware lines.

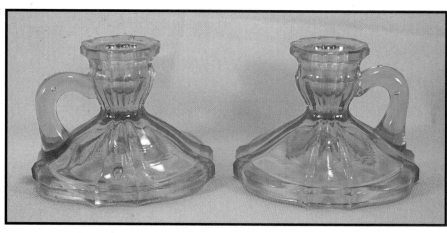

U.S. Glass 1.875" #17 child's chamber stick. Soft green, soft blue: $40-45 pair; crystal: $35-40 pair. (1926-1939).

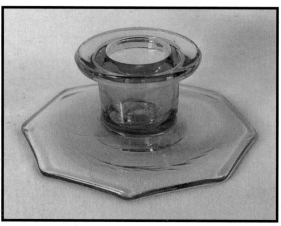

U.S. Glass 1.5" K-#94 single light low candle holder. Pink, blue, green, canary, amber, black, crystal (all in both transparent and satin): $25-30 pair. (1926-1939).

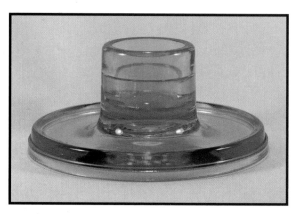

U.S.Glass 2.25" x 5" #14 single light low candle holder. This candle holder was made with two different size candle hole steps (0.875" & 1.125") inside. Blue, green, amber: $30-35 pair. (1926-1939).

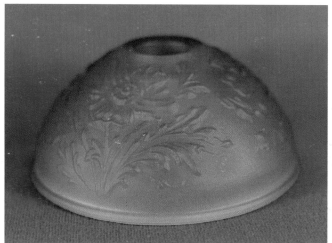

Tiffin 2" #97 'Poppy' single light domed candle holder. Pink satin glass, crystal, black, green, blue: $35-40 each.

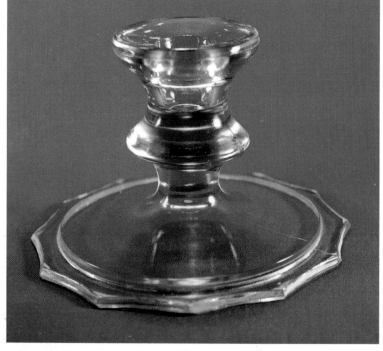

U.S. Glass 3" scalloped single light candle holder. Pink, green, blue: $25-30 pair; crystal: $20-25 pair.

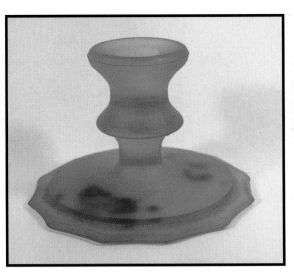

U.S. Glass 3.25" scalloped single light candle holder. Pink frosted with hand painted flowers under base, green, blue: $30-35 pair; pink, crystal: $25-30 pair.

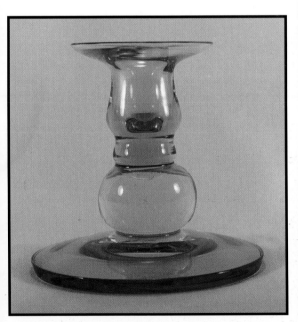

Tiffin 3.875" #17350 single light candle holder. Copen blue/crystal: $50-55 each; cobalt/crystal: $85-90 each; crystal: $35-40 each. (c. 1940s).

Tiffin 7.5" dolphin single light candle holder. Green and pink transparent or satin: $190-200 pair; crystal, crystal satin: $140-150 pair. (c. 1920s). Also made in 4.5": $90-95 pair.

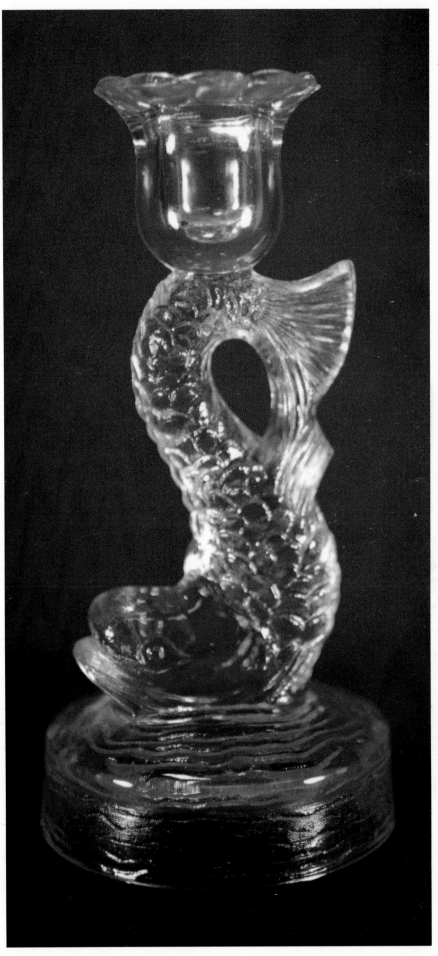

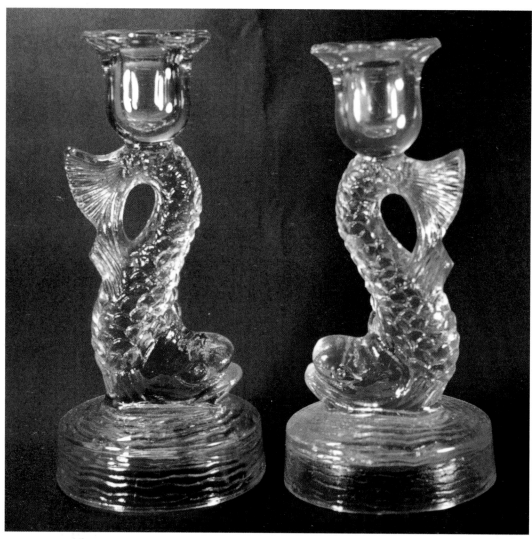

Tiffin 7.5" single light dolphin candlesticks. Pink, green: $190-200 pair.

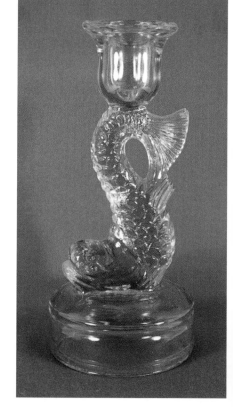

Tiffin 7.5" dolphin with plain base. Pink, green: $190-200 pair. Also made in 4.5". The plain base was frequently used in lamps.

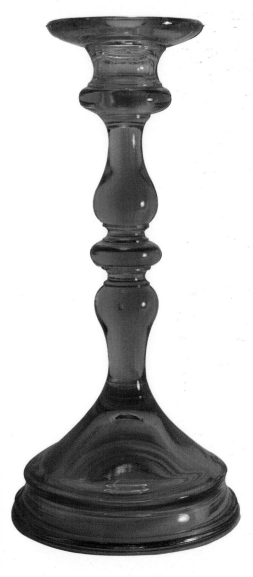

U.S. Glass/Tiffin 9" #76 single light candle holder. Skyblue, black: $115-125 pair; sapphire blue, green, crystal: $70-75 pair; amethyst: $75-80 pair; royal blue: $175-200 pair.

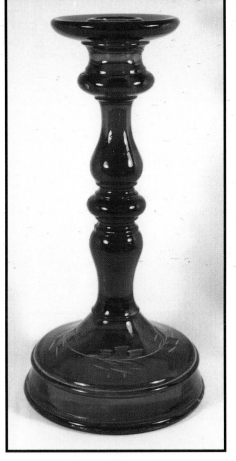

U.S. Glass 8.5" single light candle holder. Sapphire blue (teal) with cutting on base: $75-80 pair.

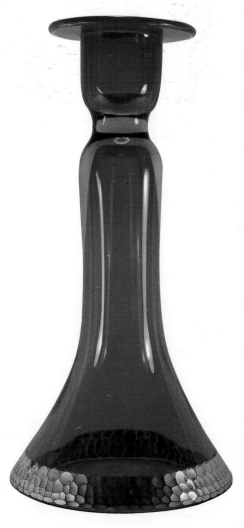

Tiffin 8.5" #151 single light candle holder. Amberina with hammered gold decoration: $190-200 pair; black, black satin: $165-175 pair; crystal, crystal satin: $120-130 pair. (c. 1924-1934). Usually decorated.

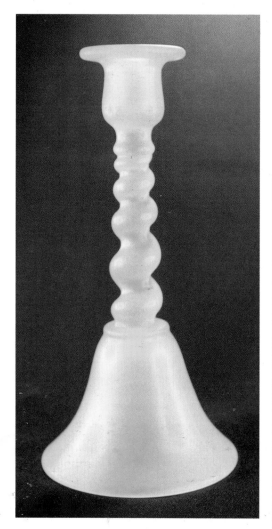

U.S. Glass 9.75" #179 bell base single light candlestick. Canary, crystal stretch: $125-135 pair; amberina satin: $100-115 pair; sky blue satin: $90-100 pair; canary stretch: $150-160 pair. (c. 1920s-1930s).

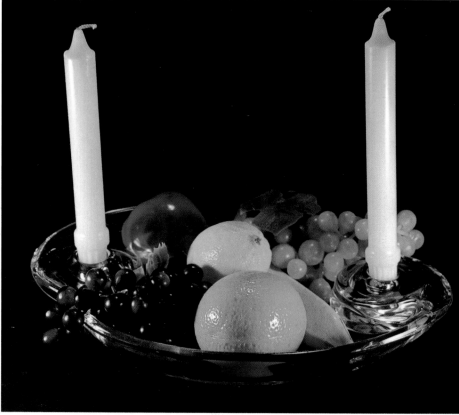

Tiffin 2.125" x 13" #6485 double light flower floater. Crystal: $45-50 each. (c. 1970s).

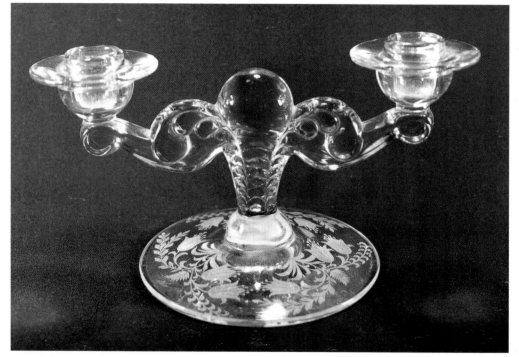

Tiffin 5" double light candelabra. Crystal with 'Fuschia' etching: $100-125 pair; crystal: $95-100 pair. (Late 1930s-early 1940s).

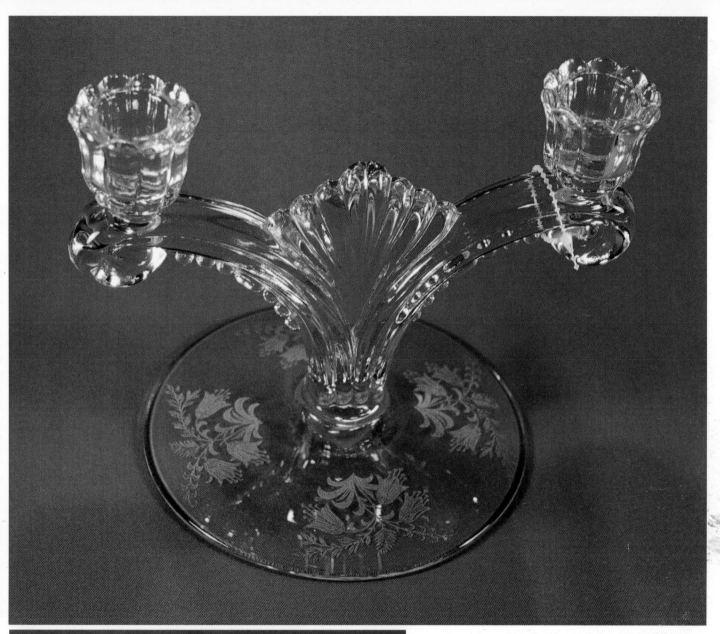

Tiffin 5.625" x 7.50" #5902 double light candle holder. Crystal with 'Fushia' etching: $95-100 pair. (1920s-1940s).

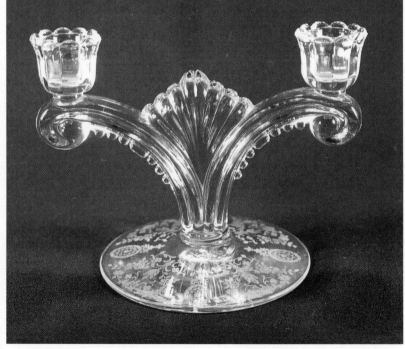

Tiffin 5.625" #5902 double light candelabra. Crystal (only) with 'June Night' etching: $95-100 pair. (1920s-1940s).

Viking Glass Company

New Martinsville, West Virginia, 1944 to 1986; 1987 to 1998, operated as **Dalzell-Viking Glass Company**. Popular modern glass.

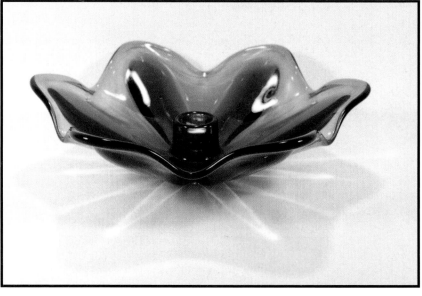

Viking 2.375" x 8.125" #119 'Epic' single light candle bowl. Amethyst: $15-20 each.

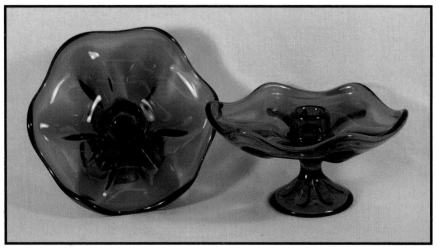

Viking 3" x 5.75" 'Epic' single light candle holder. Teal: $20-25 pair.

Dalzell/Viking 3.5" 'Bullseye' square votive candle holder. Green mist, cranberry mist, yellow mist, amber, cobalt, crystal, ice blue, plum: $35-40 each.

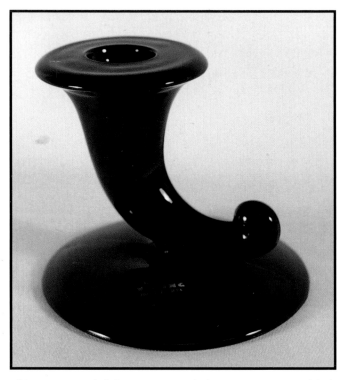

Viking 3.625" single light cornucopia. Black: $25-30 pair. Paper label.

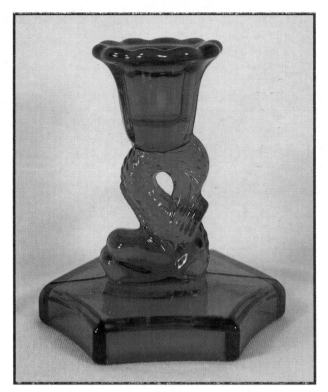

Viking/Dalzell 4.125" 'Dolphin' single light candle holder. Ruby, cranberry mist, cranberry crystal: $30-35 pair. From and old **Westmoreland** mold.

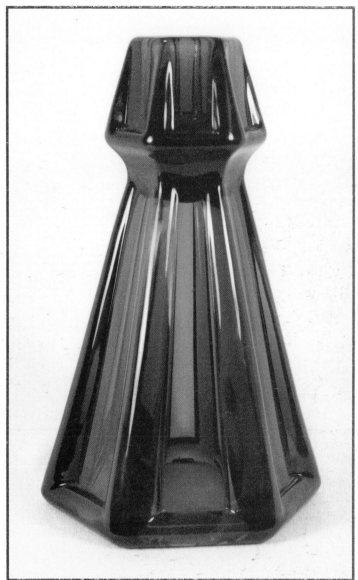

Viking 6" single light candle holder. Dark amber: $25-30 pair. Paper label.

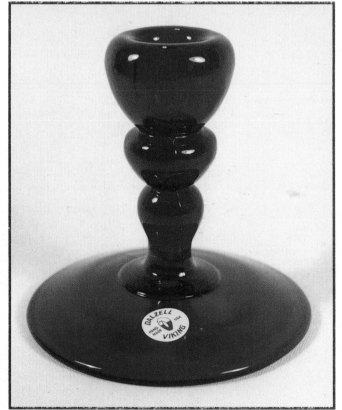

Viking 5" #970 single light candle holder. Cobalt, ruby: $30-35 pair; cranberry mist: $25-30 pair; crystal: $20-25 pair.

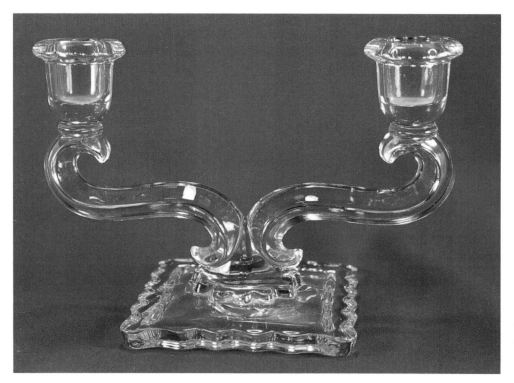

Viking 5" double light candle holder. Crystal: $40-45 pair.

Westmoreland Specialty Company

Grapeville, Pennsylvania, 1889 to 1984. Milk glass and giftware.

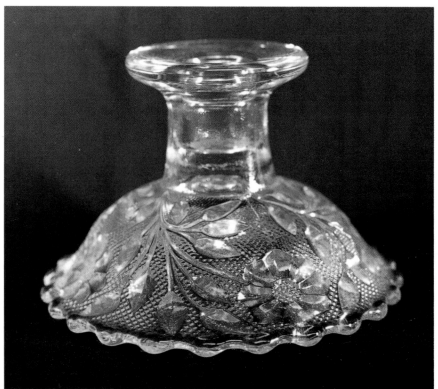

Westmoreland 3" x 4.25" line #999 'Wildflower & Lace' single light candle holder. Crystal with pressed pattern: $25-30 pair; pastel blue: $30-35 pair.

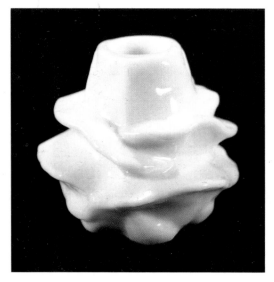

Westmoreland 2.75" #1967/9 'Rose' or 'Rose Lattice' single light candle holder. Milk glass: $40-45 pair; golden sunset: $35-40 pair; milk glass with decoration #33: $80-85 pair. Reproduced in pink frost.

146

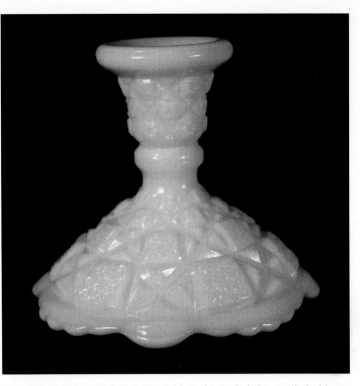

Westmoreland 3.75" line #500 'Old Quilt' single light candle holder. White milk glass only: $25-30 pair.

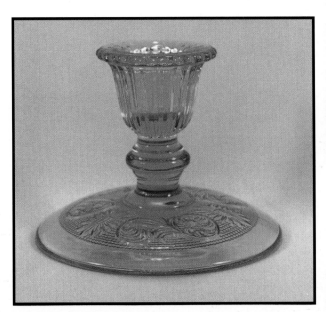

Westmoreland 3" #7 line #201 'Lace Design' or 'Princess Feather' single light candle holder with pattern on base. Golden Sunset (1960s): $30-35 pair; crystal: $25-30 pair.

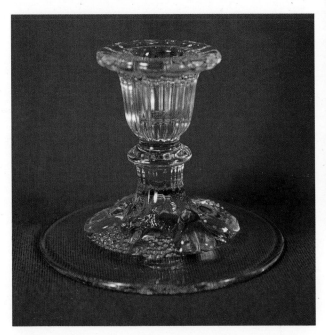

Westmoreland 3.25" line #1058 'Della Robia' single light candle holder. Crystal, crystal with fired on colors: $35-40 each.

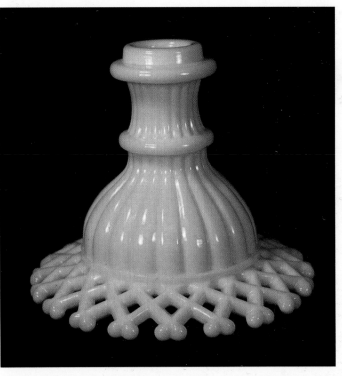

Westmoreland 4" line #1890 'Lattice Edge' single light candle holder. White milk glass only: $35-40 pair.

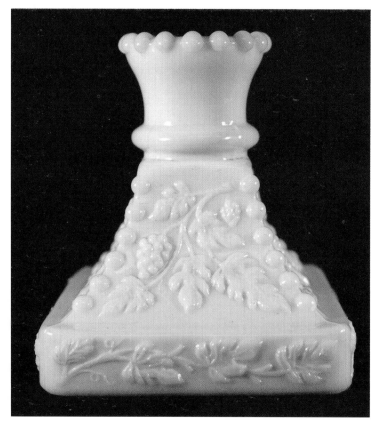

Westmoreland 4.125" x 3.75" 'Beaded Grape' single light candle holder. White milk glass: $30-35 pair; white milk glass with #85 'Pastel Fruit': $45-50 pair; white milk glass with #86 'Green and Gold': $35-40 pair; golden sunset: $35-40 pair; almond: $40-45 pair.

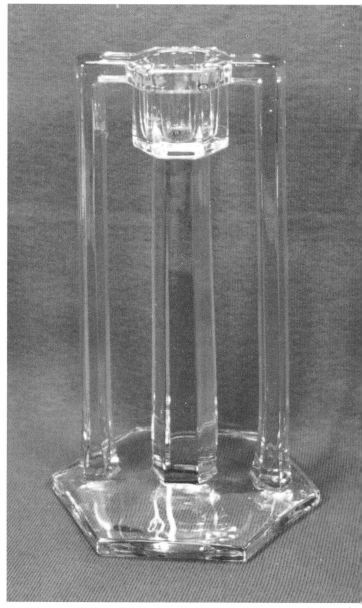

Westmoreland 6.25" #1015 'Mission' single light candle holder. Crystal only: $70-75 pair; crystal with cutting: $110-120 pair.

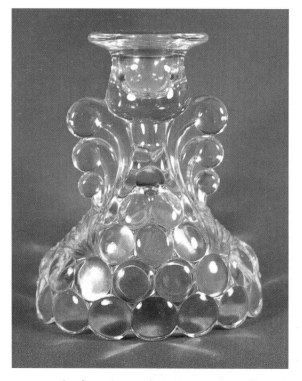

Westmoreland 5" 'Thousand Eye' single light candle holder. Crystal: $75-80 pair. Can also be found with color stains.

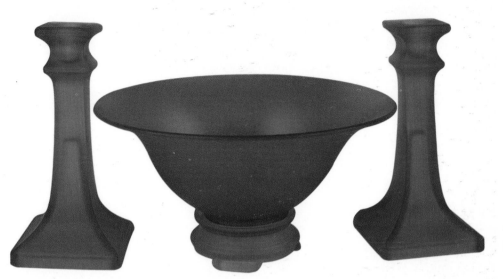

Westmoreland four-piece console set with 7" #1023 single light candlesticks and 9" bowl on base: $110-125.

Westmoreland 7" #1023 single light candlestick. Blue satin glass: $55-60 pair; crystal: $25-30 pair.

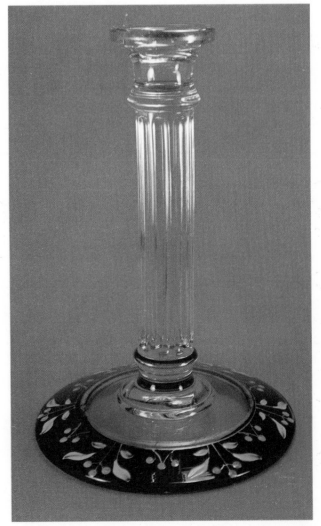

Westmoreland 8" #1002 single light candlestick. Crystal with gold and black enamel: $55-60 pair (1932); orange and black case glass: $60-65 pair.

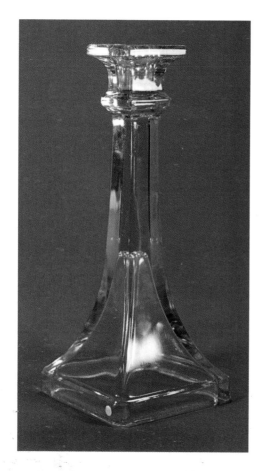

Westmoreland 9.125" single light candle pillar. Crystal only: $25-30 pair (1932); crystal with cutting: $50-55 pair.

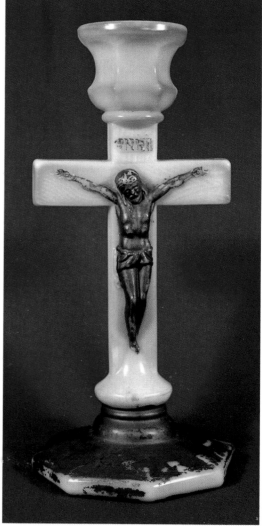

Westmoreland 6.5" #54 'Crucifix' single light candlestick. White milk glass with gold: $65-70 each. **Note:** The gold on this crucifix is not in mint condition. Some candlesticks have a gray-green tint to the milk glass.

A Few Unknowns

Candle holders in this chapter are numbered for easy reference. If you can provide documentation on any of them, we would really appreciate your help. Please write to the authors c/o Schiffer Publishing Ltd.

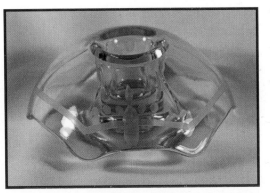

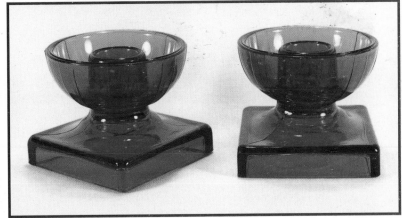

3. **Unknown** 1.875" x 4.375" mushroom single light candle holder. Pink with cutting.

1. **Unknown** 1.5" x 3.375" single light candle holder. Light green satin glass.

4. **Unknown** 2.375" x 2.875" single light candle holder. Blue.

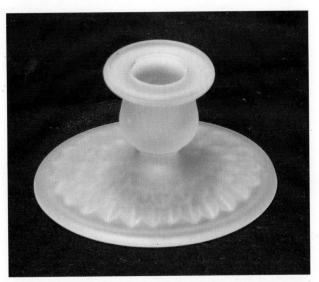

2. **Unknown** 2.5" single light candle holder. Pink frosted.

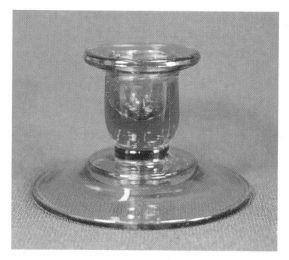

5. **Unknown** 2.25" single light candle holder. Amber.

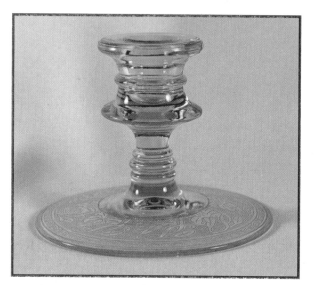

6. **Unknown** 3.5" low single light candle holder. Pink or orchid with lily etching & gold edges.

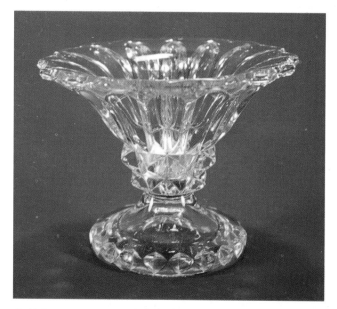

7. **Unknown** 3.875" single light footed candle vase. Crystal.

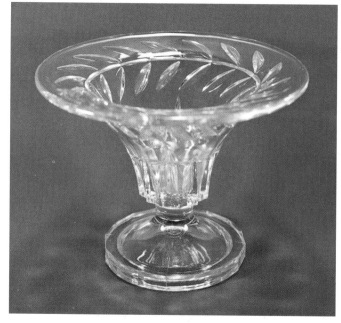

8. **Unknown** 3.875" single light candle vase. Crystal.

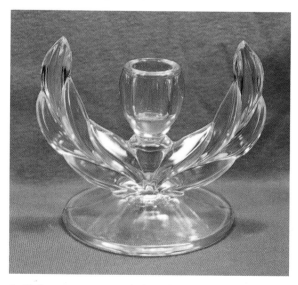

9. **Unknown** 4.375" single light candle holder. Crystal.

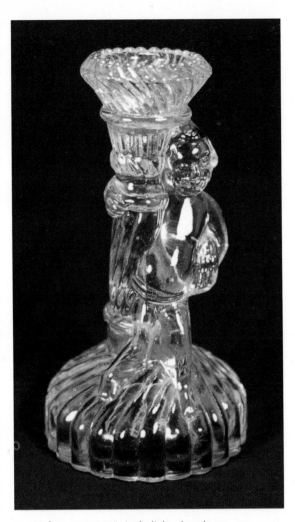

10. **Unknown** 5.125" single light cherub
candle holder. Pale marigold.

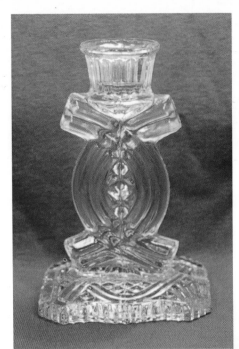

12. **Unknown** 5.75"
single light candle
holder. Crystal.

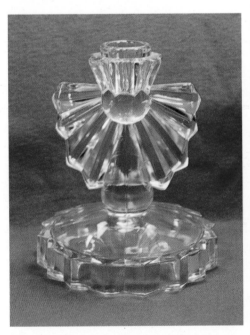

11. **Unknown** 5.5" single light candle holder.
Crystal.

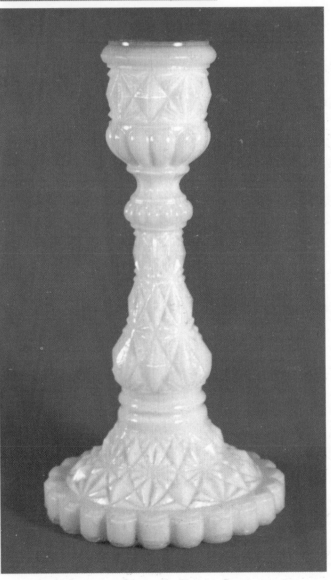

13. **Unknown** 6.25" single light candle holder. White milk glass
with ornate pressed design. Older milk glass.

153

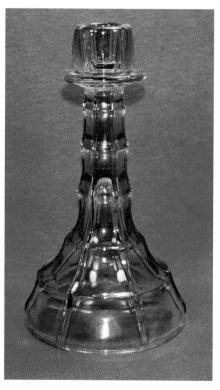

14. **Unknown** 6.75" single light candle holder. Rose amber.

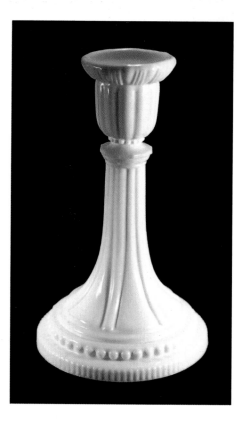

16. **Unknown** 7.25" single light candlestick. Milk glass.

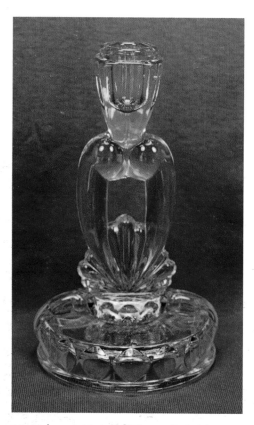

15. **Unknown** 7" single light candle holder. Crystal.

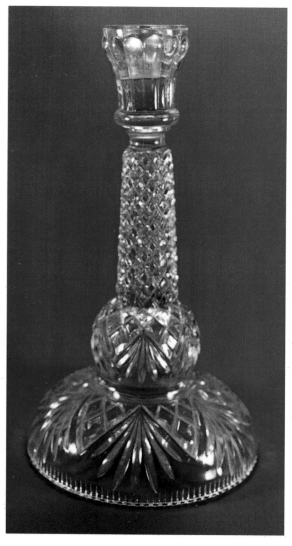

17. **Unknown** 8.875" single light candlestick. Crystal.

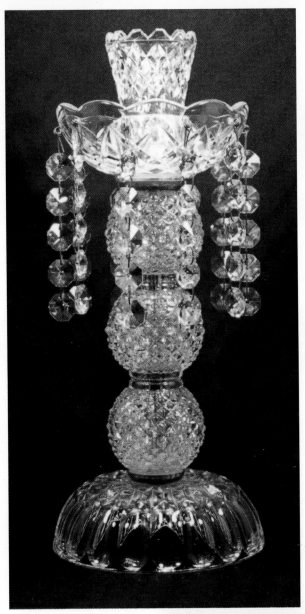

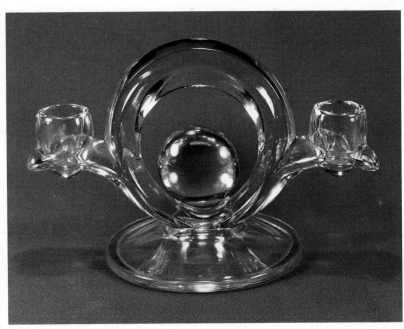

20. **Unknown** 5.25" x 8.5" double light candle holder. Crystal.

18. **Unknown** 10.375" single light candlestick. Crystal with bobeche and prisms.

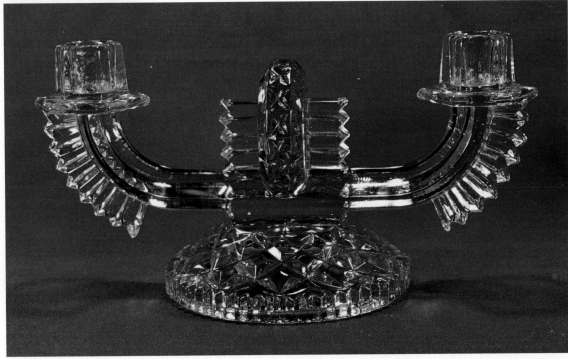

19. **Unknown** 5" x 10.625" double light candle holder with locking bobeche lips. Crystal.

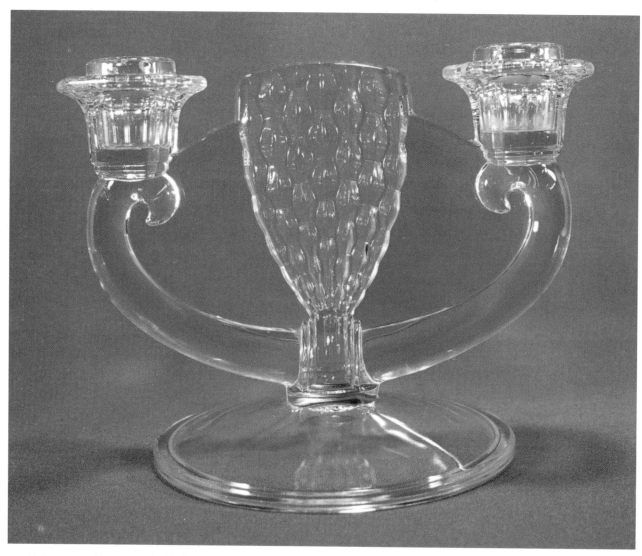

21. **Unknown** 5.5" x 7.375" double light candle holder. Crystal.

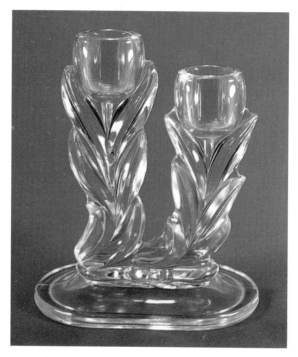

22. **Unknown** 5.5" double light candle holder. Crystal.

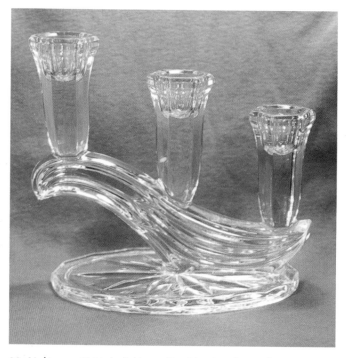

23. **Unknown** 6" triple light candle older. Lead crystal.

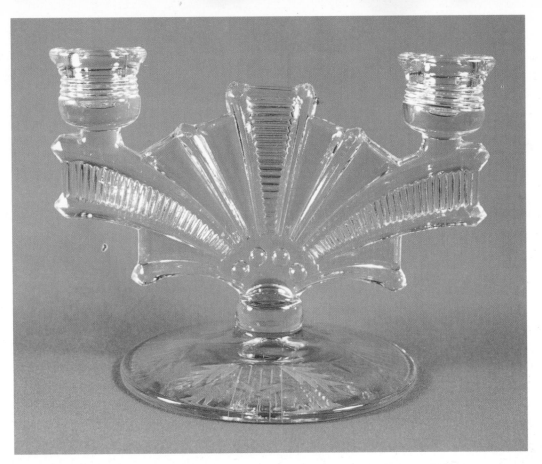

24. **Unknown** 6" x 7.75" double light candle holder. Crystal with cutting on base.

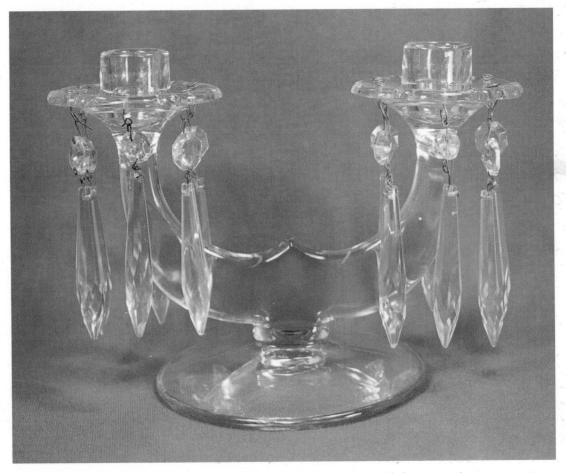

25. **Unknown** 6" double light, double lustre candle holder with prisms. Double lustre crystal.

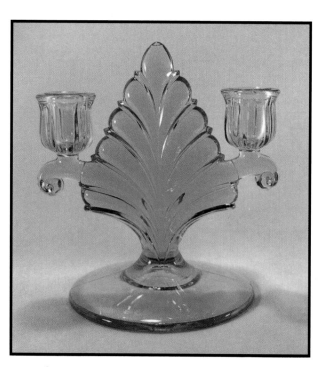

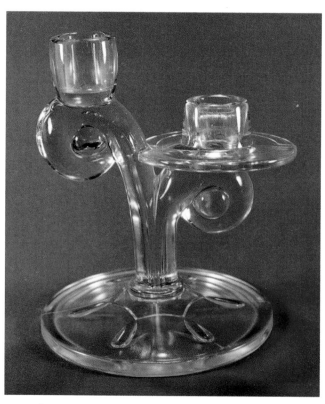

26. **Unknown** 6.5" x 6" double light candle holder. Pink.

27. **Unknown** 6.5" double light candelabra. Crystal.

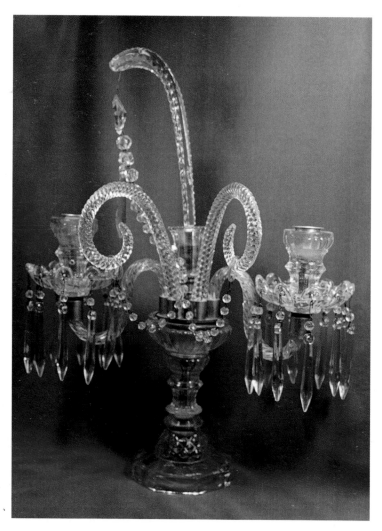

28. **Unknown** 17.5" double light candle holder with arms. Crystal.

Bibliography

Archer, Margaret and Douglas. *Imperial Glass*. Paducah, Kentucky: Collector Books, 1978.

———. *The Collector's Encyclopedia of Glass Candlesticks*. Paducah, Kentucky: Collector Books, 1983.

Baker, Gary E., et al. *Wheeling Glass 1829-1939 Collection of the Oglebay Institute Glass Museum*. Wheeling, West Virginia: Oglebay Institute, 1994.

Bickenheuser, Fred. *Tiffin Glassmasters (1929-1941)*. Grove City, Ohio: Glassmasters Publications, 1979.

———. *Tiffin Glassmasters Book II (1920-1950)*. Grove City, Ohio: Glassmasters Publications, 1981.

———. *Tiffin Glassmasters Book III (1915-1980)*. Grove City, Ohio: Glassmasters Publications, 1985.

Bones, Frances. *Fostoria Glassware 1887-1982*. Paducah, Kentucky: Collector Books, 1999.

Bredehoft, Neila. *The Collector's Encyclopedia of Heisey Glass 1925-1938*. Paducah, Kentucky: Collector Books, 1986.

Bredehoft, Tom and Neila. *Fifty Years of Collectible Glass 1920-1970 Volume I*. Dubuque, Iowa: Antique Trader Books, 1997.

Breeze, George and Linda. *Mysteries of the Moon & Stars*. Mt. Vernon, Illinois: George and Linda Breeze, (no date).

Burkholder, John R., and D. Thomas O'Connor. *Kemple Glass 1945-1970*. Marietta, Ohio: The Glass Press, Inc., 1997.

Burns, Carl O. *Imperial Carnival Glass*. Paducah, Kentucky: Collector Books, 1996.

Chiarenza, Frank, and James Slater. *The Milk Glass Book*. Atglen, Pennsylvania: Schiffer Publishing Ltd., 1998.

Doty, David. *A Field Guide to Carnival Glass*. Marietta, Ohio: The Glass Press Inc., 1998.

Etchings By Cambridge Volume 1. Brookville, Ohio: Brookville Publishing, 1997.

Felt, Tom, and Bob O'Grady. *Heisey Candlesticks, Candelabra, and Lamps*. Newark, Ohio: Heisey Collectors of America Inc., 1984.

Florence, Gene. *Elegant Glassware of the Depression Era, Seventh Edition*. Paducah, Kentucky: Collector Books, 1997.

———. *Anchor Hocking's Fire-King & More*. Paducah, Kentucky: Collector Books, 1998.

———. *Florence's Glassware Pattern Identification Guide*. Paducah, Kentucky: Collector Books, 1998.

———. *Collectible Glassware From the 40s, 50s, 60s... Fourth Edition*. Paducah, Kentucky: Collector Books, 1998.

———. *Collector's Encyclopedia of Depression Glass, Thirteenth Edition*. Paducah, Kentucky: Collector Books, 1998.

———. *Glass Candlesticks of the Depression Era*. Paducah, Kentucky: Collector Books, 2000.

Garrison, Myrna and Bob. *Imperial's Vintage Milk Glass*. Arlington Texas: Collector's Loot, 1992.

Glickman, Jay L. *Yellow-Green Vaseline!*. Marietta, Ohio: Antique Publications, 1991.

Heacock, William. *Fenton Glass The First Twenty-Five Years*. Marietta, Ohio: O-Val Advertising Corp., 1978.

———. *Fenton Glass The Second Twenty-Five Years*. Marietta, Ohio: O-Val Advertising Corp., 1980.

———. *Collecting Glass Volume 3*. Marietta, Ohio: Antique Publications, 1986.

———. *Fenton Glass The Third Twenty-Five Years*. Marietta, Ohio: O-Val Advertising Corp., 1989.

Heacock, William, et al. *Harry Northwood The Wheeling Years 1901-1925*. Marietta, Ohio: Antique Publications, 1991.

———. *Dugan/Diamond The Story of Indiana, Pennsylvania, Glass*. Marietta, Ohio: Antique Publications, 1993.

Hemminger, Ruth, et al. *Tiffin Modern Mid-Century Art Glass*. Atglen, Pennsylvania: Schiffer Publishing Ltd., 1997.

House of Americana Glassware Catalog No. 66A. Reprinted and copyrighted by National Imperial Glass Collectors Society, P.O. Box 534, Bellaire, Ohio, 1991.

Jenks, Bill, et al. *Identifying Pattern Glass Reproductions*. Radnor, Pennsylvania: Wallace-Homestead Book Company, 1993.

Kerr, Ann. *Fostoria*. Paducah, Kentucky: Collector Books, 1994.

———. *Fostoria Volume II*. Paducah, Kentucky: Collector Books, 1997.

Kilgo, Garry, et al. *A Collector's Guide to Anchor Hocking's Fire-King Glassware, Volume II*. Addison, Alabama: K & W Collectibles Publisher, 1991.

Kovar, Lorraine. *Westmoreland Glass 1950-1984*. Marietta, Ohio: Antique Publications, 1991.

———. *Westmoreland Glass 1950-1984 Volume II*. Marietta, Ohio: Antique Publications, 1991.

———. *Westmoreland Glass Volume 3 1888-1940*. Marietta, Ohio: The Glass Press, Inc., 1997.

Krause, Gail. *The Encyclopedia of Duncan Glass*. Tallahassee, Florida: Father & Son Associates, 1976.

Long, Milbra, and Emily Seate. *Fostoria Tableware, The Crystal for America 1924-1943*. Paducah, Kentucky: Collector Books, 1999.

———. *Fostoria Tableware, The Crystal for America 1944-1986*. Paducah, Kentucky: Collector Books, 1999.

Madeley, John, and Dave Shelter. *American Iridescent Stretch Glass*. Paducah, Kentucky: Collector Books, 1998.

Mauzy, Barbara and Jim. *Mauzy's Depression Glass*. Atglen, Pennsylvania: Schiffer Publishing Ltd., 1999.

Measell, James. *New Martinsville Glass, 1900-1944*. Marietta, Ohio: Antique Publications, 1994.

———. *Fenton Glass The 1980s Decade*. Marietta, Ohio: The Glass Press, Inc., 1996.

———. *Imperial Glass Encyclopedia Volume II*. Marietta, Ohio: The Glass Press, Inc., 1997.

Measell, James, ed. *Imperial Glass Encyclopedia Volume I*. Marietta, Ohio: The Glass Press, Inc., 1995.

———. *Imperial Glass Encyclopedia Volume III*. Marietta, Ohio: The Glass Press, Inc., 1999.

Measell, James, and Berry Wiggins. *Great American Glass of the Roaring 20s and Depression Era*. Marietta, Ohio: The Glass Press, Inc., 1998.

Measell, James, and W.C. "Red" Roetteis. *The L. G. Wright Glass Company*. Marietta, Ohio: The Glass Press, Inc., 1997.

Miller, C.L. *Depression Era Dime Store Glass*. Atglen, Pennsylvania: Schiffer Publishing Ltd., 1999.

National Cambridge Collectors, Inc. *The Cambridge Glass Company 1930 thru 1934*. Paducah, Kentucky: Collector Books, 1976.

———. *The Cambridge Glass Company 1949 thru 1953*. Paducah, Kentucky: Collector Books, 1978.

———. *Colors in Cambridge Glass*. Paducah, Kentucky: Collector Books, 1984.

———. *Reprint of 1940 Cambridge Glass Company Catalog*. Cambridge, Ohio: National Cambridge Collectors, Inc., 1995.

Newbound, Betty and Bill. *Collector's Encyclopedia of Milk Glass*. Paducah, Kentucky: Collector Books, 1995.

Nye, Mark, ed. *Caprice*. Cambridge, Ohio: National Cambridge Collectors, Inc., 1994.

Over, Naomi, L. *Ruby Glass of the 20th Century*. Marietta, Ohio: Antique Publications, 1990.

"Pattern Glass Preview", Issue Number Four, 1185-A Fountain Lane, Columbus, Ohio 43213.

Pina, Leslie. *Fostoria Serving the American Table 1887-1986*. Atglen, Pennsylvania: Schiffer Publishing Ltd., 1995.

———. *Popular '50s and '60s Glass*. Atglen, Pennsylvania: Schiffer Publishing Ltd., 1995.

———. *Fostoria Designer George Sakier*. Atglen, Pennsylvania: Schiffer Publishing Ltd., 1996.

———. *Circa Fifties Glass from Europe & America*. Atglen, Pennsylvania: Schiffer Publishing Ltd., 1997.

———. *Depression Era Glass by Duncan*. Atglen, Pennsylvania: Schiffer Publishing Ltd., 1999.

Pina, Leslie, and Jerry Gallagher. *Tiffin Glass 1914-1940*. Atglen, Pennsylvania: Schiffer Publishing Ltd., 1996.

Richardson, David E., in "Glass Collectors" IX (1), Marietta, Ohio: The Glass Press Inc., 1995.

Ruf, Bob and Pat. *Fairy Lamps*. Atglen, Pennsylvania: Schiffer Publishing Ltd., 1996.

Riggs, Sherry, and Paula Pendergrass. *20th Century Glass Candle Holders: Roaring 20s, Depression Era, & Modern Collectible Candle Holders*. Atglen, Pennsylvania: Schiffer Publishing Ltd., 1999.

Schroy, Ellen T. *Warman's Depression Glass*. Iola, Wisconsin: Krause Publications, 1997.

Snyder, Jeffrey B. *Morgantown Glass: From Depression Glass Through the 1960s*. Atglen, Pennsylvania: Schiffer Publishing Ltd., 1998.

Stout, Sandra McPhee. *The Complete Book of McKee Glass*. North Kansas City, Missouri: Trojan Press, Inc., 1972.

———. *Depression Glass III*. Des Moines, Iowa: Wallace-Homestead Book Company, 1976.

Toohey, Marlena. *A Collector's Guide to Black Glass*. Marietta, Ohio: Antique Publications, 1988.

Truitt, Robert and Deborah. *Collectible Bohemian Glass 1915-1945, Volume II*. Kenington, Maryland: B&D Glass, 1998.

Walk, John. *The Big Book of Fenton Glass 1940-1970*. Atglen, Pennsylvania: Schiffer Publishing Ltd., 1998.

Washburn, Kent G. *Price Survey, Forth Edition*. San Antonio, Texas: Kent Washburn Antiques, 1994.

Weatherman, Hazel Marie. *Fostoria Its First Fifty Years*. Ozark, Missouri: Hazel Weatherman, 1972.

———. *Colored Glass of the Depression Era 2*. Ozark, Missouri: Weatherman Glassbooks, 1974.

Wetzel-Tomalka, Mary M. *Candlewick The Jewel of Imperial Book II*. Notre Dame, Indiana: Mary M. Wetzel-Tomalka, 1995.

Whitmyer, Margaret and Kenn. *Collector's Encyclopedia of Children's Dishes*. Paducah, Kentucky: Collector Books, 1993.

———. *Fenton Art Glass Patterns 1939-1980*. Paducah, Kentucky: Collector Books, 1999.

———. *Fenton Art Glass 1907-1939*. Paducah, Kentucky: Collector Books, 1996.

Wilson, Chas West. *Westmoreland Glass*. Paducah, Kentucky: Collector Books, 1996.

Wilson, Jack D. *Phoenix and Consolidated Art Glass 1926-1980*. Marietta, Ohio: Antique Publications, 1989.